Painters of Fantasy

from Hieronymus Bosch
to Salvador Dali

104 reproductions
a selection introduced
by William Gaunt

Phaidon

The author would like to acknowledge the many unspecified sources
from which information has been taken. The author and publishers
would also like to thank all owners, both public and private, who have
allowed works in their possession to be reproduced. Plates 7 *(top)*,
11 *(left)*, 38 and 40 are reproduced by gracious permission of Her Majesty
The Queen. Plate 37 is reproduced by permission of the Syndics of the
Fitzwilliam Museum, Cambridge; Plates 70 *(top)* and 70 *(bottom)* by
permission of the Nymphenburger Verlagshandlung, Munich; and Plates
80, 81, 90, 91, 93 and 96 by courtesy of Madame Magritte. Plates 69, 77 and
83 are © by SPADEM Paris 1974 and Plates 73, 80, 81, 88, 89, 90, 91, 93 and
96 © ADAGP Paris 1974. Photographs have been supplied by Scala,
Florence, for Plates 5 and 23 and by Giraudon, Paris, for Plates 12 and 62.
The quotation from *The Divine Comedy* in the note to Plate 39 is taken
from Geoffrey L. Bickersteth's translation, published by the Shakespeare
Head Press, 1965.

Phaidon Press Limited, 5 Cromwell Place, London SW7 2JL

Distributed in the United States of America
by Praeger Publishers, Inc., 111 Fourth Avenue, New York, N.Y. 10003

First published 1974
© 1974 by Phaidon Press Limited
All rights reserved

ISBN 0 7148 1622 1
Library of Congress Catalog Card Number: 73-21451

Printed in Great Britain by Oxley Printing Group Limited

Painters of Fantasy

The word 'fantasy' sums up the nature of many remarkable works of art produced at various times and not confined to any particular country or period. It could be defined as the free exercise of the imagination, without deference to what we normally think of as reality. In painting it is the opposite of the realism sought after by the French Impressionists, who were mainly concerned with the optical effects of light and colour on the surfaces of objects visible to the eye. The spirit of fantasy, on the other hand, gives shape to the marvellous, the mysterious, the unknown. It has appealed to the sense of wonder in every age.

The philosophy of the painter of fantasy was succinctly stated by the nineteenth-century French painter, Gustave Moreau, in describing his own attitude. 'I do not believe', he said, 'in what I touch or what I see. I believe only in what I do not see and above all in what I feel.' Moreau's contemporary, the philosopher of the fantastic, Josephin Peladan, went into more detail in the rules he drew up for his society designed to promote imaginative art, the Salon de la Rose-Croix. He called for a sweeping rejection of the many realistic categories of painting: patriotic and military subjects; representations of contemporary life; portraits; rustic scenes; all landscapes ('except those composed in the manner of Poussin'); seascapes; picturesque orientalism; all humorous themes; all pictures of domestic animals and those related to sport; and of flowers and still-life.

After this comprehensive ban, what remained? Whimsical as it might seem the list of exclusions had the use of pointing to the separate existence and virtues of paintings inspired by legend, myth, allegory, dream and poetry, especially in its lyrical form, all modes in which fantasy has its part. It is even possible to include certain types of religious subject, though a distinction needs to be drawn between those that affirm essentials of belief and those that allow of a free interpretation. Fantasy is a term that does not apply to the pictorial rendering of Madonna and Child or the essential meaning of the Crucifixion. But there is a great amount of Christian legend which artists have been able freely to make use of without infringing basic tenets of faith, as for example the story of Salome (Plate 59) or Belshazzar's Feast (Plate 43). The visions that tormented St Anthony are variously suggested by the masters of fantasy (Plates 12, 13, 17 and 83). Hell is a conception, tremendous but undefined, that has inspired different interpretations. Fantastic indeed are the monsters assailing the saint as the German master, Grünewald, imagines them. Hell is a weird psychological dimension as pictured by Hieronymus Bosch (Plate 9) or Pieter Bruegel the Elder (Plate 16). Fantasy had a fruitful source in the accretions of legend that had grown up round the memory of some of the saints, such as the miracles attributed to St Nicholas of Bari, for example his stilling a tempest at sea, an occasion to which a Florentine or Sienese master could give delectable shape.

Often artists have identified the marvellous with the unknown. The islands of fantasy described in the *Odyssey* were those of a sea still unexplored. Geographical mystery took supernatural shape in the Homeric creations of the alluring sirens, the magically endowed Circe, the gigantic one-eyed Cyclops, themes that painters from the ancient Greco-Roman mural decorators to Turner in the nineteenth century have made their own. In a similar way medieval bestiaries include the fanciful beasts presumed to inhabit unknown lands, and early maps attach to such regions the warning notice, 'Here be monsters'.

There are subjects of a fanciful kind that have been so painted as to give the impression of a beautiful reality. The Renaissance masters took pleasure in the idea of a classical 'golden age' and in episodes of classical mythology that enabled them to represent the human body in a perfection that might be deemed godlike. It is possible to regard a scene of Bacchanalian festival painted by Titian as a kind of ideal fantasy. Yet the grotesque had its place also in the scenes from classical fable that delighted learned patrons. There were the fauns, satyrs and centaurs to be pictured in their various diversions (Plate 4). The disguises of Jupiter in his amorous relations with humanity were a series of fantasies. Many masters have celebrated his appearance as a shower of gold to Danaë, to Antiope as a satyr, to Leda as a swan, to Europa as a bull. The grotesque was a necessary element in such a favourite subject as Perseus's rescue of Andromeda from the sea monster, where Beauty was heightened in effect by the ugliness of the Beast.

The post-Renaissance centuries in Europe were on the whole less fanciful, the eighteenth century especially. Portraiture flourished, realism in landscape was growing, the rational rather than the mysterious was favoured. Yet there are always exceptions to be reckoned with. Witchcraft, a punishable offence, evidently fascinated artists and public alike (Plates 27–9). In the *fêtes galantes* of Watteau, the formal graces of the French court acquired a visionary charm; Watteau held an exquisite balance between the real and the unreal (Plate 31). Fantasy was sometimes an escape for the eighteenth-century view-painter from the repetition of familiar scenes that was his regular task. He found relief in the transformations of reality that had their sanction in a special genre, the *capriccio*. In paintings of this kind the artist could devise an architectural dream-world made up of fragments of reality rearranged as capriciously as he might choose. Thus the topographical painter Pannini at Rome made fanciful new combinations of Roman ruins, Canaletto takes the famous horses from the Basilica of St Mark's, in Venice, and places them in the Piazzetta in front of the Ducal Palace (Plate 40), and the English painter William Marlow, no doubt influenced by the Italians, depicts St Paul's in a Venetian setting (Plate 49). Piranesi, in another form of caprice, substituted his vast and labyrinthine prisons for the palaces of actuality (Plates 34, 35). Guardi at Venice turned from the ever-popular spectacle of the Grand Canal to invest little islands dotted about the lagoon with imaginary vestiges of architectural splendour (Plate 48).

With the coming of the Romantic Age at the end of the eighteenth and beginning of the nineteenth century, fantasy again became a powerful ingredient in the arts. Free imagination took issue against the control of reason. Shakespeare was rediscovered and painters were inspired to illustrate not only the supreme moments of terror and suspense of the tragedies but the fairy-tale characters met by moonlight in *A Midsummer Night's Dream*. 'The sleep of reason', to use Goya's phrase, could produce such fascinating monsters as haunt the slumbering figure which Fuseli painted in *The Nightmare* (Plate 45). Goya's own preoccupation with fantasy can be seen in his etchings as well as his paintings (Plates 46, 47 and 51).

Some parallel can be found in painting with the taste for the weirdly supernatural that had its literary expression in the 'Gothic' novels of Horace Walpole, Mrs Radcliffe and 'Monk' Lewis. Fuseli, in particular, signals this breakaway from the rational norm. The atmosphere of violence was another product of the Romantic mood. Among the Romantic creations of fantasy were pictures such as John Martin painted – the colossal and supernatural vengeance visited on Babylon and Nineveh, the spectacle of giant waves overwhelming land and people in his vision of the Deluge, or his terrifying representation of *The Great Day of His Wrath* (Plate 57).

The existence of fantasy in later nineteenth-century painting was for some time obscured by the greater attention paid to developments of a realistic kind. Contemporary life and landscape were the themes of the Realists, Impressionists and Post-Impressionists of a continental Europe, but a growing importance was attached to the purely aesthetic value of colour and form. It is only of late that the thread of imaginative art has been brought back into view.

In England it was represented by the Pre-Raphaelites. Though the Pre-Raphaelite movement began with the realistic goal of being 'true to nature', more characteristic of its later stages were visions of 'an ideal world that never was or could be', to quote the words of Edward Burne-Jones. This ideal yearning was not without influence on artists in France and Belgium who, at a time when Impressionism seemed to have carried all before it, were inclined towards a

more poetic view of art than that of painters solely concerned with external aspects of nature. In Europe the wistful nostalgia of Burne-Jones merged with the effort to convey a strangeness of sensation that gave a special meaning to the idea of 'decadence' (Plates 67, 70 and 71).

Decadence, as Verlaine poetically defined it, was the expression of 'the sensual spirit and the sorrowful flesh and of all the violent splendours of a degenerating empire'. He suggests something of the emotional complexity of artists who constructed their own world of fantasy in the 1880s and 1890s. Women became emblems of mysterious fate. Odilon Redon plumbed the depths of the macabre in illustrating the stories of Edgar Allan Poe. Gustave Moreau (Plates 59–61) gave fresh currency to ancient legend in the symbolic figures that stood for various states of mind.

Surrealism in the twentieth century has been in some ways a sequel to the Symbolism represented by Moreau and many others. The difference between the two movements appears in the replacement of the Symbolist's sin-haunted mysticism by a more clinical attitude, influenced by the investigations of the psycho-analyst. The fantasy of the dream and the strange underworld of the subconscious have gained a new place in art as well as in science. The Surrealist painters may, indeed, be said to have created a modern wonderland, and written the latest chapter of an extraordinary history (Plates 73, 80, 81, 88–91, 93 and 96).

Albrecht Altdorfer (c. 1480–1538)
1 Alexander's Battle

Panel, 62¼ × 47⅜ in. Signed and dated 1529. Munich, Alte Pinakothek.

The astonishing effect of this work comes from its combination of extremes – the vastness of aerial space and the massed effect of figures detailed with a miniaturist's minuteness. The subject is the defeat of Darius III by Alexander the Great at the Battle of Issus, in 333 B.C., in the Macedonian leader's victorious campaign against the Persians. Altdorfer – painter, engraver and town architect of Regensburg – was a pioneer of the Renaissance and a leading member of the Danube School, which played such an important part in the development of modern landscape painting. Both forest and Alpine country stimulated him to original effort in landscape. The small figures here depicted are so precise in delineation that Darius, fleeing in his chariot, is clearly visible. The battle-scene is said to have made a great impression on Napoleon but it is in his treatment of the elements that Altdorfer claims most attention and influence.

Albrecht Dürer (1471–1528)
2 The Four Horsemen of the Apocalypse

Woodcut, 15½ × 11 in. 1498.

The artists of the Renaissance era in Germany made the woodcut a vehicle of imaginative expression that has its supreme example in Dürer's *Four Horsemen of the Apocalypse,* as described in the Book of Revelation 6: 2–8. It is a work that may justly be regarded as one of the most original creations in Western art. This edition of the Book of Revelation, issued in 1498, was the first printed book in the West to be published as well as illustrated by an artist. Dürer used earlier illustrations as source material, though his genius transformed them into works of grandeur.

Hans Baldung-Grien (c. 1480–1545)
3 The Bewitched Groom

Woodcut, 13¼ × 7¾ in. New York, Metropolitan Museum of Art.

Hans Baldung-Grien, a painter and engraver who may have been employed in his early years in Dürer's workshop, was, like Dürer, an artist of imaginative quality. He seems to have acquired the nickname 'Grien' through his preference for green. In black and white he was able to invest an otherwise formal or simple design with an air of fantasy. Here, the Renaissance science in perspective and the dramatic strangeness of the prone figure at eye level are combined to startling effect.

Piero di Cosimo (1462–c. 1521)
4 A Mythological Subject

Panel, 25¾ × 72¼ in. London, National Gallery.

The fanciful element in Florentine art of the early Renaissance period, derived from classical myth and legend, sometimes took a grotesque and whimsical form in Piero's work but has a singular delicacy and pathos in this picture. A little faun (with exquisitely pointed ears) gently touches the shoulder of a girl lying dead of a throat wound, while a dog adds its mournfulness. The concourse of birds and animals on the shore of a distant estuary conveys the suggestion of some primal epoch. The picture for a long time bore the title *The Death of Procris,* but the absence of Procris's husband, Cephalus, whose dart accidentally killed her, threw doubt on the connection between picture and fable, and the picture's title is thus now left vague. The proportions of the panel suggest that it may have been painted to decorate the wainscoting of an interior.

Giulio Romano (1499?–1546)
5 The Fall of the Giants

Fresco. 1532–4. Mantua, Palazzo del Tè.

The decorations of the Palazzo del Tè, carried out by Giulio Romano for Federigo Gonzaga, Duke of Mantua, give a remarkable instance of fantasy resulting from the extreme of illusionism. The pupil and assistant to Raphael from his early years and his right-hand man in completing the schemes of decoration for the Vatican, Giulio was considered Italy's foremost painter/designer after Raphael's death in 1520 and was received with great respect at Mantua, where the Duke wished to give palatial form to a group of buildings and stables called the T. Well versed in architectural planning and fresco and influenced by Michelangelo's dramatic powers as well as Raphael's classicism, Giulio made a special effort, his *tour de force* being the wall painting reproduced here. Occupying the whole of one room from ceiling to floor, the work pictures a tremendous scene of disruption, with giants fleeing from the thunderbolts of Jove, the effect being intensified by the real flames that would be seen in the fire-place.

After Hieronymus Bosch (c. 1450–1516)
6 The Human Tree

Etching, 12½ × 9¾ in. St Louis, Missouri, St Louis Art Museum.

The pen sketch for the 'human tree' of *The Garden of Earthly Delights,* preserved in the Albertina, Vienna, differs in several respects from the painted version in the Prado triptych (see Plate 9) and so does the etching after the figure that attests its popular appeal. Several changes include the bagpipes on the figure's head in the painting, complementing the lute, harp and barrel-organ beneath him. As a symbol on the flag the bagpipes replaced the crescent that Bosch drew originally – a symbol of heresy. The graphic works have many of the curiosities of form appearing in the finished painting but it is only the painting that can reveal the sombreness beneath the wall of flame, a world of lost souls and psychotic activities rather than a place of punishment by demons of medieval type.

Leonardo da Vinci (1452–1519)
7 *(top)* Allegory

Red chalk, 6¾ × 11 in. About 1516. Windsor Castle, Royal Library.

One of Leonardo's most tantalizing drawings is this allegory. A wolf seated in the stern of a boat holds the tiller with one paw and rests the other on a compass pointing at an eagle perched on a globe. The boat's mast is an olive tree. The subject has been interpreted in different ways, none of them fully convincing. Bernard Berenson saw it as an allegory of Papal ambition, the wolf traditionally symbolizing the Papacy and the eagle the Emperor. But A. E. Popham has pointed out that the eagle wears the French crown, which suggests that the drawing alludes to the alliance between Pope Leo X and Francis I of France in 1515. On the other hand there is a purely scientific explanation that this is a scientific allegory and refers to the property of the magnetic pole. Or was Leonardo concocting, in his subtle mind, some emblem without political purpose or significance? The beautiful drawing is one of the enigmas of his enigmatic brain.

Andrea Mantegna (1431–1506)
(bottom) Battle of Sea Gods

Engraving, 13 × 7⅜ in. About 1490. London, British Museum.

The subject-matter of this work has been variously explained. One theory regards it as a description of the mythical fish-eaters of antiquity and of how this phlegmatic race would behave if divided by Envy; but this seems a dubious interpretation. At all events the engraving shows Mantegna's delight in an antique theme and the originality of his graphic technique, in which there was both the learning of the early Renaissance and the plastic feeling he derived from the great Florentine sculptor Donatello. Mantegna used the engraver's burin rather like the sculptor's chisel. His 'straight line' method of shading has produced a carved quality distinct from the imitative rendering of light and shade and curved forms usual in the reproductive engraving.

Hieronymus Bosch (c. 1450–1516)
8 The Last Judgement

Panel, 64⅛ × 50¼ in. Vienna, Akademie der Bildenden Künste.

The triptych of which this picture is the central panel is an astounding production in its mass of bizarre detail and grotesque incident and character. The left wing has an ominous disquiet, an onrush of evils disturbing the sky; in the central panel, a medieval Heaven of clear colour and calm throws into lurid contrast the fearful depths below. A medley of scenes in dark, hot colours depicts the punishments of sinners with a painstaking exactitude, the slaughterhouse where lechers are cut in pieces, the wheel of torture, the

cauldron in which murderers are burnt alive. The symbolic and spiritual side of Bosch is here so much less in evidence than in his other pictures that some critics have seen in the work the hand of some more materially minded follower. But there are many details it may be thought only Bosch could have invented, such as a marvellous dragon that seems to breathe diabolical counsel.

Hieronymus Bosch (c. 1405–1516)
9 'The Musical Hell' (Detail)

Panel, 86 × 38 in. About 1500. Madrid, Prado.

There is no more extraordinary way of entry into the fantasy world of Hieronymus Bosch than the great triptych in the Prado, part of whose right wing is reproduced here. Often called *The Garden of Earthly Delights,* from the brilliant, carnival-like spectacle of life in the central panel, the work reaches its intensely impressive climax of strange imagery in the final scene, dominated by the broken and degenerate figure of the 'human tree'. This panel has been described as a 'Musical Hell' because of the many musical instruments, which perhaps symbolize the wrongful use of what should have served higher purposes. But symbolism, much of it still awaiting – or resisting – explanation, is omnipresent. The broken body has been associated with the 'world's egg' of alchemy, in completeness a symbol of perfection but here cracked and turned into a kind of inner hell, the resort of the dissipated. The gnarled limbs are a decay of physical faculties, their insecure balance on the fragile boats that do duty for feet suggesting they are sinking into the mire of the underworld. According to one theory, the head of the figure is a portrait of the artist himself, implying that he did not consider himself immune from human failings.

Giorgio Ghisi (c. 1520–82)
10 The Dream of Raphael or The Melancholy of Michelangelo

Engraving, 14⅞ × 21¼ in. London, Victoria and Albert Museum.

This is an outstanding example of the Mannerist art that developed in the early sixteenth century, with its love of complex imagery and allegory. Neither of the alternative titles by which the print has been traditionally known provides an obvious explanation of its theme. It is nowadays supposed to be a fanciful analogy with Aeneas's visit to the Underworld. Instead of Theseus chained to a rock, this interpretation sees the central figure as the melancholy soul tormented by evil dreams and reaching out to Love for salvation. The engraved Latin inscription exhorts the observer not to surrender to evils but to face them boldly. The design has been attributed to various hands, though Ghisi, who engraved it, seems to have been an artist of invention as well as skill. Apart from speculations as to its origin the engraving can be appreciated as an allegory, fascinating in its oppositions of stress and hope and its mass of curious detail.

Leonardo da Vinci (1452–1519)
11 (left) Five Grotesque Heads

Pen and ink, 10¼ × 8⅛ in. Windsor Castle, Royal Library.

It is one aspect of Leonardo's universality of outlook that he did not concern himself as an artist solely with an idea of perfect beauty but was equally interested in the fantastic and the grotesque. Ugliness of feature as in these drawings seems a product of his comprehensive study of expression and an experimental exercise of his extraordinary genius. Though his biographer Vasari relates that Leonardo's delight in 'curious heads' was such that he 'would follow about anyone who had thus attracted his attention for a whole day', it seems clear that he did not make portraits of persons in real life with the comic distortion or exaggeration of feature that comes under the heading of Caricature. Caricature was a later by-product of art, from which Leonardo's seriously – and even scientifically – motivated studies are different in kind.

Cornelis Bloemaert (1603–80)
(right) Two Owls Skating

Engraving, 8⅛ × 5¾ in. Rotterdam, Museum Boymans-van Beuningen.

To imagine animals and birds in human dress and with some reflection of human characteristics is a type of fantasy with a long history in both art and letters, coming down to the present day, when Walt Disney's Donald Duck in sailor's garb and other celebrated creations delight a worldwide audience. Cornelis Bloemaert's engraving is after a design attributed to Adriaen van de Venne (1589–1662), who shows himself a forerunner of the Disney genre in his portrayal of two owls dressed in the costume of the northern Netherlands in the first half of the seventeenth century and equipped with skates, like the Dutch citizens who skim over the frozen waterways of Holland in so many paintings of the time. Van de Venne's owls are pictured with the humour that belongs to the genre but with a slightly sinister suggestion that as far as small rodents were concerned the birds were the villains of the piece.

Matthias Grünewald (c. 1470–1528)
12 The Temptation of St Anthony

Panel, 104½ × 54¾ in. About 1515. Colmar (Alsace), Unterlinden Museum.

Among the few works of the great German painter Grünewald (Mathis Neithardt-Gothardt), the folding altar painted for the church of the Antonite monastery at Isenheim, Alsace, stands out as a work of the greatest emotional intensity and range, from the beauty of the Annunciation and the angelic choir to the agony of the Crucifixion and the glory of the Resurrection. The painted wings when open show two events in the life of St Anthony Abbot: on the left wing we see his visit to the hermit Paul in the desert and on the right wing (illustrated here) his temptation, the latter a vision without equal of the frightful spectres besetting him. The effect is the more fantastic in contrast with the scene of saintly discussion on the left wing and with the ecstatic heights of emotion to which the other panels of the work rise. Though Grünewald was the contemporary of Dürer, he was little affected by Renaissance influence and his grotesque imagery was still Late Gothic in its power.

Hieronymus Bosch
13 The Temptation of St Anthony

Central panel, 51¾ × 46⅞ in. About 1500. Lisbon, Museu Nacional de Arte Antiga.

No more astonishing picture of complex imagery and symbolism has been devoted to the often painted *Temptation of St Anthony* than this version by Bosch, which is the central panel of a triptych. St Anthony Abbot, who lived in the fourth century, was born in Upper Egypt of wealthy parents. According to legend, he gave his wealth to the poor and withdrew to the desert for solitary meditation. He was there assailed by the succession of terrors and temptations of which Bosch makes characteristically imaginative use. There is a black mass in progress in the foreground. Demons swarm out of a huge gourd, and monstrous forms parade in the centre, such as the trunkless *gryllus,* its head growing from its legs, a beast of ancient legend resuscitated by Bosch's imagination. Fires in the background signalize the forces of evil. The flying boats and their passengers that skim through the sky overhead suggest the absence of all restraint. The left-hand panel shows the Saint overcome for the moment by the horror of the scene. Like Grünewald (Plate 12) Bosch laid stress on intimidation rather than enticement, though the right-hand panel has its suggestion of the worldly pleasures to be resisted.

Agostino de' Musi, called Agostino Veneziano (1490–after 1531)
14 The Skeletons

Engraving after Baccio Bandinelli, 12¼ × 20⅛ in. New Haven, Connecticut, Yale University Art Gallery (Gift of Ralph Kirkpatrick).

Agostino de' Musi, who was born in Venice about 1490, was one of the Renaissance engravers working for Marcantonio Raimondi on the reproductions of the works of Raphael, for which there was a great demand. Baccio Bandinelli, a Florentine sculptor and painter ambitious to excel in anatomy, employed Agostino as engraver, with the specific purpose of showing the progress he had made in his anatomical studies. Bandinelli provided Agostino with a skeleton made up of dried bones, from which to make an anatomical plate. Though gruesome in effect, the plate is said to have been much admired.

Ascribed to Agostino Veneziano (1490–after 1531)

15 The Carcass

Engraving, 11⅞ × 24¾ in. About 1518?

The fanciful details of the Renaissance painter's invention as well as the many motifs and emblems of ancient decorative art provided an extensive repertoire of fantastic design for the Italian engravers of the sixteenth century. The example of Agostino's own part in the work of reproduction provided many examples of Raphaelesque design. One may contrast the open composition and High Renaissance naturalism in the treatment of the figure with the closely packed fantasy of Ghisi's *Dream of Raphael* (Plate 10). The subject was probably a scene of witchcraft and the skeleton figures are recalled by such a later work as Salvator Rosa's *Scene of Witches* (Plate 27).

Pieter Bruegel the Elder (*c.* 1525–69)

16 The Triumph of Death

Oil on panel, 46 × 63¾ in. About 1562. Madrid, Prado.

This masterpiece of Bruegel's fantasy elaborates on its one main theme – that death comes to all, irrespective of colour or creed – in what seems an almost endless series of permutations and combinations. On foot the skeleton figures impartially mow down king, cardinal, commoner, age and youth, clutch at the skirts of a beautiful girl and slay the gamesters and feasters with a morbid jocoseness. With sweeping scythe, Death on his horse drives the crowds into a common grave. The painting, which is related stylistically and in subject-matter to *The Fall of the Rebel Angels* (Plate 18) and *'Dulle Griet'* (Plate 19), shows Bruegel's aptitude for grotesque invention and his preoccupation in the early 1560s with thoughts of Death and the Day of Judgement. The work may be taken to foreshadow conflict to come; the background is such a vista of fires, sinking ships and ravaged land as the Duke of Alva's persecution was to create when he was sent by Philip II of Spain to quell the revolt in the Netherlands in 1567.

Jacques Callot (1592/3–1635)

17 The Temptation of St Anthony

Etching, 14⅛ × 18¼ in. 1634.

The brilliant and prolific French draughtsman, engraver and etcher, Jacques Callot, though selecting his subjects mainly from the events of his own time, gave his own dramatic interpretation of the legendary religious scene that had inspired masterpieces by Matthias Grünewald and Hieronymus Bosch (Plates 12 and 13). The subject evidently had a fascination for many artists of post-medieval Europe in the scope it gave for exercising the imagination. Callot's etching was perhaps an indirect reference to the upheavals of the Thirty Years War, which he witnessed. Born at Nancy, and achieving great success at Florence in the court of Cosimo de' Medici with his engravings of festivals and characters of the *commedia dell'arte*, Callot, on his return to Nancy, was much in demand for drawings of battles and sieges in a Lorraine ravaged by war. In his 'Miseries of War' he vied with Goya. In the *Temptation* he selects the moment when, as described in *The Golden Legend*, winged monsters make their appearance, howling above the scene of battle and raging round the Saint amid the ruins of buildings.

Pieter Bruegel the Elder (*c.* 1525–69)

18 The Fall of the Rebel Angels

Panel, 46 × 63¾ in. 1562. Brussels, Musées Royaux des Beaux-Arts.

In this painting Bruegel depicts a religious subject, popular at the time, in a style still recalling the Middle Ages rather than the middle of the sixteenth century and still making use of fantastic elements derived from Hieronymus Bosch. The rebel 'angels' are a remarkable miscellany of Bosch-like creatures, hybrid in shape, part human, fish-like and bird-like, reptilian and otherwise monstrous. They suggest the sins and vices that were the fit objects of angelic attack rather than any remaining trace of angelic attribute. Crowded though the composition is, Bruegel retained a basic order in the central and dominating place of the armour-clad St Michael and in the size of the militant angels, dressed in white, on either side of him, with their attendant trumpeters of victory. The rout and chaos of the rebel army is depicted with the intense energy found in the *Triumph of Death* (Plate 16).

Pieter Bruegel the Elder (*c.* 1525–69)

19 'Dulle Griet' (Mad Meg)

Panel, 45¼ × 63⅜ in. 1562. Antwerp, Mayer van den Bergh Museum.

As complex a piece of fantasy as Bruegel ever painted, this work is full of the supposedly alchemical symbols and monstrous figures that the Bruegel derived from Hieronymus Bosch. The meaning of the composition is obscure enough to have invited a variety of explanations. Was Meg a Fury from Hell – though her features scarcely convey as much; a bogey-woman of Flemish folk-lore; a personification of avarice or a prentice-alchemist about to descend, sword in hand, into some underworld initiation? Or could it be that she is a homely symbol of popular anger at the sinister political network that surrounded the Netherlands? Or again, was Bruegel making a final sweep of diablerie? However this may be, the *Griet* is a whole museum of wonders, before Bruegel's realism prevailed over fantasy.

Pieter Bruegel the Elder (*c.* 1525–69)

20 (top) Landscape with a Walled Town

Pen and ink, 9⅜ × 13¼ in. 1553. London, British Museum.

(bottom) Spes (Hope)

Pen and ink, 8⅞ × 11⅝ in. 1559. Berlin, Kupferstichkabinett.

These are two contrasted examples of the element of fantasy that is so pervasive in all Bruegel's work. The *Landscape,* although based on scenery that the artist would have seen on his journey from Flanders to Italy as a young man, has a quaintness, a picturesque fondness for walls and towers and dramatic distances, that belongs more to Bruegel's imagination than to any kind of geographical fact. *Spes* (the Latin word for hope), like *The Triumph of Death* (Plate 16) and *The Fall of the Rebel Angels* (Plate 18), shows how Bruegel took a basic theme, or idea, and visually elaborated on it. The figure of Hope stands on a large anchor in a choppy sea, which symbolizes the troubles of the world. In one hand she holds a spade and in the other a scythe, while on her head there is a beehive: all these are symbolic of difficult or dangerous activities and lend point to the Latin inscription along the bottom of the drawing. 'The assurance that hope gives us', it says, 'is most pleasant and most essential to an existence amid so many nearly insupportable woes'. The disasters at sea, the prisoners in their cell and the burning house illustrate further tribulations that encourage hope. As in *The Triumph of Death,* Bruegel employs a high viewpoint and a strong diagonal emphasis in the composition, which tie the design together. *Spes* is the preliminary drawing for an engraving and is one of a series of seven Virtues that Bruegel drew in the late 1550s. He had previously designed a series of seven illustrations of Vices; one of them *Luxuria* (Lechery), is reproduced as Plate 21 (bottom). Bruegel's prints were evidently popular; and he must have depended on them for a good part of his living.

Pieter Bruegel the Elder (*c.* 1525–69)

21 (top) The Bee-Keepers

Pen and ink, 8 × 12⅛ in. About 1568. Berlin, Kupferstichkabinett.

(bottom) Luxuria (Lechery)

Pen and ink, 8⅞ × 11¾ in. 1557. Brussels, Bibliothèque Royale.

In the earlier part of his career, when he produced many of his designs for prints, Bruegel deliberately aped the style of Bosch (see Plates 8, 9 and 13), whose own creations were apparently popular with the general public; one of Bruegel's own designs was even published with a false inscription attributing it to Bosch. In *Luxuria* the strange demons, the curious buildings looking as though they had been hollowed out of monstrous vegetables, and the multiplicity of incident, all belong to the Bosch tradition. The actual symbolism is relatively straightforward. The naked woman in the centre is Lady Lechery. The various animals to be found throughout the drawing – peacocks, swans, sheep, dogs, monkeys – were all associated, in Flemish folklore, with the idea of lechery. In the middle distance a procession moves towards the right, led by a man playing the bagpipes (another symbol of lust). The naked man riding on the monster is evidently guilty of adultery and is being publicly punished (this actually happened in Flanders). In the drawing, the man wears a bishop's mitre; but this was obviously thought too controversial for the subsequent engraving, where the figure is given a rather nondescript hat. The inscription under the drawing means 'Lechery stinks, it is full of uncleanness, it breaks the powers and weakens the limbs.' *The Bee-Keepers* is an extension of the idea – common to both Bosch and Bruegel – of animals, humans and inanimate objects taking on each other's character-

istics. The figures are wearing wicker masks as a protection against the bees, and the visual effect is strangely Surrealist.

Giuseppe Arcimboldo (1527–93)
22 Winter

Panel, 26¼ × 19⅞ in. 1563. Vienna, Kunsthistorisches Museum.

A Milanese artist and Court Painter to the Austrian Emperors, Ferdinand I, Maximilian II and Rudolf II, Arcimboldo is remembered mainly by the bizarreries in which he ingeniously made up heads and figures from painted details of such objects as fruit, flowers, vegetables and fish, 'The Elements' and 'The Seasons' being principal series. Arcimboldo's pictures were so much to the taste of Rudolf II that he appointed him Count Palatine. For a long time ignored as no more than a passing fashion, his work has experienced a revival of interest in the twentieth century because of its Surrealistic qualities.

Michelangelo Merisi da Caravaggio (1573–1610)
23 Medusa

Panel, diameter 21¾ in. About 1596? Florence, Uffizi.

A revolutionary genius with great influence on the course of European painting, Caravaggio was in one aspect the promoter of the dramatic realism that became characteristic of the seventeenth century. This is partly defined by his practice of introducing everyday and plebeian types into subjects where it was usual to aim at some idealism of features, and on this account some of his works were refused by the authorities which had commissioned them. Equally striking were the powerful effects of light and shade which he developed and which seem a reflection of his own violence of temperament. Something of this appears when he chose such a subject of classical fantasy as the head of the Gorgon, Medusa, whom Perseus, under cover of Minerva's shield, was able to slay. Medusa's head was placed on the shield but retained the power of turning objects into stone. Caravaggio gives a naturalistic interpretation of legend.

Christopher Jamnitzer (1563–1618)
24 *(top)* Tournament

Etching, from the *Neuw Grottessken Buch,* 1610.

This is one of a series of etchings published in Nuremberg in 1610. The two goblins and their steeds – part bird, part shell – are wholly fanciful; but the design is, at the same time, a kind of parody of a contemporary tournament scene, and is set in a relatively conventional landscape. The goblins belong to the Bosch-Bruegel tradition, while the monsters are made up from disparate elements, as Leonardo da Vinci had recommended in a famous text about the depiction of fabulous beasts.

Guercino (1591–1666)
(bottom) A Monstrous Foot

Pen and ink and wash, 5⅞ × 8¾ in. Oxford, Ashmolean Museum (on loan from the Gathorne-Hardy Collection).

Il Guercino (meaning 'squint-eyed'), nickname of Giovanni Francesco Barbieri and now the name by which he is best known, was one of the leading Baroque masters and a prolific draughtsman. His drawings include grandiose studies for his religious paintings and a number of landscapes, the flow of movement in pen and wash being notable. They were much sought after in eighteenth-century England (as many as six hundred being in the Royal Collection at Windsor Castle). The example illustrated was evidently a spontaneous graphic idea of expression, and in the grotesque union of foot and hand Guercino seems already an unconscious Surrealist.

Filippo Morghen (active mid-eighteenth century)
25 Two Fantastic Scenes

Etchings, from *Raccolta delle Cosa,* 1764.

These etchings, from the *Raccolta delle Cosa* (Anthology of Trifles), have all the playful fantasy that essentially belonged to the Rococo style of the eighteenth century. They reflect the elegance and artificiality which were applied to all forms of decoration and which especially appealed to rulers and aristocracies weary of the rigid disciplines and serious purposes earlier imposed by authority such as that of Louis XIV of France. Morghen, born in Florence in 1730, was an etcher, engraver and print-publisher and worked in Rome and Naples. He was entirely in tune with Rococo fashion. The delicate curves of his designs and a whimsical extravagance of idea go well together in the scenes where a fantastic animal is lured into an impracticable-looking trap and a grotesque bird has its role in a fishing expedition.

Francesco Zucchi (1562–1622) (?)
26 Summer

Canvas, 39⅝ × 55¼ in. Hartford, Connecticut, Wadsworth Atheneum.

The painter of this picture is not known for certain, although it is obvious that he was influenced by the visual ideas of Arcimboldo (Plate 22). Arcimboldo's own fanciful figures, are usually in an upright format and shown against a plain background, in contrast to *Summer,* where the implications of the theme are made even clearer by the inclusion of a sunny landscape behind the figure. The idea of a form that can be understood as two separate things (in this case, either a pile of fruit and vegetables or a reclining man) recurs in European art over the centuries; and in our own day it has been given a new lease of life in the cinema, and in particular in cartoons, where talking oak-trees and dancing brooms have become almost commonplace. Cartoons, of course, appeal to children; and pictures in the Arcimboldo idiom must originally have appealed to the simple, almost childlike love of ingenuity and the grotesque that we perhaps all share. Arcimboldo was rediscovered in the twentieth century, in the age of Surrealism, and it is possible that his pictures have been slightly misunderstood, and taken too seriously, because they have been judged from the Surrealist point of view, with its sophisticated interest in dreams, psychoanalysis and the irrational. The works of Arcimboldo and his followers are, first and foremost, entertaining; and their main strength lies in the skill with which the double illusion is maintained.

Salvator Rosa (1615–73)
27 Scene of Witches

Canvas, 28¼ × 52 in. About 1645. Althorp, Earl Spencer.

Though witchcraft still incurred grim penalties in the seventeenth century in the more primitive communities of extreme Puritan beliefs, its representation in art answered to a taste in cultivated circles for night scenes and weird happenings. In addition to his rugged landscapes and coastal scenes and pictures of battle, Salvator Rosa produced paintings answering to the taste for the macabre, of which this is a vivid example. Separate groups are seen engaged in the various activities of witches. The hooded figure at left appears to be a mock-priest. The characters fumigating the hair and clipping the toenails of the hanged man collect the relics considered particularly acceptable to witches as coming from one who died by violence. The group mounted on skeletons may be compared with those in Agostino Veneziano's *The Carcass* (Plate 15). A satirical spirit may be divined that gives an anticipation of Goya.

Jacob de Gheyn II (1565–1629)
28 A Witches' Sabbath

Pen and ink and wash, 14¾ × 20½ in. Oxford, Christ Church.

The influence of Italian art on the Netherlands left traces in both style and subject in the confused period before Dutch realism and the products of the Counter-Reformation in the southern Provinces had clearly demarked the character of north and south. Italian mannerism led to the development of an extravagant style that had its focus in what was known as the 'Haarlem Academy', principal figures being the painter and chronicler of art, Karel van Mander (1548–1606), and the engraver and draughtsman, Hendrik Goltzius (1558–1617). A pupil of Goltzius was Jacob de Gheyn II, primarily an engraver and draughtsman like his master and showing something of the extravagance of manner that belonged to the group, though it was used by him with a distinctive originality. The interest in scenes of witchcraft, which was a fashionable taste in the Italian cities, was another aspect of Italian influence inspiring such a remarkable drawing as the one here reproduced.

Jacob de Gheyn II (1565–1629)
29 A Witches' Kitchen

Pen and ink and wash, 11 × 16 in. 1600? Oxford, Ashmolean Museum.

Here as in the preceding drawing (Plate 28) de Gheyn makes a vivid fantasy out of witchcraft, his world of the grotesque being distinct in character from that of Bosch and Bruegel, which stemmed from the Netherlandish traditions of the Middle Ages. The popularity of his subjects is attested by the engraved compositions published after his designs.

Claude Lorraine (1600–82)
30 The Embarkation of St Ursula

Canvas, 44½ × 58½ in. 1641. London, National Gallery.

This masterpiece fuses together the nostalgic conception of an ideal classical past, the fantasy of legend and the truthful vision of nature into an extraordinary unity. The French master does not seem unduly concerned about the fate in store for St Ursula and the 11,000 virgins whose legendary pilgrimage was to end in martyrdom at the hands of the Huns at Cologne. But the composition provides one of Claude's most beautiful distances, an infinite delicacy of early morning light dispersing the mist, from which the waiting ships emerge. The removal of brown varnish at the time of the First World War, when the work was seriously damaged, disclosed its perfect freshness of technique, details such as the fleurs-de-lis on the ships' flags becoming visible for the first time in modern experience. The painting may appropriately be called an 'enchantment'.

Antoine Watteau (1684–1721)
31 The Embarkation from Cythera

Canvas, 50¾ × 76½ in. About 1718. Berlin, Schloss Charlottenburg.

A delightful dream-world in which there was nothing grotesque or inharmonious, but only thought of love, grace of figure and elegance of manners and dress was Watteau's contribution to fantasy in art. The French court in the *Embarkation from Cythera* was transformed into a company of charming phantoms leaving that imagined island that was anciently sacred to Aphrodite. The painting was a retreat from reality in a symbolic sense and (if one chose to look on it in that way) as pointed a comment on the eighteenth century in France as the stern call to arms of David's *Oath of the Horatii* shortly before the Revolution. If there is a shade of sadness in Watteau's Utopian make-believe it may be attributed also to the few years of life that remained to the artist suffering from a fatal illness.

Giovanni Battista Piranesi (1720–78)
32 Two Roman Roads Flanked by Colossal Funerary Monuments

Etching, 16⅛ × 25⅜ in. About 1756. London, P. & D. Colnaghi & Co Ltd.

It was the achievement of the Venetian, Piranesi, to picture a fantastic magnificence of Roman architecture, real and imagined. He was well equipped for both tasks from study with his uncle (an engineer and architect), with an engraver, and with his own brother, a Carthusian monk, who instructed him in Roman history. His first major archaeological work was an account of the antiquities of the city of Rome and its environs. Though Viscount Charlemont did not produce the promised financial support, *Le Antichità Romane,* 1756, was an immediate success. The etching here reproduced formed the frontispiece of Volume II of the work. It displays an astonishing ability to pile up richness of ornamental detail in a monumental ensemble.

Hubert Robert (1733–1808)
33 Capriccio: The Finding of the Laocöon

Canvas, 47 × 64 in. 1773. Richmond, Virginia Museum of Fine Arts.

Robert gives a fanciful idea of the discovery in 1506 of the famous Greek sculpture now in the Vatican Museum. The basilica with its vast perspective in which Robert places the sculpture was imagin-

ary. The picture was painted some years after the artist's return to Paris from Rome, where he had acquired a passion for classical antiquity and had earned the title of 'Robert des Ruines'. His interest in ruins was, however, picturesque rather than scholarly and he painted many scenes in which everyday life took its placid course among the relics of antiquity. He was successful in Paris with his decorative panels, which included a number painted in homage to antique sculpture. Imprisoned for a time during the Revolution as an official of the royal household (he was appointed garden designer to Louis XVI) Robert was released after the fall of Robespierre and in later years painted views of Paris and further reminiscences of Rome and its past.

Giovanni Battista Piranesi (1720–78)
34 Prison Scene

Etching, from *Invenzioni Capric di Carceri*. About 1745–50.

Among the masterpieces of fantasy and in their own way unrivalled are Piranesi's imagined prison interiors, which are the most exciting products of his graphic genius. They were developments of earlier experiments in perspective. The traditions of stage design may also have influenced him. He returned to Rome from a visit to Venice in the 1740s with fresh ideas of the potentialities of etching derived from acquaintance with the work of Tiepolo and the etched views of Venice that were being published by Canaletto and Marieschi. The result was a release of imagination and freedom of technical execution. The crushing weight of stone is indicated with linear shading that is light and free, while the nightmare visions of endless balconies and galleries baffle and captivate the eye. With these 'caprices' Piranesi soared into a region far beyond the confines of topography.

Giovanni Battista Piranesi (1720–88)
35 Prison Scene

Etching, from *Carceri d'Invenzione*. 1761.

After some ten years Piranesi gave fresh scrutiny to the fourteen plates of the *Invenzioni Capric di Carceri* (see Plate 34), viewing with some dissatisfaction the free sketchiness of style in the original impressions. He decided to work on all the plates afresh, using darker effects of shadow obtained by special inking as well as re-etching and adding such details of bolts and bars, instruments of torture, chains, ropes, and fantastic terraces, as heightened the terror of a dungeon from which, vast as it was, there was no way out. Two new plates, more detailed and containing numerous figures, were added. The etchings here reproduced give an idea of the differences between the original plates and the reworked ones, which ran into at least five editions. Though De Quincey did not see the *Carceri* plates but judged them by Coleridge's description, he makes a perceptive remark in the *Confessions of an English Opium Eater* on their character and especially on 'the power of endless growth and self-reproduction'.

Sebastiano Ricci (1659–1734) and Marco Ricci (1676–1730)
36 Memorial to Admiral Sir Cloudesley Shovel

Canvas, 87½ × 62½ in. Washington, D.C., National Gallery of Art (Kress Collection).

An example of a patron's fantasy dutifully given shape by artists he employed, this painting was one of a series of twenty-four allegorical pictures, painted between 1722 and 1729 in memory of 'British Monarchs, the valiant Commanders, and other illustrious Personages, who flourish'd in *England* about the End of the seventeenth, and the Beginning of the eighteenth Centuries'. The series was commissioned by Owen MacSwinny (d.1754), playwright and manager of the Queen's Theatre, Haymarket, London, until he went bankrupt and retired to Italy. Venetian and Bolognese artists were employed on the subjects, for which he supplied the 'Invention'. Sebastiano Ricci seems to have painted figures and sculptures in the Shovel painting, his nephew Marco the landscape and details of ruins. Symbols of naval power are not lacking, but references to Sir Cloudesley (1650–1707), the scourge of the Barbary pirates and taker of Gibraltar with Sir George Rooke, are as little specific as might be expected from the two Italian painters. Among the onlookers are a colourfully dressed Moor in the centre foreground, alluding to the admiral's operations off the north African coast, and a young man seated on a stone, sketching.

Giovanni Battista Pittoni (1687–1767)

37 An Allegorical Monument to Sir Isaac Newton

Canvas, 86¾ × 54½ in. About 1727–9. Cambridge, Fitzwilliam Museum.

One of the series of twenty-four allegorical pictures painted between 1722 and 1729 and commissioned by Owen MacSwinny in honour of illustrious Englishmen 'about the End of the seventeenth, and the Beginning of the eighteenth Centuries', this painting successfully combines a spacious architectural setting and graceful realism with an indication of the great scientist's discoveries, the prismatic decomposition of light being an abstract element reconciled skilfully with Pittoni's normal facility of style. The harmony achieved by the artists contributing to the scheme is evident if one compares Pittoni's work with the memorial to Sir Cloudesley Shovel by Sebastiano and Marco Ricci (Plate 36). It may be partly explained in this instance by the fact that Pittoni had always been much influenced by the Ricci, though the 'Invention' supplied by MacSwinny may have contributed a unifying factor.

William Hogarth (1697–1764)

38 The Bathos

Pen and ink over chalk, 10⅛ × 13 in. 1764. Windsor Castle, Royal Library.

This is a preparatory drawing for Hogarth's last print, which was publicized in two London newspapers, in April 1764, at a cost of 2s. 6d. The advertisements make clear that it was intended to 'serve as a Tail-Piece to all the Author's engraved Works, when bound up together', and the design appropriately works in many references to 'the end of all things'. The tumble-down inn is entitled 'The World's End', and near it Father Time expires, his hour-glass and scythe broken. The 'Tail-Piece' also has a precise, satirical meaning. The full title of the print is 'The Bathos, *or Manner of Sinking, in Sublime Paintings, inscribed to the Dealers in Dark Pictures'*, and it alludes to a work of the poet Alexander Pope, entitled *Peri Bathous* (1728), which dealt with the pretentious, falsely sublime element in poetry in the same way that Hogarth, an inveterate enemy of puffed up connoisseurship in art, deals with it in the print.

William Blake (1757–1827)

39 Dante and Virgil on the back of Geryon

Watercolour, 14½ × 20¾ in. 1824–7. Melbourne, National Gallery of Victoria.

This watercolour is one of a series of 102 illustrations to Dante's *Divine Comedy,* commissioned by the painter John Linnell (1792–1882), whom Blake first met in 1818. The Dante watercolours were begun in 1824 – in a volume of fine Dutch paper given to the artist by Linnell – and were still incomplete when Blake died in 1827. This scene shows an episode from the first part of *The Divine Comedy* (the section known as the *Inferno*), in which Dante and Virgil (his guide to the Underworld) are carried on the back of the monster, Geryon, down to Malebolge, or the Eighth Circle of Hell. Dante's description of the monster in Canto 17 is followed quite closely by Blake:

> Its face was the face an honest man hath got,
> so benign looked it outwardly, but its
> remaining parts were a serpent's, all the lot.
> It had two paws, hairy to the armpits;
> its back and breast and both sides of its spine
> had, painted on them, knots and annulets . . .
> Its tail twitched in the void – for of that none
> had grounded – twisting up the venomed fork
> which armed the point, as in a scorpion.

Dante and Virgil sit on Geryon's shoulders. The serpent is often used in art to symbolize evil, and here Geryon represents the sin of materialism, following on the Fall and leading to fraud, the vice punished in the Eighth Circle of Hell.

Antonio Canaletto (1697–1768)

40 Capriccio: The Horses of the Basilica of St Mark's in the Piazzetta

Canvas, 42½ × 51 in. About 1743. Windsor Castle, Royal Collection.

One aspect of fantasy, making for an effect of surprise, was the placing of familiar objects in an unfamiliar setting. This painting was one of thirteen executed for Canaletto's admirer, Joseph Smith, British Consul of Venice, and intended as decorations over doorways, the decorative purpose allowing of a free treatment of the principal features of the city. Canaletto effected his transpositions of architecture with an authority that made them convincing. The antique bronze horses, transferred from the façade of St Mark's, become a triumphant perspective of monuments. The Royal Collection still contains nine pictures of the series. They were part of Smith's art collection sold in 1765 to King George III.

Giovanni Paolo Pannini (c. 1692–c. 1765)

41 Gallery of Cardinal Valenti-Gonzaga

Canvas, 78 × 105½ in. 1749. Hartford, Connecticut, Wadsworth Atheneum.

An early exponent of the architectural view-paintings that were popular with visitors to Italy in the eighteenth century, Pannini painted the ruins of classical Rome either as part of the actual aspect of the city or as fanciful *capricci*. His *Gallery* presents one of those long classical perspectives, which suggest that some painters of easel pictures may have taken a lesson from stage design. There is an element of fantasy in the great number of pictures hanging on the walls of the gallery, their subjects depicted with minute care. Though he lacked the imaginative force that distinguished his contemporary at Rome, Piranesi (Plate 32), his influence was fruitful as an encouragement to Canaletto to picture Venice in an equally comprehensive fashion.

Charles Robert Cockerell (1788–1863)

42 The Professor's Dream

Pen, pencil and wash, 55½ × 78½ in. 1849. London, Royal Academy.

When first shown at the Royal Academy in London this astonishing drawing was described as 'A synopsis of the principal architectural monuments of ancient and modern times.' It is also a vision of great buildings through the ages, designed in a way to touch the imagination. The drawing recalls Cockerell's long stay and careful study of architecture in Italy, Greece and the Middle East as well as, in England, his admiration for the work of Sir Christopher Wren. Impressively grouped together as main features are the Pyramids, the dome of St Peter's in Rome, Florence Cathedral and St Paul's. The 'Professor' of the title was accurately descriptive of Cockerell himself, as he was professor of architecture in the Academy for twenty years (1839–59), as well as having an active architectural practice.

John Martin (1789–1854)

43 Belshazzar's Feast

Mezzotint, 18½ × 10⅝ in. 1821. London, Alexander Postan Fine Art.

Mezzotint was a graphic medium well suited to convey the drama of John Martin's light and shade and he himself used it with great success to reproduce his sensational painting *Belshazzar's Feast*, exhibited at the British Institution in 1821. The extraordinary perspective, the massive conception of ancient architecture, dramatic lighting and multitude of figures, gained lavish praise for the work when it was first shown, with only a few dissenting critics, Charles Lamb among them. Though the large original (63 × 98 in) was not again seen in public after 1821 until the International Exhibition of 1862, the mezzotint versions had a prolonged vogue and the picture was also made familiar by engravings in illustrated editions of the Bible.

Joseph Wright of Derby (1734–97)

44 The Old Man and Death

Canvas, 40 × 50 in. About 1774. Hartford, Connecticut, Wadsworth Atheneum.

The theme of men being confronted with Death in the form of a skeleton – a subject with a long tradition in north European painting, from Holbein and Bruegel to Rowlandson – was taken up by Joseph Wright, perhaps with a scientific interest in physiognomical expression under the influence of strong emotion but also with a suggestion of the growing Romanticism that was so strongly attracted to the macabre. The expression and gesture of the old woodcutter are vividly rendered and contrasted with the coaxing movement of the spectre. The background of ruins overgrown with vegetation may have had a symbolic meaning.

Henry Fuseli (1741–1825)

45 The Nightmare

Canvas, 39¾ × 49 in. 1781. Detroit, Michigan, Detroit Institute of Arts.

Born in Zurich, the son of a Swiss portrait painter, though associated for the greater part of his life with England, Fuseli (who used this Italian form of his name) became famous in middle age through his *The Nightmare*, a visualization of the horror of unpleasant dreams that coincided with a growing Romantic taste for horror and fantasy in art. He made several variants of the theme. One version is in the Kunsthaus, Zurich, and another, upright one, with the image reversed, is in the Goethe Museum, Frankfurt. Other excursions into fantasy followed, his work for Alderman Boydell's Shakespeare Gallery including renderings of *Macbeth* and of the fairy court of Queen Titania in *A Midsummer Night's Dream*. Still another form of fantasy appears in his drawings of women in curious finery and with exaggerated headdresses, to which it has been supposed some erotic significance was attached.

Francisco de Goya (1746–1828)

46 (left) You Won't Escape

Etching and aquatint, from *Los Caprichos*. 1799.

(right) The Sleep of Reason Brings Forth Monsters

Etching and aquatint, from *Los Caprichos*. 1799.

Los Caprichos ('Caprices' or 'Fancies') was the first of Goya's great graphic series, made while he was recovering from a paralytic stroke, which left him deaf and for a time disabled. Unable to carry out his usual type of commission as painter he turned to small prints, which he accompanied with bitter comment. *Los Caprichos*, consisting of eighty subjects, was published in 1799 but met with so little success that in 1803 Goya offered the copperplates and unsold prints to Charles IV for the royal print collection in exchange for a pension for his son Javier. Goya was sometimes cryptic but title and image are closely allied in one of his most famous prints, the 'Sleep of Reason'. There was, however, no proto-Surrealist idea in the title. His own handwritten commentary intended a moral – that 'Imagination abandoned by reason produces impossible monsters: united with her she is the mother of the arts and the source of their wonders'. Evidence may also be found in the series of a covert attack on the corruption of court and clergy.

Francisco de Goya (1746–1828)

47 Disorderly Folly

Etching and aquatint, from *Los Proverbios*. About 1815–24.

Often obscure and without engraved titles or written commentary, the series to which this belongs is a fantasy with scathing allusions to human shortcomings. The etchings remained unpublished during Goya's lifetime but the prints were finished before he went to Bordeaux in 1824 and the copperplates were stored by his son. On the latter's death, eighteen of the twenty-two plates came to light and were acquired by the Real Academia de San Fernando, which published the first edition in 1864 under the title *Los Proverbios*. Some of them can reasonably be associated with Spanish proverbs and popular sayings but a number of the working proofs were found to have the manuscript titling, supposedly by Goya himself, of *Disparates* (i.e. 'Follies') of various kinds. The view may be taken that human folly has been a regular butt of proverbial wisdom and that *Proverbios* and *Disparates* are fittingly alternative for a series with such complex and tragic hidden meanings as the print here reproduced.

Francesco Guardi (1712–93)

48 Landscape with Ruins

Canvas, 36¾ × 29 in. About 1760–70. London, Victoria and Albert Museum.

Though Guardi is best known for his brilliant views of eighteenth-century Venice that partnered those of Canaletto, he was far from being a mere topographer and he gave rein to his imagination in works such as that reproduced here. Some of his free architectural compositions recall the islands of the Venetian lagoon but this 'caprice' is of the more classical order, of which Pannini had set an example in Rome. He gives a reminder of the pyramidal form the Romans borrowed from Egypt for their tombs, as in the Pyramid of Cestius at Rome. Such compositions were not only free arrangements but were decorative in the sense of according harmoniously with an interior setting. The picture reproduced is one of a pair that well illustrate this decorative function in their present placing in the Victoria and Albert Museum.

William Marlow (1740–1813)

49 St Paul's and a Venetian Canal

Canvas, 51 × 41 in. About 1795? London, Tate Gallery.

Here a sedate eighteenth-century topographer and landscape painter takes a leap into fantasy with his mirage of Venice replacing the London realities of the approach to St Paul's. Marlow had travelled in Italy in the 1760s, and no doubt was encouraged to this anglicization of the *capriccio* by the example of the Italian view-painters, Pannini, Piranesi, Canaletto and Guardi. The canal brushing the steps of St Paul's and the Venetian palaces on either side combine with the great church to make a singularly attractive composition. Marlow exhibited at the Royal Academy in his later years and painted a number of views of English country houses and estates, but this *capriccio* is the first picture by him to have entered the National Gallery of British Art.

Eighteenth-century Italian

50 Magic Scene

Panel, 21¼ × 11⅞ in. Private Collection.

The authorship of this painting has not yet been determined with certainty but the indications are that it is Italian and of the early eighteenth century. Analogies can be found in the work of Marco Ricci and Andrea Locatelli and in iconography with Salvator Rosa, as may here be seen by comparison with Rosa's scene of witchcraft (Plate 27). The artist has produced a more complete and documentary survey of the black arts than Salvator, each creature and object being clearly identified. The magician weaving spells is surrounded by devils, bones, bats, monkeys, an owl and a hanged man. In the background monsters are being conjured from the cave.

Francisco de Goya (1746–1828)

51 The Colossus

Canvas, 45½ × 41½ in. About 1812. Madrid, Prado.

In this sombre work of Goya's later years he represents a wild stampede of human beings and animals terrified by a giant apparition in human form. The picture can be regarded as an allegory of Fear stalking the land, the sum of individual fears transmitted from one to another and attaining the gigantic proportions of general panic. The mists that coil round the limbs of the giant emphasize his size as compared with the small figures below and, it may be, also suggest his emanation from a multitude of human minds. Having disrupted one community the apparition is turned away as if to continue the work of striking terror elsewhere. Sombre colour and eerie lighting add to the painting's powerful impact. It is possible that Goya intended comment on the unhappy situation of Spain in the period of Napoleonic occupation and the War of Independence, but as an allegory of a more general kind it is no less profound in effect.

William Blake (1757–1827)

52 Nebuchadnezzar

Colour print and watercolour, 17⅝ × 24¾ in. 1795. London, Tate Gallery.

In one of Blake's most powerful visions taken from biblical history, he depicts the madness of Nebuchadnezzar in the period of his defiance of heavenly rule when, as told in Daniel 4:33 'he was driven from men, and did eat grass as oxen, and his body was wet with the dew of heaven, till his hairs were grown like eagles' feathers, and his nails like birds' claws.' The figure of the Babylonian king was adapted by Blake from that of the Saint crawling on all fours in the background of Dürer's engraving *The Penitence of St John Chrysostom*. Blake's anatomical conventions and exaggerations added an appropriate wildness of fantasy to the beautifully coloured design. Originally in the collection formed by Blake's friend and patron Thomas Butts, the work was later acquired by the artist and collector W. Graham Robertson, who presented it to the Tate Gallery in 1939.

Antoine Wiertz (1806–65)
53 Buried Alive

Canvas, 71 × 100½ in. 1854. Brussels, Musée Wiertz.

The work of the Belgian painter Antoine Wiertz displays a strange mixture of the would-be sublime, the commonplace and the macabre. The son of a tailor who had high ambitions for him, he studied in Italy and sought an effect of classic grandeur in his *Patroclus* (though a derisive French critic remarked of this painting that it made the path clear from the sublime to the ridiculous). Returning to Belgium he alternated between middle-class portraiture and horrific scenes, of which an example is reproduced here. The subject was inspired by the danger of death certificates being carelessly signed in times of epidemics, leaving the supposed corpse to wake in the desperate condition depicted. The picture is one of many fantasies contained in the house and studio (now the Musée Wiertz), which the Belgian Government allowed him a subsidy to build in 1850, the studio being designed at his own request on the plan of the Greek temple of Paestum.

Sir Joseph Noel Paton (1821–1901)
54 The Fairy Raid

Canvas, 35⅝ × 57¾ in. 1861–7. Glasgow Art Gallery.

Sir Joseph Noel Paton was born in Dunfermline but trained as an artist in London, where he studied at the Royal Academy Schools. He was a painter of both religious and romantic subjects but is mainly remembered by his fanciful creations of a world of elves, gnomes and fairies. He was first inspired to paint subjects of the kind here reproduced by *A Midsummer Night's Dream,* early successes including the two pictures, of 1847, on the quarrel and reconciliations of Oberon and Titania, purchased for the National Gallery of Scotland. In the devotion to detail in nature that led him to paint every plant and flower minutely and the like minuteness with which he depicted the figures of fancy, he might almost seem a Scottish Pre-Raphaelite. Yet he was never attached to the English movement, and a different character appears in the crowded compositions in which he expressed his own poetry of outlook. In addition to painting, he published several volumes of poems.

Samuel Colman (active 1816–40)
55 A Romantic Landscape

Canvas, 35 × 47 in. Bristol, City Art Gallery.

A discovery of recent years is the Bristol painter of the early nineteenth century, Samuel Colman, who had a naïve imagination of a delightfully individual kind, as may be appreciated in this work, one of the three paintings by him acquired since 1970 by the Bristol City Art Gallery. Little is known of him, save that he was listed in the Bristol Directories from 1816 to 1838 as a portrait painter and drawing master. He exhibited with other Bristol artists but has suffered from a confusion of identity with another Samuel Colman (1832–1920), a member of the American Hudson River School. Paintings by him have also been attributed to his contemporaries, John Martin and Francis Danby. In 1973 the Bristol exhibition 'Francis Danby and his School' helped to reinstate Colman as an individual artist. The *Romantic Landscape,* in its combination of architecture, trees, water and processional figures, is almost like a Claude done over in primitive but none the less fascinating fashion.

Arnold Böcklin (1827–1901)
56 The Isle of the Dead

Canvas, 43¾ × 61 in. 1880. Basle, Kunstmuseum (on permanent loan from the Gottfried Keller-Stiftung).

Böcklin was a Swiss painter of fantastic and mythological subjects, much of whose work was produced in his long residence in Italy, from 1874 until his death. He may be compared to some extent with Moreau (Plates 59–61) in his ability to create ancient legend afresh, though his naiads, centaurs and nature-deities were more boisterous and realistic. But apart from these was the work of sombre fantasy for which the appropriate title *The Isle of the Dead* was suggested to him by the art dealer Fritz Gurlitt. Böcklin painted five versions of the picture, which has never failed to make a deep impression by its eerie stillness and the sense of complete withdrawal from the living and familiar world that it imparts. Surrealist painters in particular have admired this unique work as (in the artist's own words) 'a picture for dreaming about'. It is the first version that is reproduced here.

John Martin (1789–1854)
57 The Great Day of His Wrath

Canvas, 78 × 121 in. 1853. London, Tate Gallery.

Originally called *The End of the World* this painting of stupendous turbulence was based on passages in The Revelation: 'And the heaven departed as a scroll when it is rolled together; and every mountain and island were moved out of their places. . . . For the great day of his wrath is come; and who shall be able to stand?' (Rev. 6:14, 17). According to Martin's son, Leopold, *The Great Day* was inspired by a journey through the industrial Midlands at night: 'The glow of the furnaces, the red blaze of light together with the liquid fire seemed to his mind truly sublime and awful. He could not imagine anything more terrible even in the regions of everlasting punishment.'

Richard Dadd (1817–86)
58 The Fairy Feller's Master-Stroke

Canvas, 21¼ × 15½ in. 1855–64. London, Tate Gallery.

This hauntingly beautiful picture was the masterpiece of a painter whose life was one of the saddest and strangest of any Victorian artist. It was painted while he was an inmate of the Criminal Lunatic Asylum at Bethlehem Hospital, London, having been the victim of a mania that led him to kill his father and attempt another murder. Confined for the rest of his life he never recovered sanity but retained powers of intellect and a technical ability that is brilliantly displayed in this work, on which he spent many years of patient skill. Shakespeare's *A Midsummer Night's Dream* and *The Tempest* had previously inspired his poetic imagination but the subject of this picture has not been related to any literary source. All the figures in the composition are under a magic spell, from which they can be released by the cracking of a nut, and are watching the Fairy Feller, who is engaged on this task of liberation. Dadd's own account indicated that the marvellous array of small, independent figures took form from a long contemplation of a canvas roughly smeared with paint, though detail, colour and individual characterization have exquisite precision.

Gustave Moreau (1826–98)
59 Salome

Canvas, 56¾ × 41 in. 1876. United States, Armand Hammer Foundation.

Among the many figures of myth and legend, classical and biblical, conceived by the strange genius of Gustave Moreau, Salome has a special eminence. The works she appears in unfold the various phases of the drama of incest and murder, of which her dance was the fatal centre. Here, in a great hall of barbaric architecture, the dance begins. Salome seems lost in trance, mesmerized by her mother, Herodias, who is to claim the head of her enemy, John the Baptist, as the reward of her incestuous husband's approval of the performance. The executioner is ready with raised sword. Later came Moreau's *L'Apparition* (Louvre), when the ghostly head of the decapitated Baptist is seen to fill Salome with terror.

Gustave Moreau (1826–98)
60 The Dead Poet Borne by a Centaur

Watercolour, 17⅝ × 9½ in. 1870. Paris, Musée Gustave Moreau.

Moreau was a painter of fantasy in the respect he paid to figures of myth and legendary story, and something more in the symbolism and universal character he associated with them. The poet was his hero, whom he painted in various classical guises but not as one confined to a mythical world. If he painted a poet dead in a world of such imaginary creatures as the centaur it seems to have been with the idea that the poet might periodically die to attain fresh life. Orpheus and Apollo were but names for the long line of creators of poetry and music who extended a contact with the divine through the centuries.

Gustave Moreau (1826–98)
61 Galatea

Panel, 33½ × 26⅜ in. 1880–1. Paris, Robert Lebel Collection.

Gustave Moreau painted several versions of the fabled love of the Cyclops, Polyphemus, for the sea-nymph, Galatea, this being, with

some alterations, the version exhibited in the Salon of 1880, regarded by Moreau's admirers as his masterpiece. The setting is the sea-cave that J. K. Huysmans described with enthusiasm as 'a vast jewel-case where beneath the light falling from a lapis-lazuli sky, a strange mineral flora throws out its fantastic roots'. Moreau studied the fantastic forms of marine growth in the botanical gardens of Paris in preparation for the work. The interpretation of Moreau as a symbolist is as complex here as in other paintings. It is suggested for instance that there is a criss-cross of dreams, the eye in Polyphemus's forehead being fixed with immutable longing on his submarine love, while she is dreaming of her lover, Acis. In another aspect it is the fable of 'Beauty and the Beast'.

Henri Rousseau (1844–1910)
62 War (La Chevauchée de la Discorde)

Canvas, 45 × 76¾ in. 1894. Paris, Jeu de Paume.

Supreme among naïve painters, the self-taught Henri-Julien Rousseau – often nicknamed 'le douanier' from his having served in the Customs and Excise Department in Paris – may be said to have revealed the existence of an unknown world of art at the beginning of the twentieth century. After various modest employments – mainly in the customs service, from which he retired in 1885 – he began to paint in earnest, transforming reality into a fascinating dimension of his own. War shows him dealing with a traditional subject: the symbolic figure of War is shown riding across a desolate landscape covered with the dead and dying, spreading destruction and death wherever she goes. This kind of image can be compared with Dürer's famous portrayal of the Four Horsemen of the Apocalypse (Plate 2), a theme which continues to inspire artists to this day (Plate 94). Rousseau's treatment is entirely characteristic; even here he could not resist the introduction of the branches and leaves which he painted with such meticulous care in his jungle pictures (see Plate 63).

Henri Rousseau (1844–1910)
63 The Dream

Canvas, 80½ × 117½ in. About 1910. New York, Museum of Modern Art (Gift of Nelson A. Rockefeller).

Rousseau claimed that in his youth he had seen tropical jungles as a member of the force sent out in the 1860s by Napoleon III to bolster up Maximilian as Emperor of Mexico. These images remained vividly in his mind, as can be seen in this work dating to his last years and signed in the year of his death. The 'jungle' is defined in curious detail. But the 'dream' was not a simple memory of landscape – it is a portrait of the cherished love of his youth, the Polish girl Yadwiga, reclining on the otherwise incongruous couch for whom the tropical flowers, the strange animals and the native piper were the stuff of both the artist's and her own dreams.

James Ensor (1860–1949)
64 Two Skeletons Fighting over a Dead Man

Canvas, 23¼ × 29 in. 1891. Antwerp, Musée Royal des Beaux-Arts.

This painting belongs to the period when three themes were prominent in the artist's work, masks, death and demons. The skeletons here represent the satirical attitude he had come to adopt, partly as a result of much misunderstanding and neglect of his abilities. The world became a sort of puppet play, in which there was more absurdity than seriousness, as in the performance of his skeleton models. The Flemish side of the half-Belgian, half-English painter predominates and there is a distant connection between this painting and Bruegel's Triumph of Death (Plate 16), though a difference can be found in Ensor's humour. It was a humour fed by the masks and carnival properties of the family souvenir stall at Ostend. The effect is enlivened also by the feeling for colour in which Ensor excelled.

Giorgio de Chirico (b. 1888)
65 The Soothsayer's Recompense

Canvas, 53½ × 71 in. 1913. Philadelphia Museum of Art (Louise and Walter Arensberg Collection).

The early paintings of de Chirico, of which this is a splendid example, gave a vision of Italian cities touched with magic. In contrast to the contemporary Italian Futurists, who were all for progress and modernization, de Chirico conveyed a dream-like repose and sense of nostalgia. The sculpture in a tranquil square suggests the classic glories of the past. The distant puff of steam from a train is scarcely enough to disturb the dreaming atmosphere and suggests a very leisurely advance into the modern age. Indeed time seems to stand still.

Gustave Doré (1832–83)
66 The Gnarled Monster

Wood-engraving, from the Legend of Croquemitaine.

If anything, the fantasy of the French painter and illustrator, Gustave Doré, as displayed in the prodigious number of his book illustrations, gained in effect from the translation of his wash drawings by professional wood-engravers. Their uncompromising black-and-white brought out fully the grotesque character of his work, which depended on the horrific nature of his subjects rather than such original niceties of draughtsmanship as might be lost in a reproductive engraving. From the circles of Dante's Inferno to the fairy-land of Charles Perrault's Contes and the slums of Victorian London, a great variety of themes were material for a gusto that left its ruthless stamp on all. He was well able to make the most of the grimness inherent in fairy-tales, and the monster from the bogey-man legend of Croquemitaine is an instance.

Rodolphe Bresdin (1822–85)
67 La Comédie de la Mort

Etching. 1854. The Hague, Gemeentemuseum.

The graphic art of the French artist Rodolphe Bresdin was a typical product of what has been called the 'Age of Decadence' in France, the period following the Franco-Prussian War and the Commune of 1871. The sense of political decline had some counterpart in the melancholy and morbidity of art and letters of which this is an example. The landscape has become a charnel-house and the artist introduces us into a macabre world of dreams. In Huysmans' decadent novel A Rebours the lithograph is commended as being like the work of a primitive Albrecht Dürer and 'the product of a mind inspired by opium'. The life of Bresdin, however, is no story of self-indulgence or aesthetic pleasures. Poverty, illness and obscurity were his lot, which was not improved by his wanderings from place to place. Towards the end of his life he was forced to work as a road-sweeper to earn enough to subsist on.

Marc Chagall (b. 1887)
68 I and the Village

Canvas, 75⅝ × 59⅝ in. 1911. New York, Museum of Modern Art (Mrs Simon Guggenheim Fund).

This painting shows, in a very characteristic way, the unique ability of the Russian-born artist Marc Chagall to combine a nostalgic vision of old Russia with a modern technique. It was painted when he was already working in Paris and sharing the avant-garde enthusiasm of the time for Cubism. The composition is devised in Cubist fashion with sharply defined and geometrical elements of form and a defiance of normal proportion and realism of effect. Yet the dream of the past that he seems always to have had in mind loses none of its vividness. In the mind's eye there remains the glimpse of the simple life, the girl milking a cow, the peasant off to the fields. But there is a fairy-tale atmosphere too about the tumble-down village he pictures in the background, the figure turned upside-down suggesting a magical freedom that was to reappear in many later works.

Max Ernst (b. 1891)
69 Napoleon in the Wilderness

Canvas, 18¼ × 15 in. 1941. New York, Museum of Modern Art.

The fantasy that is a product of technical process and experiment has a striking instance in this painting. Technique in the process derived by Ernst from Oscar Dominguez was a means of extracting forms, poetic and imaginative, from the impress of paint on canvas. The process is exemplified here in the figures that have emerged like strange sculptures in a desert. Napoleon, far from being the main subject, is a fancied likeness in one of the monoliths the artist has brought together.

Alfred Kubin (1877–1959)

70 *(top)* **Kraken**

Pen and ink and wash, $5\frac{1}{4} \times 8\frac{1}{2}$ in. 1906–7. Vienna, Albertina.

(bottom) **'The Idol'**

Pen and ink and wash, $9\frac{1}{8} \times 12\frac{1}{2}$ in. About 1903. Vienna, Albertina.

In these drawings it is possible to see how the liking for the mysterious and weird in art continued to be an influence in the twentieth century. The strange gods and uncanny monsters of the Austrian painter and draughtsman Alfred Kubin continued the tradition in which the French symbolist Odilon Redon, in his more fantastic moods, had been outstanding. Kubin was associated with the German *Blue Rider* movement in its early stages, but was out of sympathy with the abstract side that laid emphasis on form and colour in themselves as represented by the 'Expressionism' of the Russian-born painter and theorist, Wassily Kandinsky. In contrast Kubin withdrew into what he himself called his 'Dream World', the bizarre nature of which can be appreciated in the examples here given.

Félicien Rops (1833–98)

71 Satan Sowing Weeds

Etching, $11 \times 8\frac{1}{4}$ in. Brussels, Royal Library.

Though the Belgian-born artist Félicien Rops painted landscapes from time to time, he was mainly admired for drawings and etchings in which there was a strong erotic and satanic element. Sin and Satan were subjects that especially appealed to the latter-day romantics of the *fin de siècle* in France and, like his contemporaries Gustave Doré and Rodolphe Bresdin (Plates 66, 67), Rops continued the Romantic tradition into the last years of the century. *Satan Sowing Weeds* is an example of his work in which the importance of the satanic figure is emphasized by its size, a device used in a very different context by Goya (Plate 51).

Paul Delvaux (b. 1897)

72 Venus Asleep

Canvas, $68 \times 78\frac{3}{8}$ in. 1944. London, Tate Gallery.

It is the special faculty of the Belgian painter Paul Delvaux to introduce us into a world of dreams, a separate dimension mysteriously still and peopled with realistic phantoms, whose nudity seems gravely appropriate to the land of sleep-walkers. This work is a remarkable example. It was painted in Brussels in 1944 during the attacks by flying bombs. The artist aimed at an effect of disquiet, contrast and mystery. The classical arcade with its temples lit by the moon is a calm setting for Venus sleeping undisturbed, but in contrast are the figures behind and the nude at the right who signal agitation. The unconcern of the watching skeleton and dressmaker's dummy is an added dreamlike element.

Salvador Dali (b. 1904)

73 Sleep

Canvas, $19\frac{5}{8} \times 28\frac{1}{4}$ in. About 1937. The Edward James Foundation.

Dali's conception of Sleep makes an interesting contrast with that of Paul Delvaux (Plate 72). They have opposite approaches. Delvaux involves the spectator in the trance-like condition that may be likened to the actual dream-state, with the sort of phenomena that belong to it: Dali, on the other hand, presents an analysis or symbolism of his own (unscientifically different from that of Freud, who was suspicious of an artist's incursion into scientific ground). In his own witty fashion (and with declared intention) he conveys, by a series of crutches upholding the head, what he terms the 'psychic balance' to make sleep possible. Remove one of them, he has asserted, and the result would be insomnia. The nature of these 'psychic balances' is left to the imagination. An expanse of dreamland is suggested in distant perspective.

Giorgio de Chirico (b. 1888)

74 The Mathematicians

Pencil, $12\frac{5}{8} \times 8\frac{5}{8}$ in. New York, Museum of Modern Art (Gift of Mrs Stanley B. Resor).

The fantastic creations of the Italian painter who had so strong an influence on artists associated with the Surrealist movement included manikin figures of the type represented in this drawing, said to have been first suggested by the figures in a play written by his brother. Constructed in geometrical fashion the lay figure has a strange life of its own. The drawing shows how the 'robot' man, so often appearing in the phase of his painting that he called 'metaphysical', was first evolved.

Pavel Tchelitchew (1898–1957)

75 Tree into Hand and Foot

Watercolour and ink, $14 \times 9\frac{3}{4}$ in. About 1939. New York, Museum of Modern Art (Mrs Simon Guggenheim Fund).

The analogy between the shape of a tree and the human form is one that has had a strong appeal to romantically minded artists, among them the Russian-born painter and stage designer Pavel Tchelitchew. In this drawing he has skilfully converted branches, trunk and roots into limbs, with perhaps some remembrance of the grotesque fancies of Gustave Doré's book illustrations, by which he was influenced in early youth, though in his mature years he had varied sources of inspiration.

Joan Miró (b. 1893)

76 Women, Bird by Moonlight

Canvas, 32×26 in. 1949. London, Tate Gallery.

This is a brilliant example of the highly individual style and poetic association of ideas that the Spanish painter has made his own. If looked at simply as a pattern of an abstract kind the painting has an immense vivacity. There is an exhilarating sense of freedom to be derived from the silhouettes, in which black and white become as it were extra colours, reinforcing the richness of red and blue. The moon and star, woman and bird, were associations the artist often had in mind in his later works, though the series to which this picture belongs, executed in the 1940s, first had the general title of 'Paintings'. He adopted more precise titles, as in this instance, to give a more objective and concrete meaning.

Paul Klee (1879–1940)

77 A Young Lady's Adventure

Watercolour, $17\frac{1}{4} \times 12\frac{5}{8}$ in. 1922. London, Tate Gallery.

The charm of unusual colour, a richness of design, in which there is a great deal to discover, and humour of a kind both delicate and fantastic distinguish this work by Klee. It is one of the paintings and drawings by him in which the subject seems to have taken shape as he worked, the title he wrote in German on the mount – *Abenteuer eines Fräuleins*–seeming the final touch of humorous invention. Fancy can rove, as no doubt that of the artist did, imagining various plans and thoughts in the 'young lady' known to Klee's colleagues at the Bauhaus as 'The English Miss', including possible temptations as suggested by the strange bird at the left and risks which the red arrow seems to point out.

Maurits Cornelis Escher (1898–1972)

78 Concave and Convex

Lithograph, $10\frac{7}{8} \times 13\frac{1}{4}$ in.

This contemporary Dutch artist has sought (in his own words) to express 'amazement and wonder at the laws of nature that operate in the world around us', their enigmas often bringing him into the domain of mathematics. In *Concave and Convex* he has developed the idea that in looking at a cube formed from a combination of three diamond shapes it remains a question whether we are looking at the cube from within or without. The mental inversion possible is illustrated in the three houses in his lithograph, each under a cross-vaulted roof. A complex game for the eye is to decide whether the middle house is to be seen as an exterior or an interior view, the left-hand house being an exterior view and that on the right an interior. There are other inversions in the print that give different aspects of the question.

Maurits Cornelis Escher (1898–1972)

79 Day and Night

Woodcut, $15\frac{3}{8} \times 26\frac{3}{4}$ in. 1938.

The artist shows what happens when the eye fixes on a specific object, everything round it being reduced to background. His

design seems to go through a magical change according to the focus of vision. The rectangular fields can be seen to turn into two flights of birds, appearing alternately to consist of black birds flying to the left and white birds to the right. At the left the white birds merge into the daylight landscape, at the right the black birds into the night reflection of the same landscape. These mirror images are united by the grey fields, and the illusion of their turning into birds is repeated as often as one looks.

René Magritte (1898–1967)
80 La Bonne Aventure (The Crystal Ball)

Gouache, 13¼ × 16 in. 1939. The Edward James Foundation.

The resource of Magritte was seemingly endless in the freedom of thought that enabled him to transpose the familiar into the un-familiar as in this painting. He carries out his plan of, as he expressed it, 'spontaneously assembling shapes from the world of appearance in an order given by inspiration'. The 'likeness' involved is likeness to a thought, neither agreeing with commonsense nor defying it but conveying enchantment in much the same way as a fairy-tale or nursery rhyme. To 'explain' why the dark mass of buildings should suddenly glitter with stars and a crescent moon appear close to a lighted window would be impossible. It is certainly a way of refreshing the idea of magic and poetry attaching to the nocturnal scene. The title is the poetic idea appropriate to his picture but equally defiant of prosaic definition.

René Magritte (1898–1967)
81 Nuit de Pise

Canvas, 38 × 51 in. 1958. New York, Mrs Henry Heinz.

This is an entirely characteristic example of Magritte's imagery; and the success of the image depends on two reversals of ordinary experience. The first is the idea of a feather the height of the Leaning Tower of Pisa; and the second is the possibility that an object as light as a feather could hold up a mass of solid masonry. Reversals of this kind are frequent in the art not only of Magritte but also of the Surrealists in general. One has only to think of what is perhaps Dali's most famous visual idea – the melting watches. In the paintings of Magritte we have flying birds made of stone, mirrors that do *not* reverse the image (Plate 96), boots that unaccountably merge into human feet, and walls that are not walls but the star-filled sky (Plate 80). This ambiguity in the image has a long history; and in the art of earlier periods, we have only to think of Arcimboldo's strange vegetable men (see Plate 22), where a comparable reversal of expectations is achieved.

Edward Burra (b. 1905)
82 John Deth

Gouache, 22 × 30 in. 1932. London, Private Collection.

The British painter Edward Burra has a satirical gift of expression in watercolour and line that is very impressive in this scene of disarray, in which the skeleton emblems of mortality invade the pleasure-seekers' orgy. Its vividness of colour adds to the dramatic tension of the scene. The nature of its subject recalls the long series of works in which artists have treated the theme and once again shows how aptly it may be used in comment on contemporary society at any period. Wars and the threat of wars seem to have added a trenchancy to his work that has two aspects. In the 1920s he displayed an awareness of the seamy side of city life, in which there was something of the post-war disillusion of George Grosz. But later came the feeling of threat that made for more generalized representations of violence and destruction. Both elements make a tense combination in the marvellous watercolour here reproduced.

Max Ernst (b. 1891)
83 The Temptation of St Anthony

Canvas, 42⅞ × 50¾ in. 1945. Duisburg, Wilhelm-Lehmbruck Museum.

If there was any one theme of religious story that could appeal to a Surrealist it was the Temptation of St Anthony, because of the possibilities it offered of giving shape to fantastic forms of hallucination. Max Ernst was directed to the subject by a competition, organized by a film company, for a picture figuring in a film based on Guy de Maupassant's novel, *Bel Ami*. He was thus reminded of

the genius of Grünewald, with whom he offers a close comparison in the creation of monstrous forms assailing the Saint (Plate 12). Rich colour and sinister detail, in which there is a metamorphosis of vegetable into evilly active shapes, make an impressive variant on Grünewald's version of the legend.

Yves Tanguy (1900–55)
84 The Transparent Ones

Canvas, 38¾ × 32 in. 1951. London, Tate Gallery.

The French surrealist Yves Tanguy carried fantasy to a meeting-point with abstraction in his paintings of strange forms that had their being on endless plains. *The Transparent Ones* was one of a group of pictures painted in the 1950s, after he had settled in the United States. The amoeba-like forms he had painted at an earlier date are replaced by sharply cut images that might be likened to a phantom reflection of a mechanistic civilization. The needle-pointed obelisk, the pseudo-mechanical intricacies, and even the suggestion at right of a 'Concorde', lead thought in this direction, though the background of nature in other works of this period suggests the influence of the rocky landscape of Arizona. Tanguy conveys the opposite of anything that may be called 'humanism' and gives his own impressive comment on science fiction and what the future of art may have in store.

Pavel Tchelitchew (1898–1957)
85 Igor Markevitch and his Mother

Canvas, 36 × 28¾ in. 1930. London, Tate Gallery (on loan from the Edward James Foundation).

In a painting like this, Tchelitchew is still following in the tradition of Arcimboldo (see Plates 22 and 26): forms are made to play a double role, the draperies existing not only in their own visual right, as cloth, but also by extension as the parts of the bodies of the two people represented. But where Tchelitchew differs from Arcimboldo is in the degree of illusionism thought necessary. The two figures in the modern painting are much more casually painted, the ambiguity of the image is less forcibly suggested. Tchelitchew's picture does not look like a highly wrought puzzle – which is what Arcimboldo's *Winter* (Plate 22) is – so much as an intriguing modern work of art. Tchelitchew, who was all his life fascinated by visual ambiguity, also applied the same principles to religious scenes, albeit less successfully (*The Annunciation* of 1931 follows exactly the same pattern as *Igor Markevitch and his Mother*), and even to landscape motifs (see Plate 75).

Loudon Sainthill (1919–69)
86 The Musician II

Gouache, 30½ × 22½ in. About 1959. Private Collection.

A brilliant designer for the stage, responsible for more than fifty productions, Loudon Sainthill was also a painter whose imaginative gift can well be appreciated in his harlequin-like picture of a musician. It is a measure of his originality that he was able to draw upon the work of other artists, past or contemporary, and turn his study of their methods to individual effect through his strong feeling for fantasy. There are reminders in this work of an early attachment to Arcimboldo (Plate 22) in the way the figure has been constructed out of a lattice-work ingeniously put together, with perhaps a hint of de Chirico also; but the poetically fantastic figure that emerges was endued with Sainthill's own sensibility and can be appreciated as an enrichment of tradition in style and feeling.

Ivan Albright (b. 1897)
87 The Picture of Dorian Gray

Canvas, 85 × 40 in. 1943–4. New York, Kennedy Galleries, Inc.

Dissolution has been a favoured theme of this American painter and Oscar Wilde's moral tale of the fatal portrait that implacably recorded change and decay was a subject ready-made for his brush. The last stage of transformation from the likeness 'of exquisite youth and beauty' to the reality 'withered, wrinkled and loathsome of visage' is imagined with a force of colour and varied detail that rivets attention. The picture reflects the artist's own philosophy that in every part of life you find something either growing or disintegrating. It was specially painted for the film *The Picture of Dorian Gray*, based on Wilde's story and released by MGM in 1945.

Salvador Dali (b. 1904)
88 Autumn Cannibalism

Canvas, 25 × 25 in. London, Tate Gallery (on loan from the Edward James Foundation).

'Cannibalism' is one of the terms by which the Spanish Surrealist, Salvador Dali, has sought to draw attention to the extreme nature of his conceptions, using it, especially in the titles of his paintings in the 1930s, to describe the way in which he depicted forms torn apart or disintegrating. It was also a way of indicating the process by which he turned one form into another. Things and people could be 'devoured' metaphorically speaking, even the Surrealists themselves ('we are food of the best quality,' he said,'decadent, stimulating, extravagant . . .'). This painting has all the minuteness of execution with which Dali carried out his programme of creating shock and surprise.

Salvador Dali (b. 1904)
89 Impression of Africa

Canvas, 36 × 46¼ in. 1938. London, Tate Gallery (on loan from the Edward James Foundation).

The painter is at his easel, his right eye fixed on us from behind his canvas, and his hand raised in a gesture familiar to studio-painters enjoining that a model must keep the position held. But it is a Surrealist proposition, with the fantastic suggestion that all Africa must hold still while he paints. In the meantime images of another kind course through his mind and are detailed in the background. This is how one may imaginatively view the canvas, with its suggestion of labour of a scrupulously objective kind and of an imagination that recognizes no bounds.

René Magritte (1898–1967)
90 Time Transfixed

Canvas, 57½ × 38⅜ in. 1939. Chicago, Art Institute (Joseph Winterbotham Collection).

Magritte was always a master of the unexpected and this painting is well calculated to arouse both astonishment and amusement. There is the pleasure of a fairy-tale to be derived from his manipulation of time and space. The diminution of the locomotive that takes the place of a stove-pipe in a dining-room fireplace is a metamorphosis of a kind that has varied forms in his work and is realized with a typical relish for incongruity. There is also a metaphor of a Surrealist type in the likeness between locomotive and fireplace as fuel burners. The halt of furious speed between the calm verticals of the interior and the unhurried clock is a contrast pointed with all the artist's characteristic humour.

René Magritte (1898–1967)
91 Le Siècle des Lumières

Canvas, 19 × 19½ in. 1967. London, Marlborough Fine Art.

Most of Magritte's paintings give the effect of three-dimensional space, a light blue sky often serving as a delicate background for the main theme, but on occasion he counteracts this naturalism by turning the sky into a mysterious stage. Some of his early works were derived from experiments with collage, in which he cut out and pasted together shapes from printed or other sources. He seems to have returned to the idea of collage later, as in the painting here reproduced, where the features have the appearance of being separately stuck on to a flat ground. A huge apparition without contour, with a balloon to add an equivocal element, appears. A delicate colour scheme adds its own charm, though Magritte observed with some severity that his conception of painting was strictly limited to placing colours together in such a way that their real appearance vanished and a 'poetic' image would emerge.

Karl Korab (b. 1937)
92 Head

Oil on board, 14¾ × 16½ in. 1973. London, Fischer Fine Art.

Fantasy is still to be reckoned with in the second half of the twentieth century. This vivid painting illustrates the work of one of the younger Austrian artists associated with the group that has acquired the name of the 'Fantastic Realist' school. With them an enthusiasm for that great master of fantasy and realism, Pieter

Bruegel (Plates 16 and 18–21), has opposed the trend to abstraction. Karl Korab has felt this influence, though he is perhaps nearest to the spirit in which Arcimboldo delighted the Habsburgs by his curious combinations of objects (Plate 22). Korab paints fairground figures, still-lives and architectural compositions. He has been able to put together the wooden heads of the Prater fairground at Vienna, together with the accessories of the shooting-gallery, with a liveliness and humour which are well exemplified here.

René Magritte (1898–1967)
93 'The Enchanted Domain' (Detail)

Canvas, 26¾ × 36¼ in. 1951–3. Casino Knokke, Belgium, Nellens Collection.

Magritte produced several versions of this strangely fascinating made-up figure, with the outer aspect of an elderly man resting by the roadside serving as the framework for a birdcage. Described as 'The Therapeutist' and 'The Liberator', the hybrid figure, with variations of detail, this being one of the most elaborately conceived. It was one of a series of eight paintings commissioned from the artist for a mural (about 14 ft high by 234 ft long) in the Salon d'Honneur in the casino at Knokke-Le-Zoute, Belgium. Magritte personally supervised for three months the execution of his mural, which was painted by a team of assistants. The painting reproduced illustrates Magritte's habit of surprising the spectator by placing objects where one would least expect to find them. It seems in keeping with Magritte's way of thought that the prosaic garments he depicts should give rise to a fantastic idea. It is an instance where he would have deprecated the question, 'What does it mean?' The sense of mystery defies explanation.

Vasco Taskovški
94 The Riders of the Apocalypse (1939)

Canvas, 45¼ × 54 in. 1971. Belgrade, The People's Army Club.

A Yugoslav artist is strikingly successful in giving a demonic rush of movement to the Apocalyptic bearers of war, famine, pestilence and death. As with other Yugoslav artists of today, his feeling is strongly anti-militaristic and this has its impetus to give. Colour plays its part in the intensity of effect, its spectral gamut ranging from an icy blue to yellow, red, and the sinister purple cloud beneath. The horsemen of the original vision – depicted with so much grandeur by Albrecht Dürer (Plate 2) – are fittingly described in the more general term 'Riders', in that they seem to bring a modern proliferation of armaments and sinister modern weapons into action against a suffering multitude.

Milic Stanković (b. 1934)
95 October 1944: The Day of Liberation

Canvas, 48 × 57½ in. 1971. Belgrade, The People's Army Club.

This brilliant fantasy by the Yugoslav artist Stanković is a vision of the liberation of Belgrade as imagined in retrospect by one of the younger school. The artist is one of the Belgrade painters who appear to have been influenced to some extent by the Surrealist tradition. Traces of it may be found in this work, though perhaps even more striking is the likeness to the fantasies of the early Flemish masters, Bosch and Bruegel. In the fortifications spitting flame over a Belgrade luridly lit, it is possible to find an equivalent to the hell-mouths and monstrous forms in the Flemish scenes of supernatural warfare. The debris flying through the air plays its part in the effect of strangeness.

René Magritte (1898–1967)
96 La Reproduction Interdite

Canvas, 32 × 25½ in. 1937–9. The Edward James Foundation.

In this painting, which is a portrait of Edward James, the Belgian Surrealist seems at first sight to present us with the portrayal of academic correctness of a young man with his back turned as he looks into a mirror. It may take a second or two to realize that where we should expect to see the face reflected in the glass there is instead a repetition of the back view. The well-groomed head is the same, but the volume of Edgar Allan Poe on the mantelpiece is faithfully mirrored. In Surrealist fashion Magritte has made the impossible an exercise of wit and an intimation to the onlooker that in the Surrealist's world nothing is to be taken for granted.

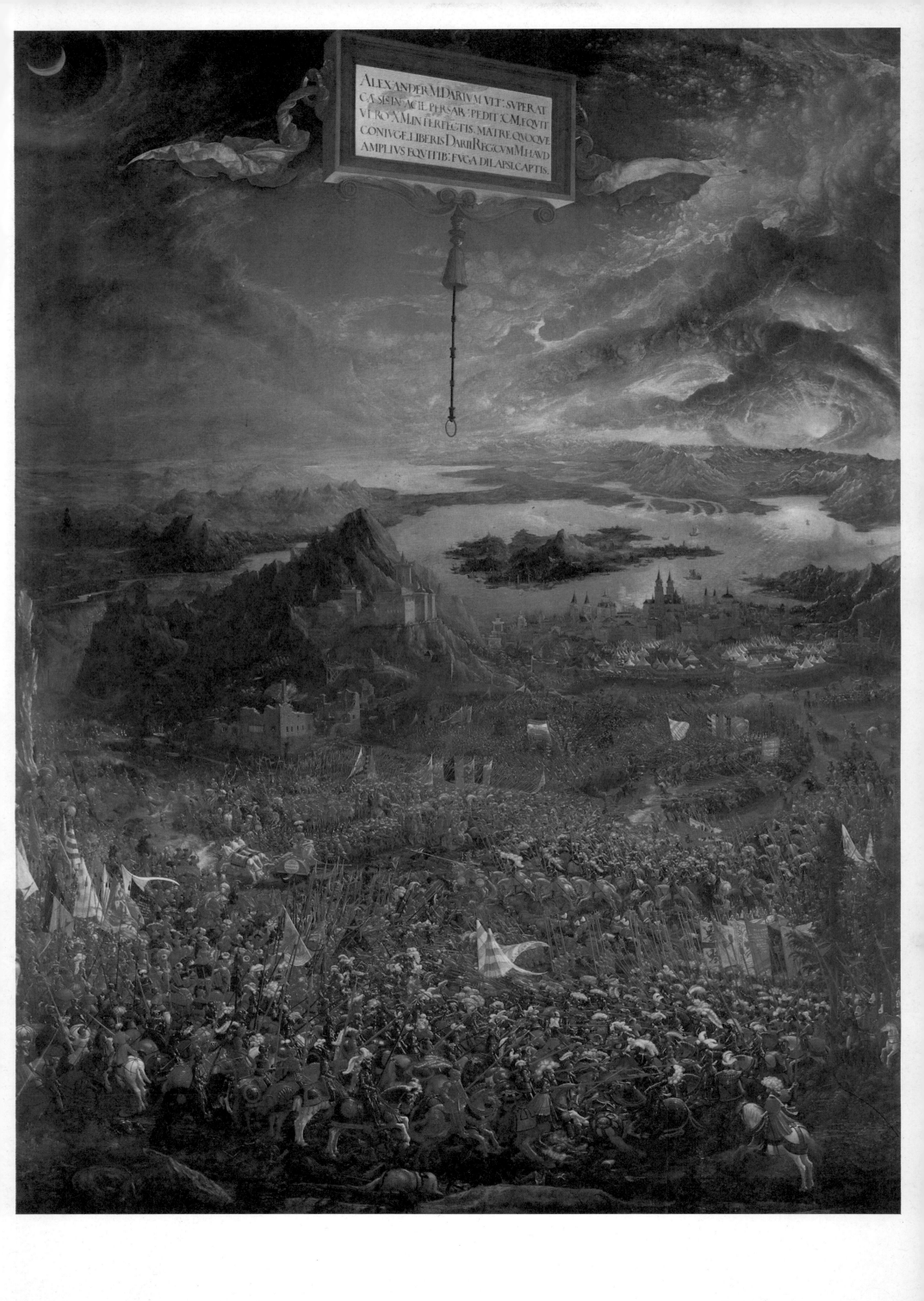

ALEXANDER·M·DARIVM·VLT·SVPERAT
CÆSIS·IN·ACIE·PERSAR·PEDIT·CM·EQVIT
VERO·XM·INTERFECTIS·MATRE·QVOQVE
CONIVGE·LIBERIS·DARII·REG·CVM·M·HAVD
AMPLIVS·EQVITIB·FVGA·DILAPSI·CAPTIS·

1

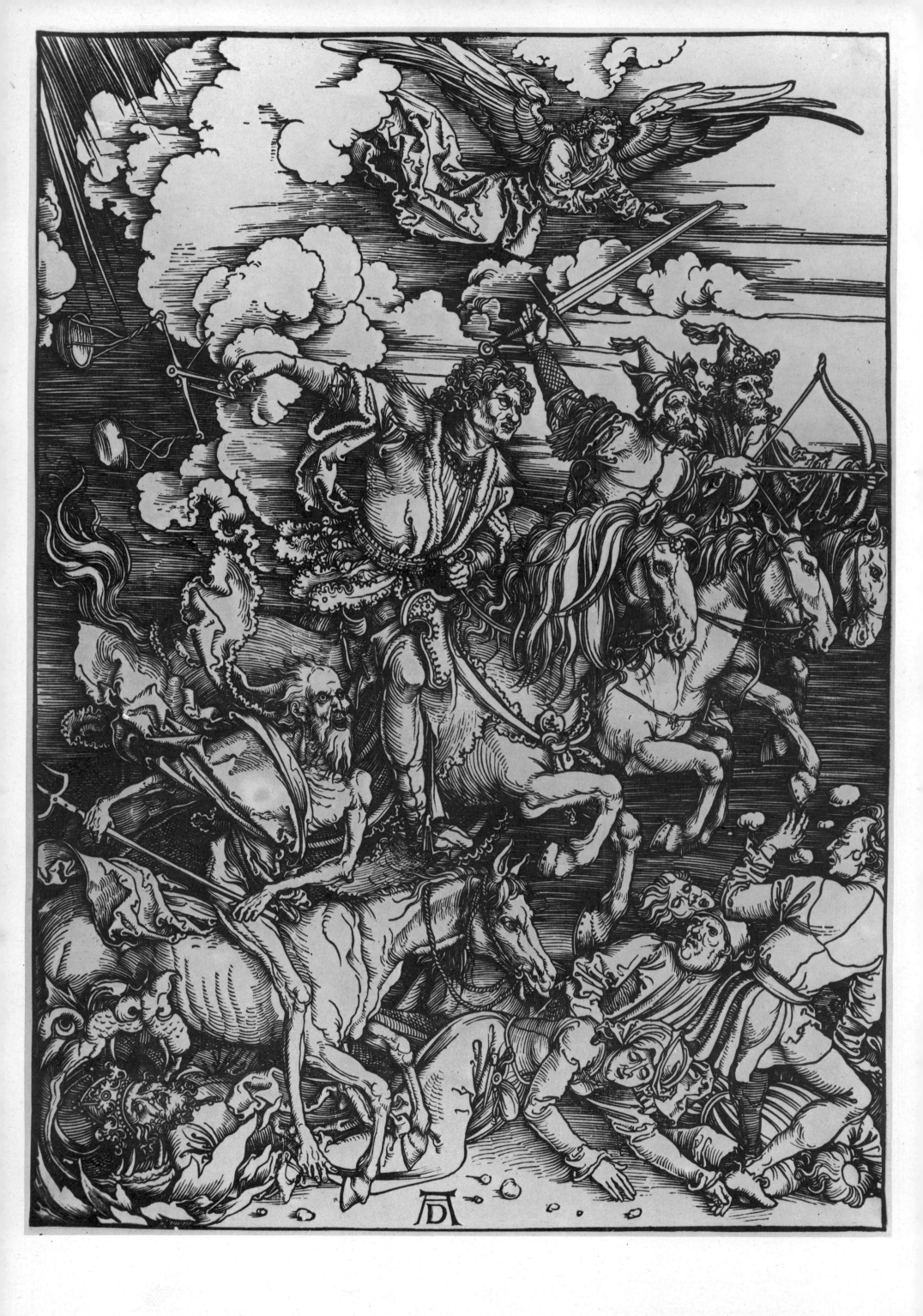

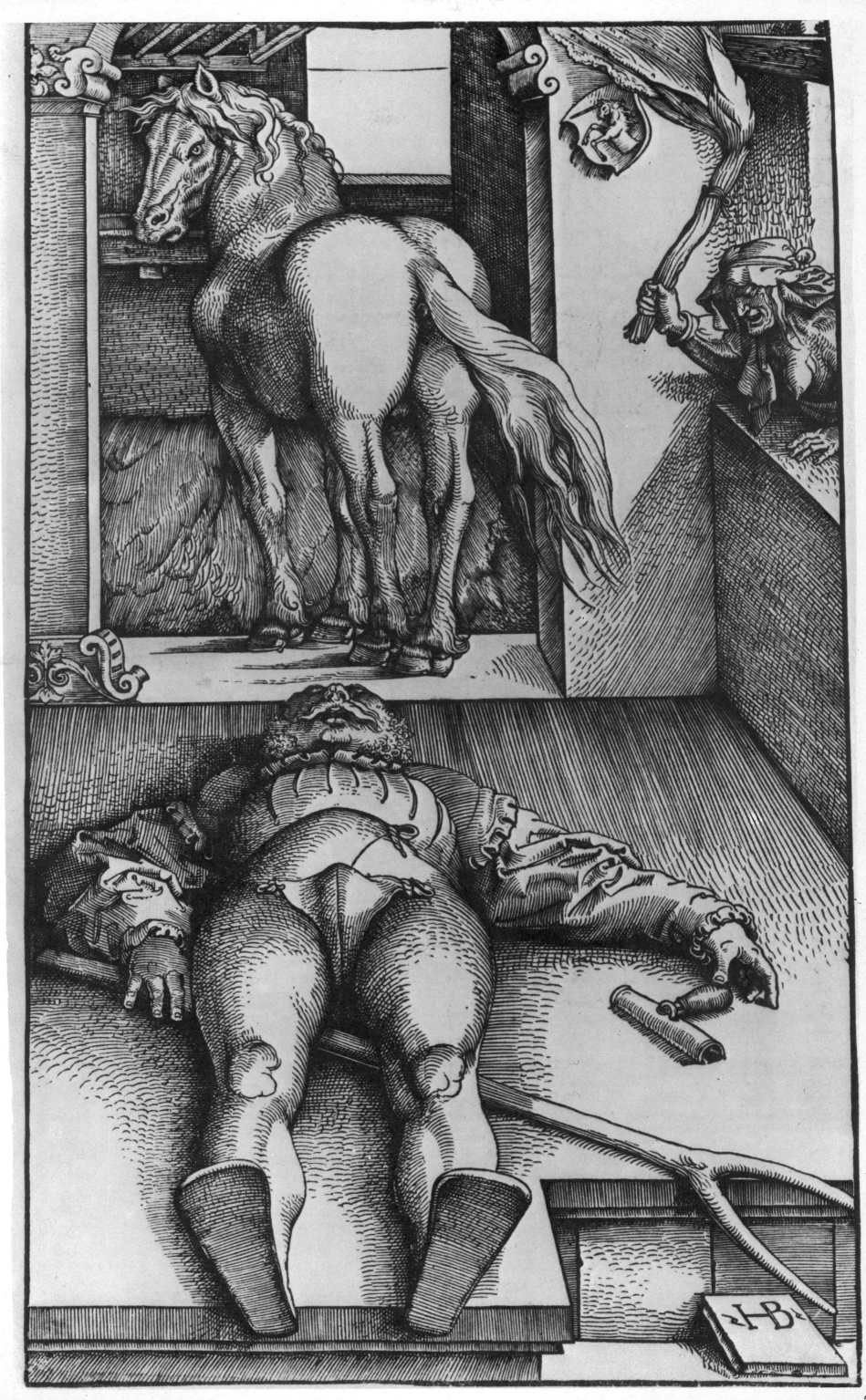

3

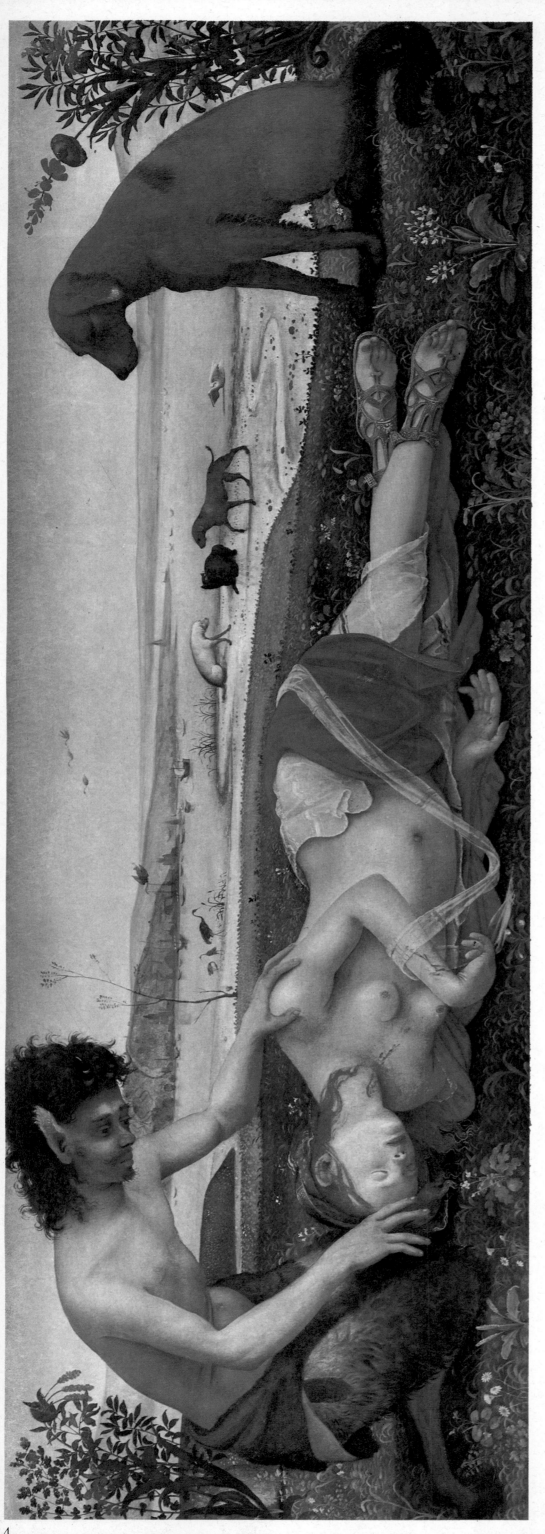

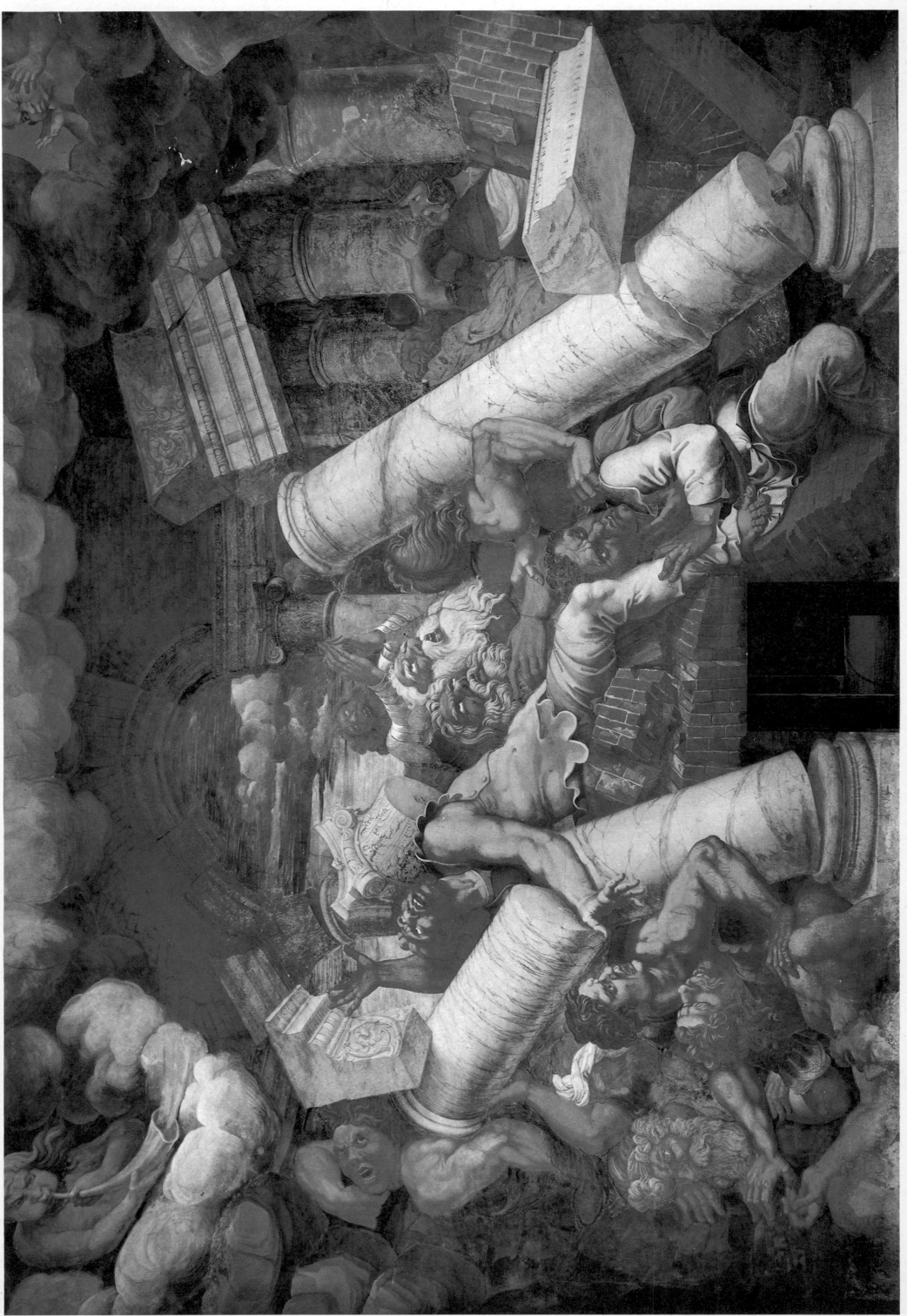

5

6

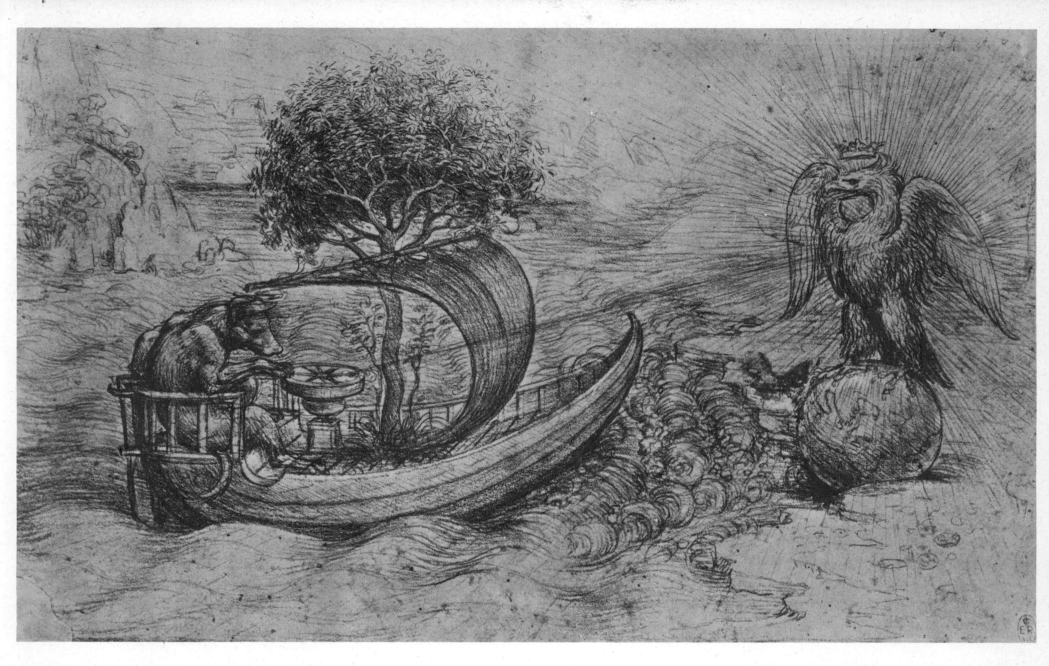

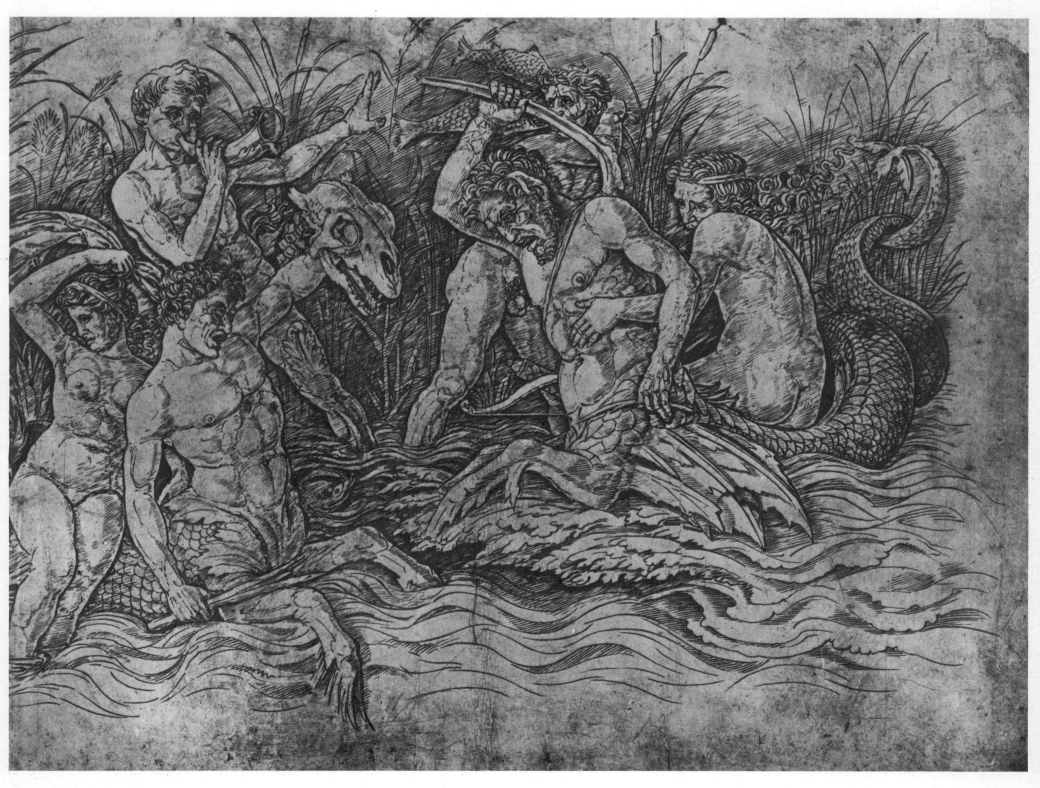

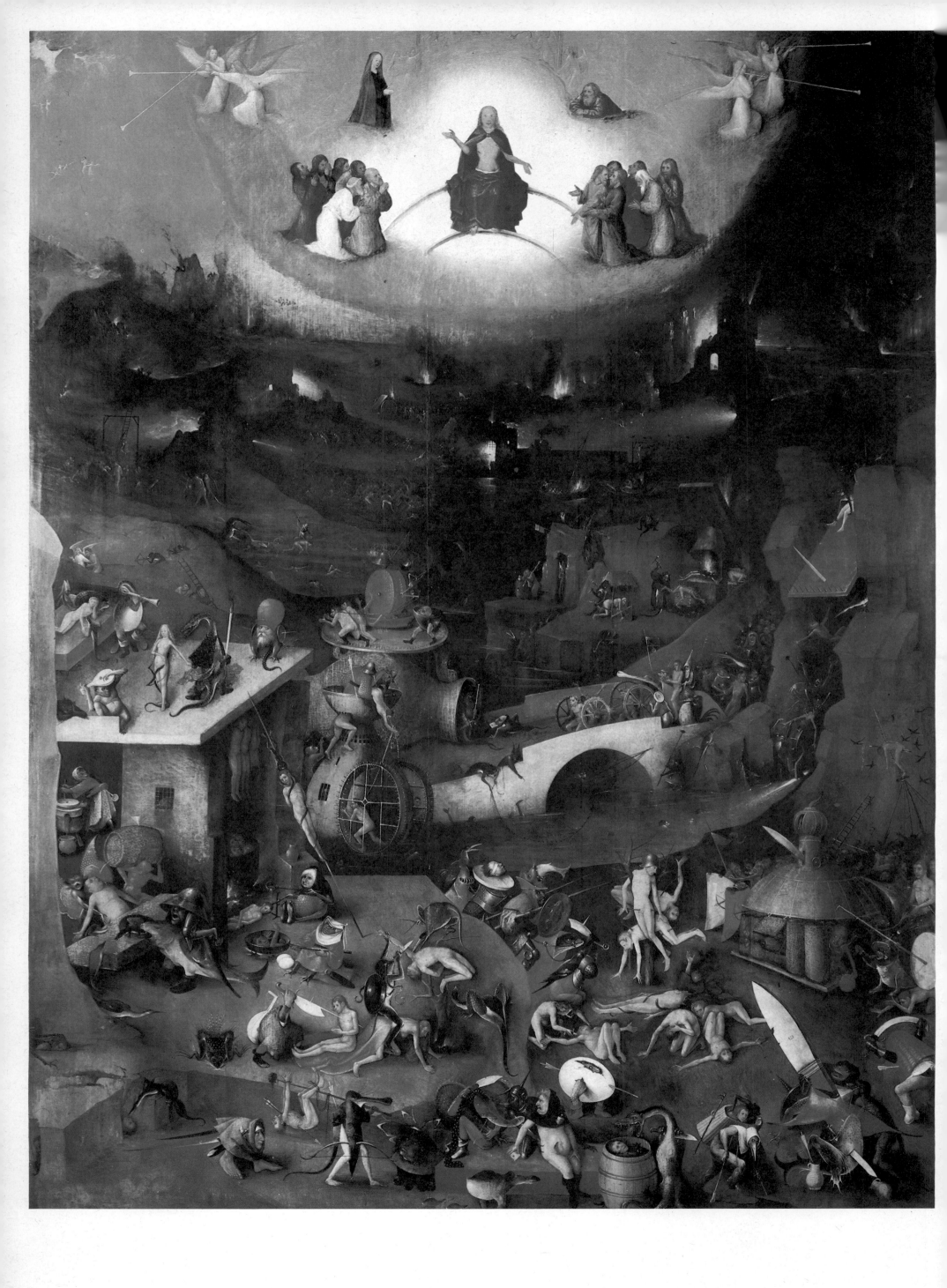

8

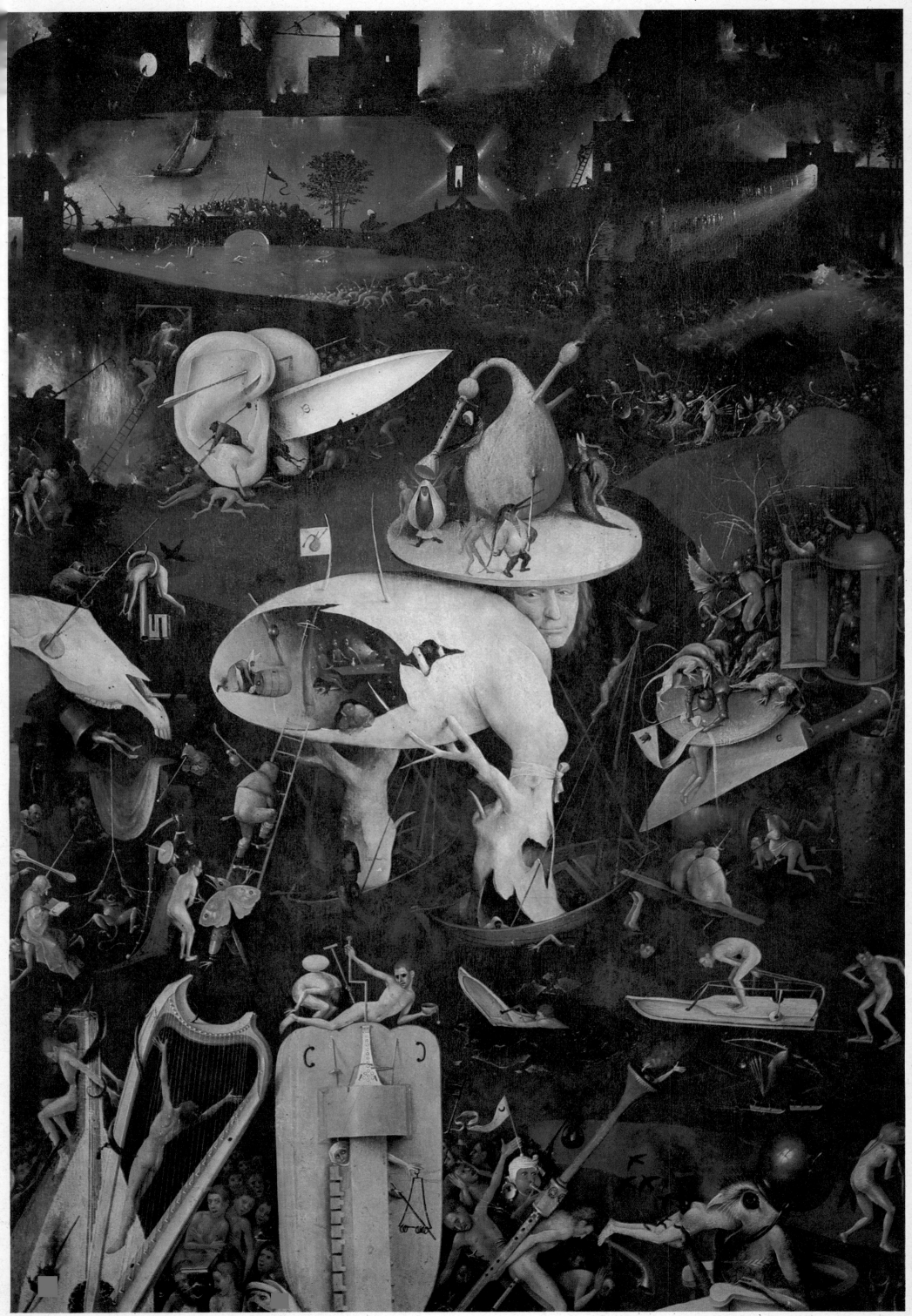

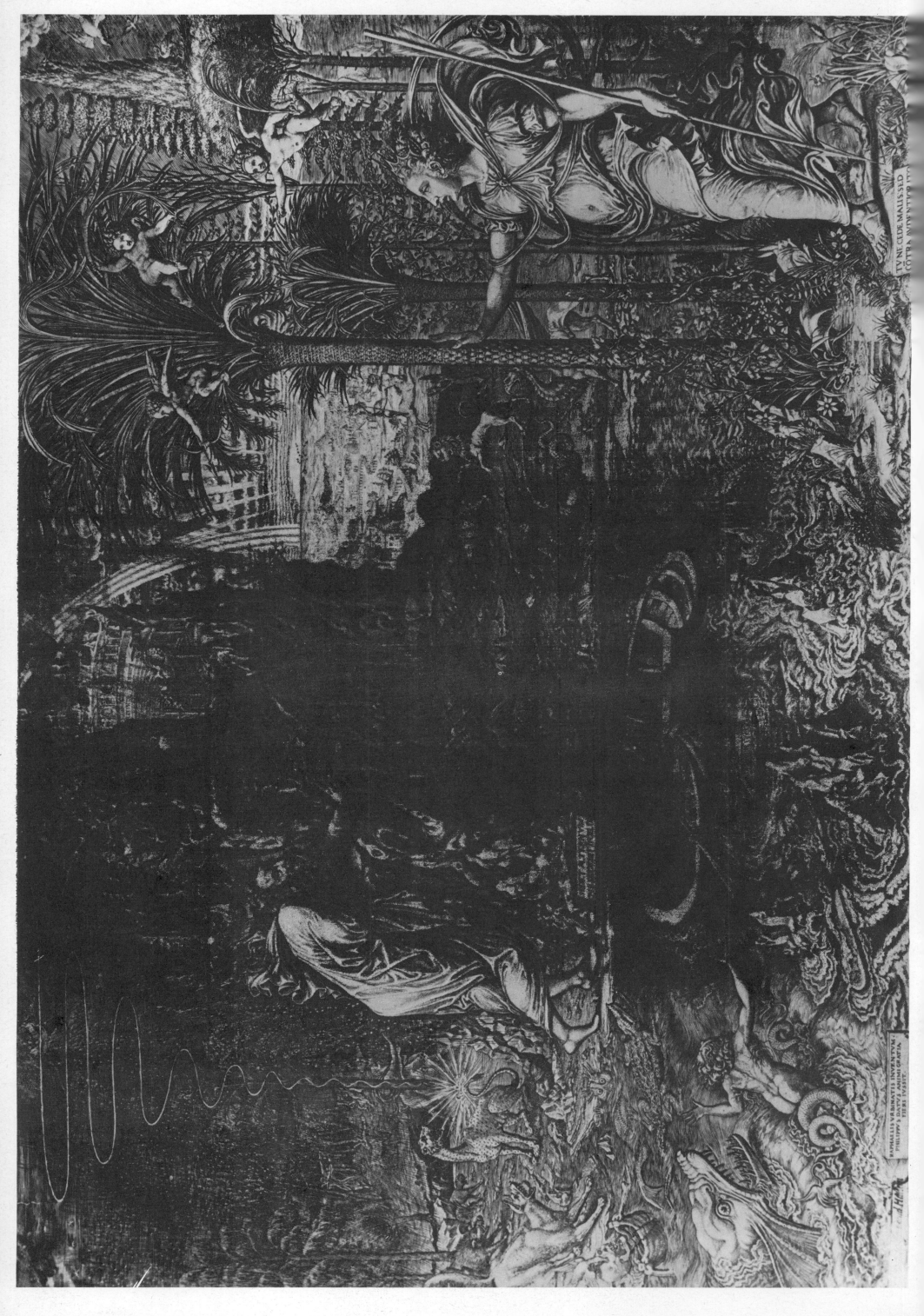

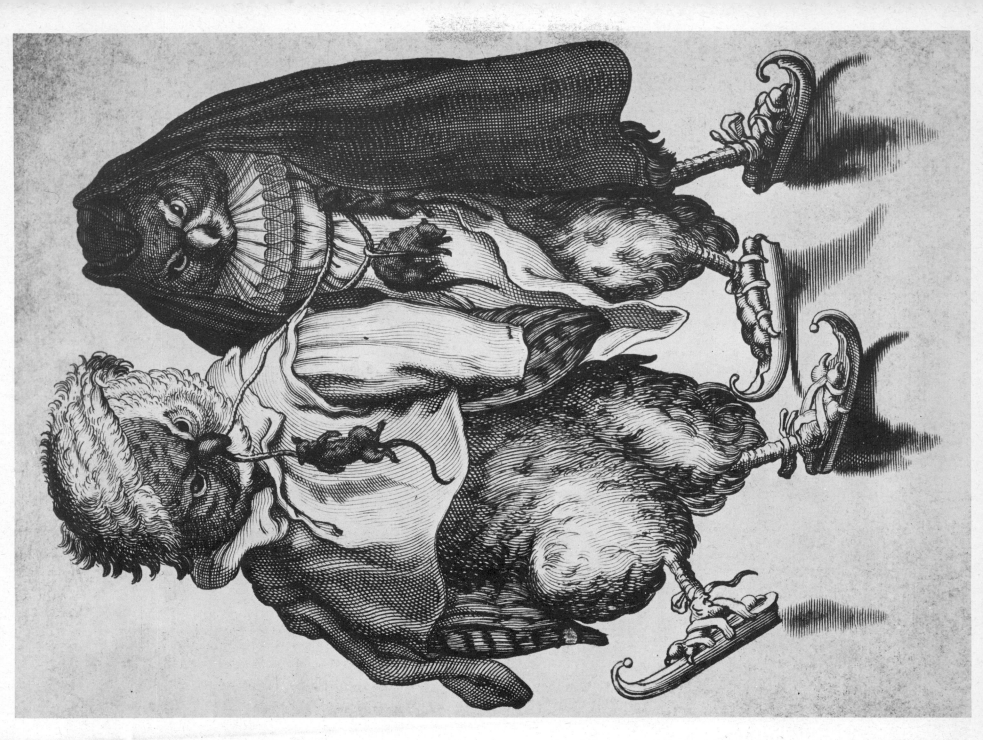

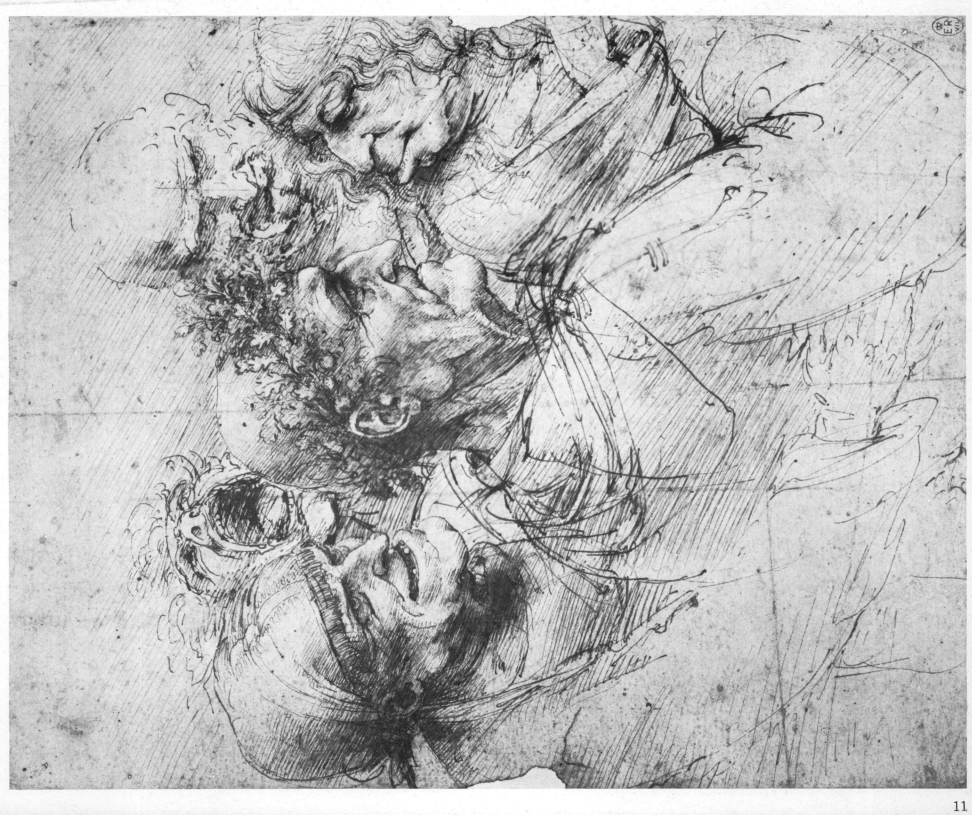

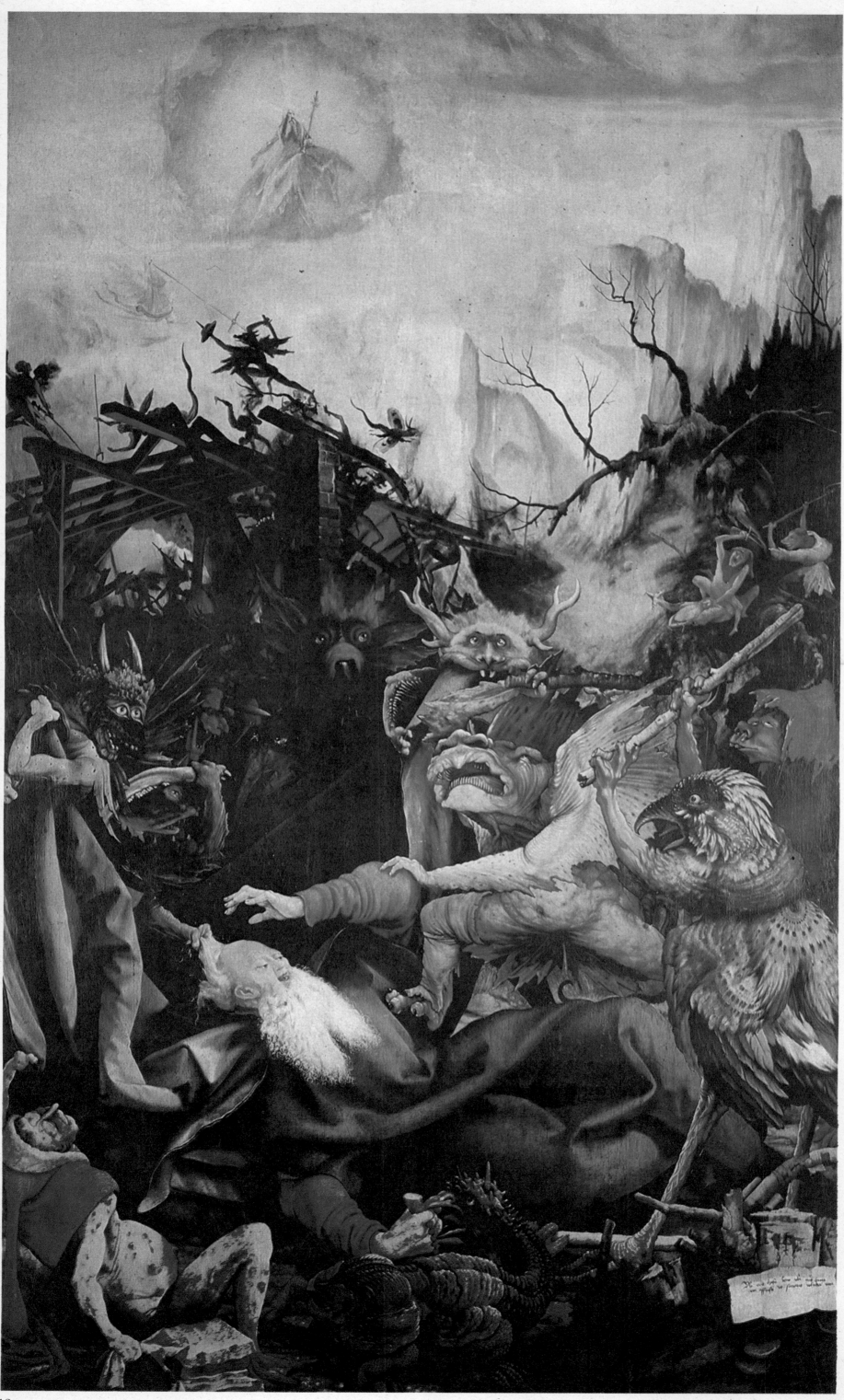

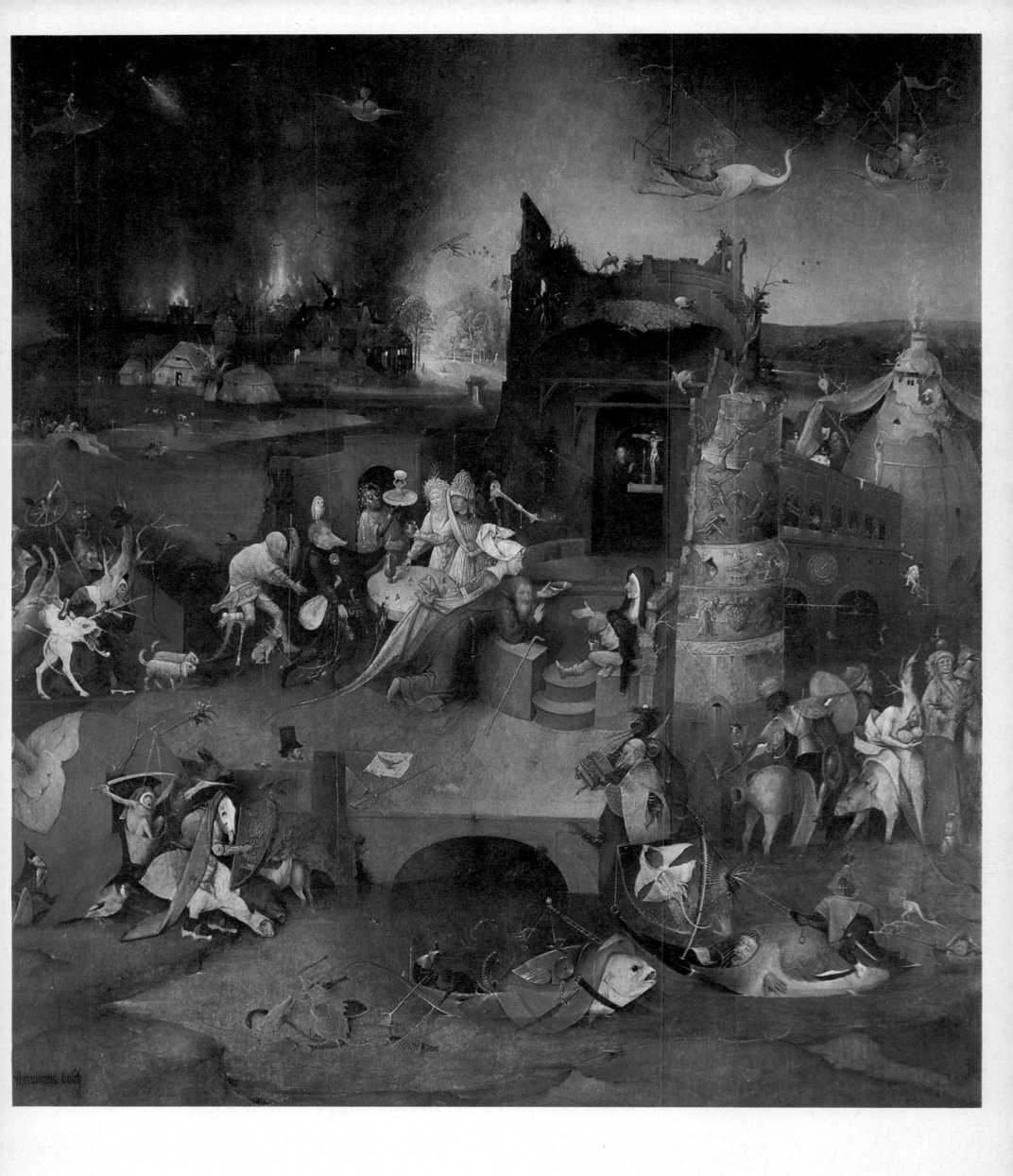

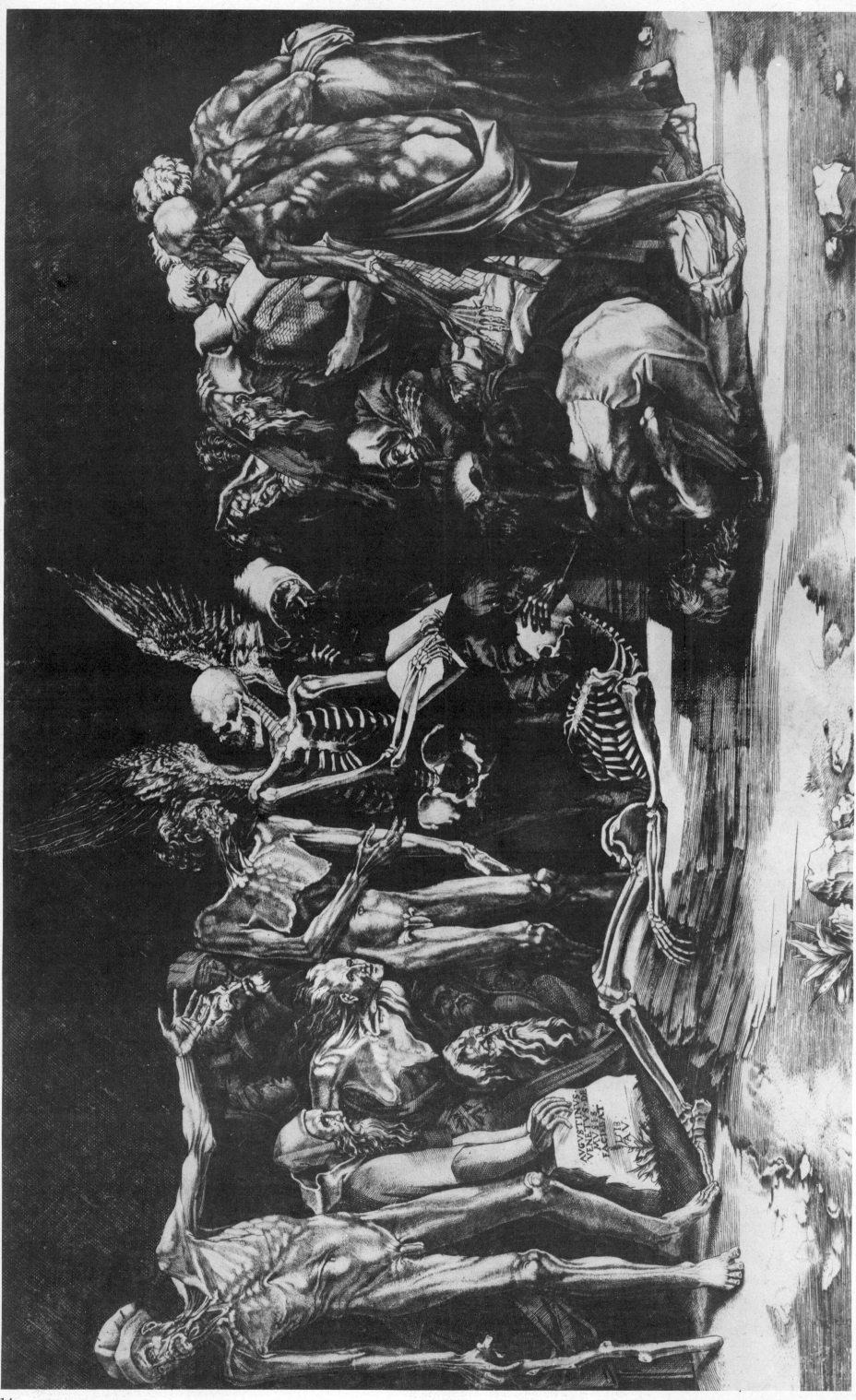

14

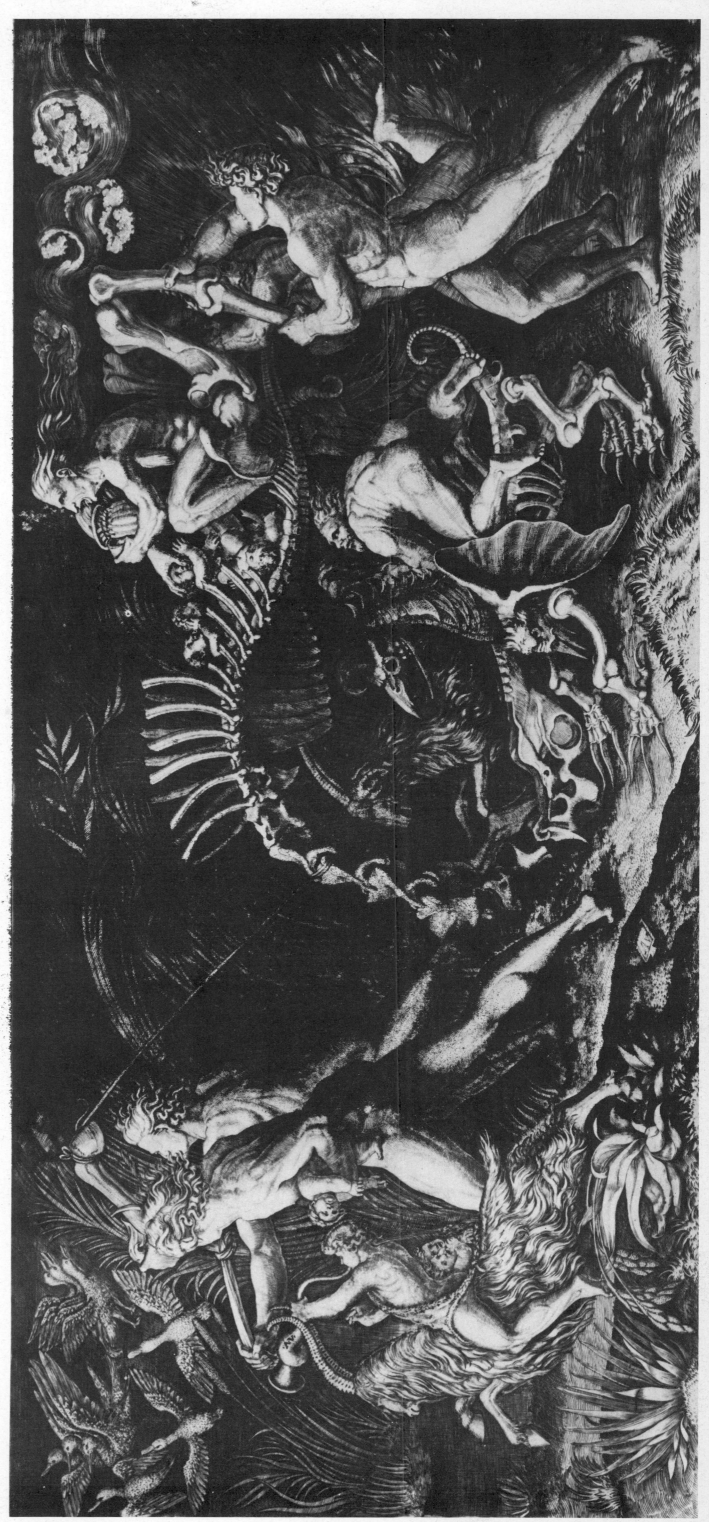

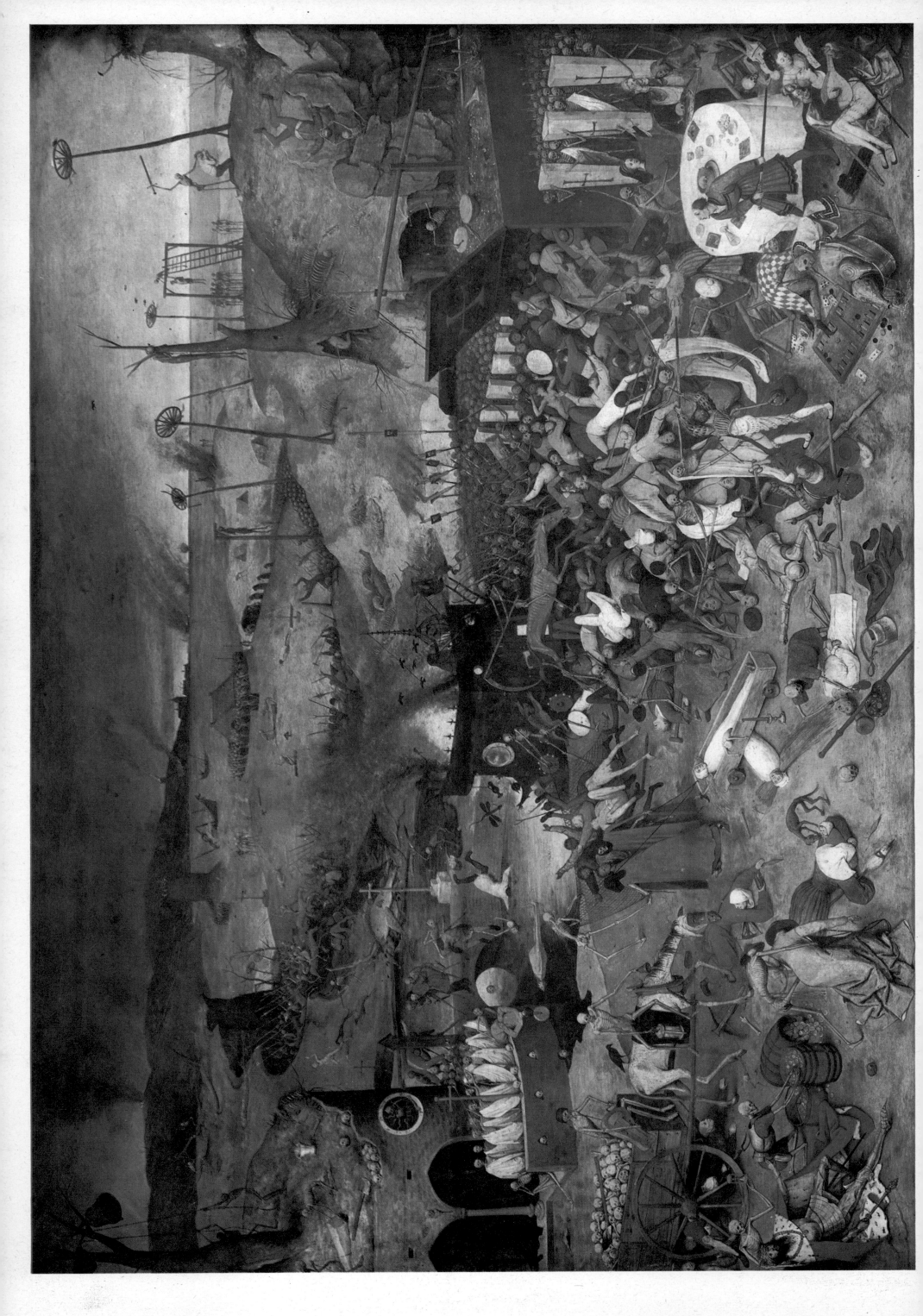

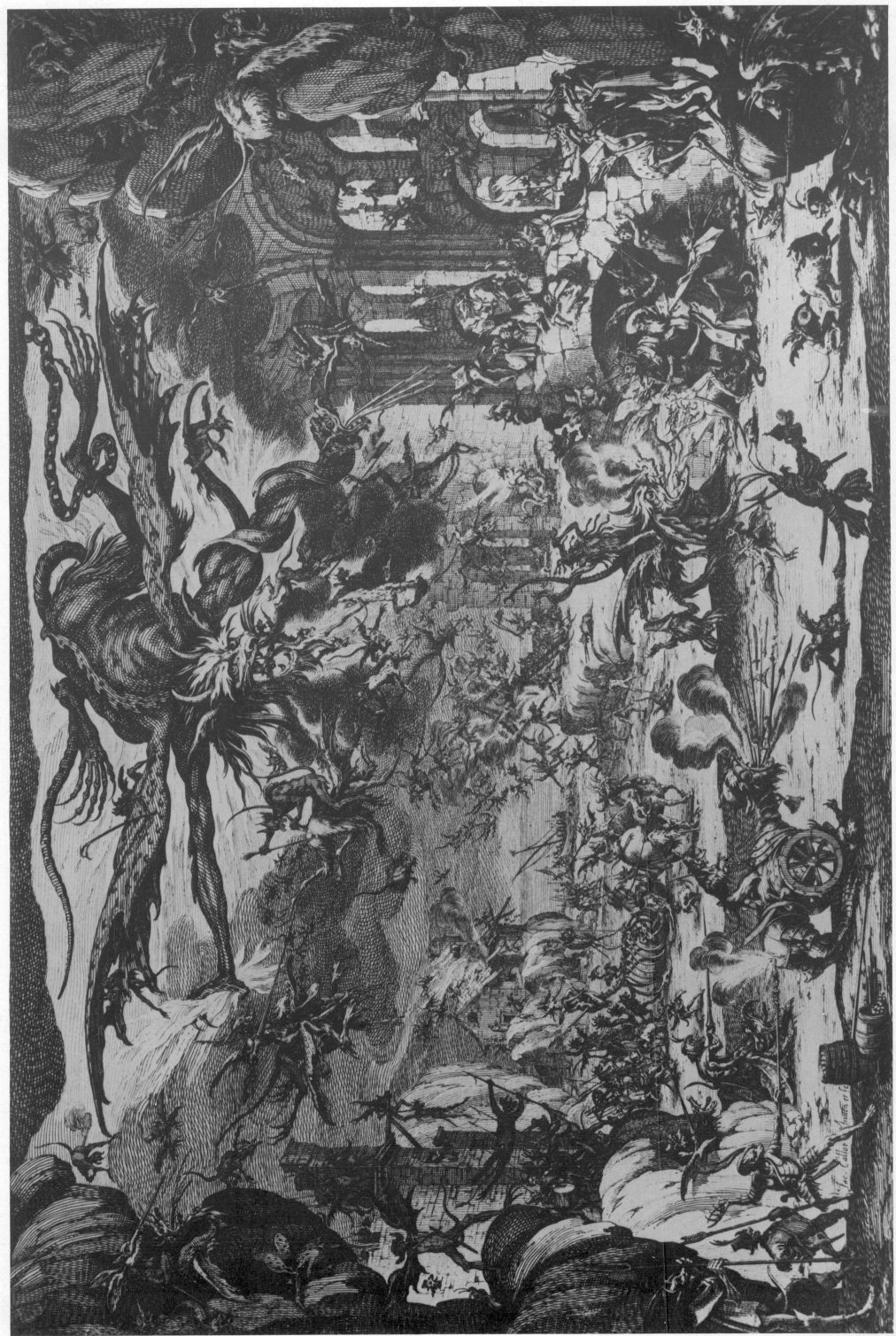

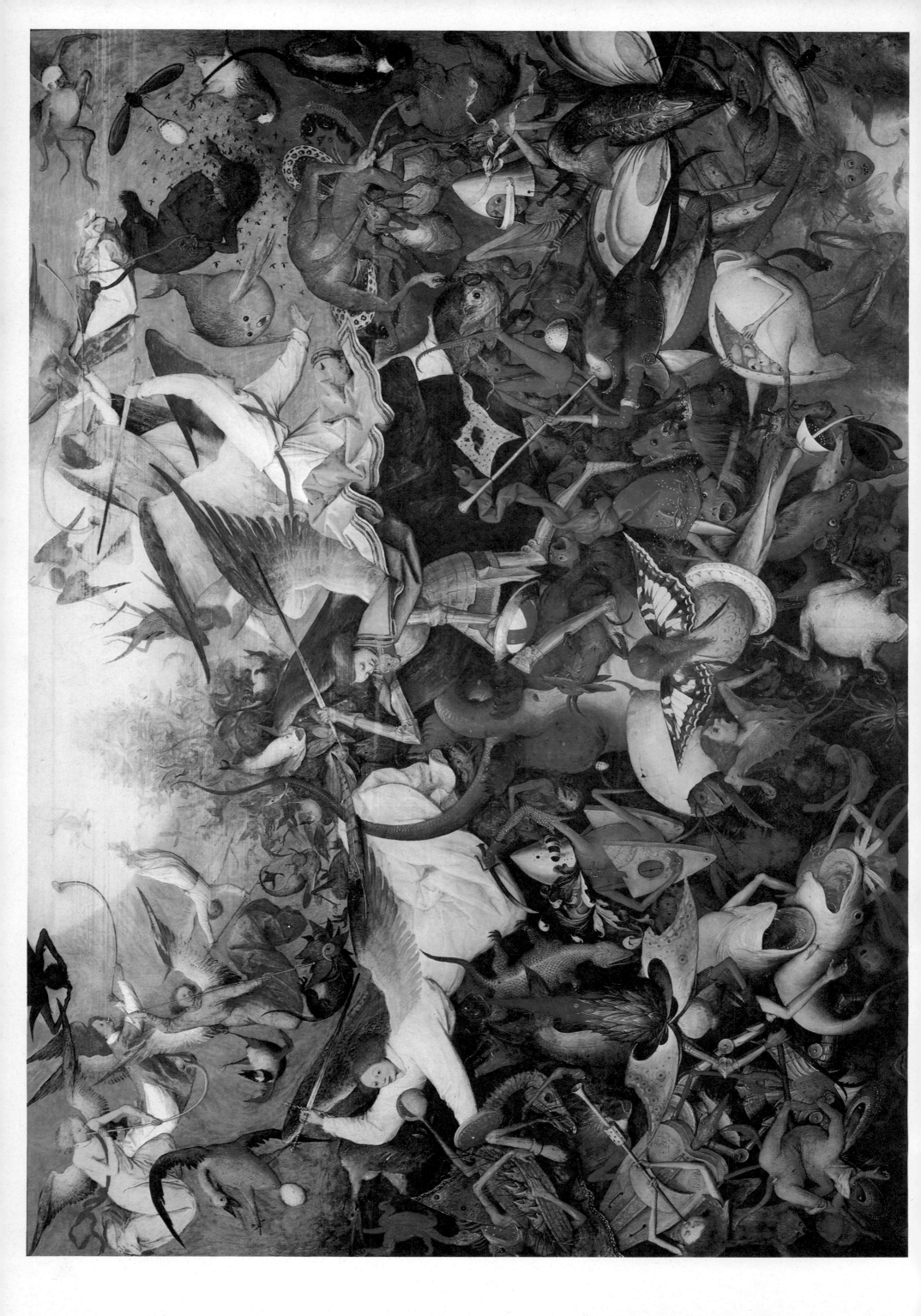

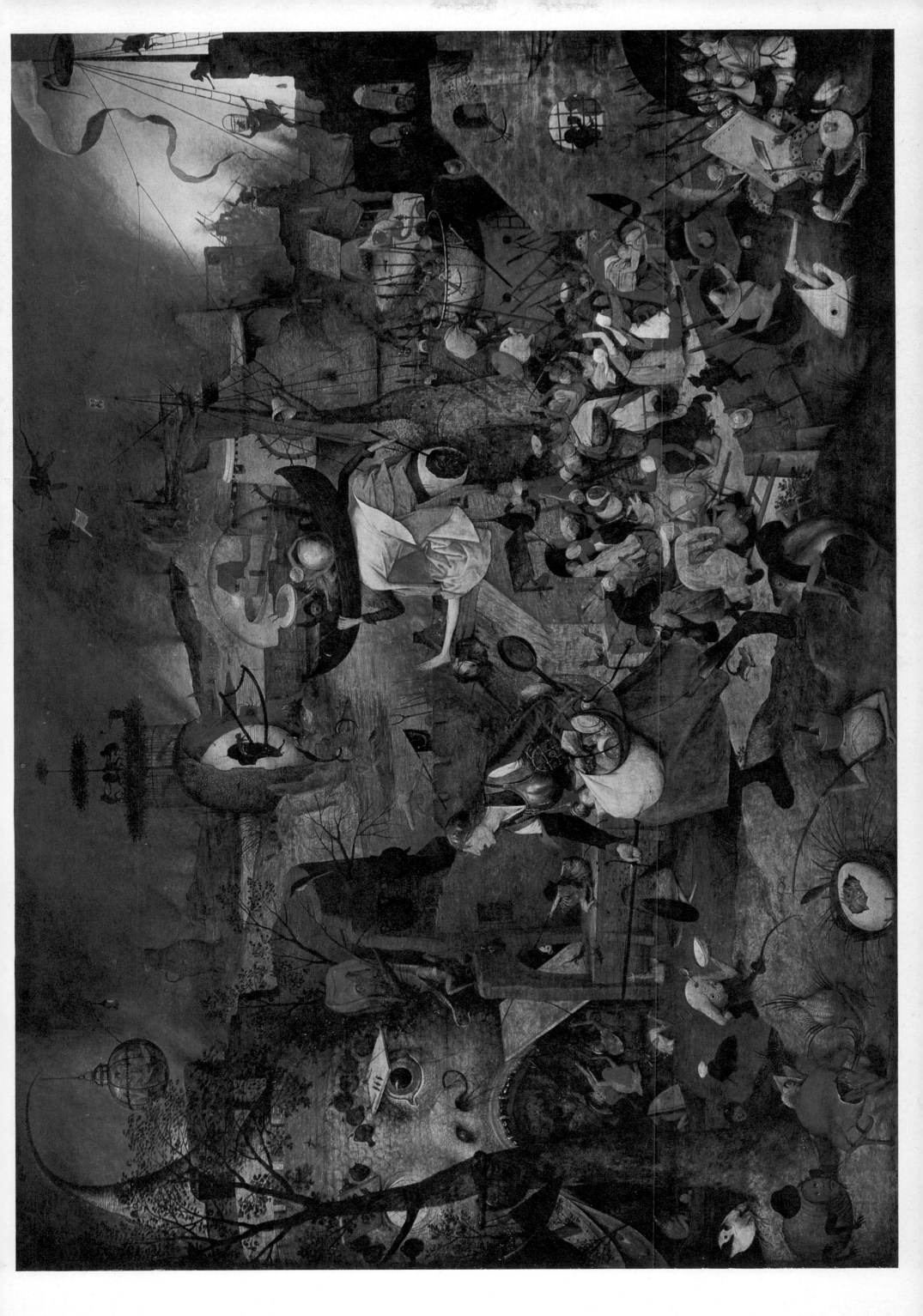

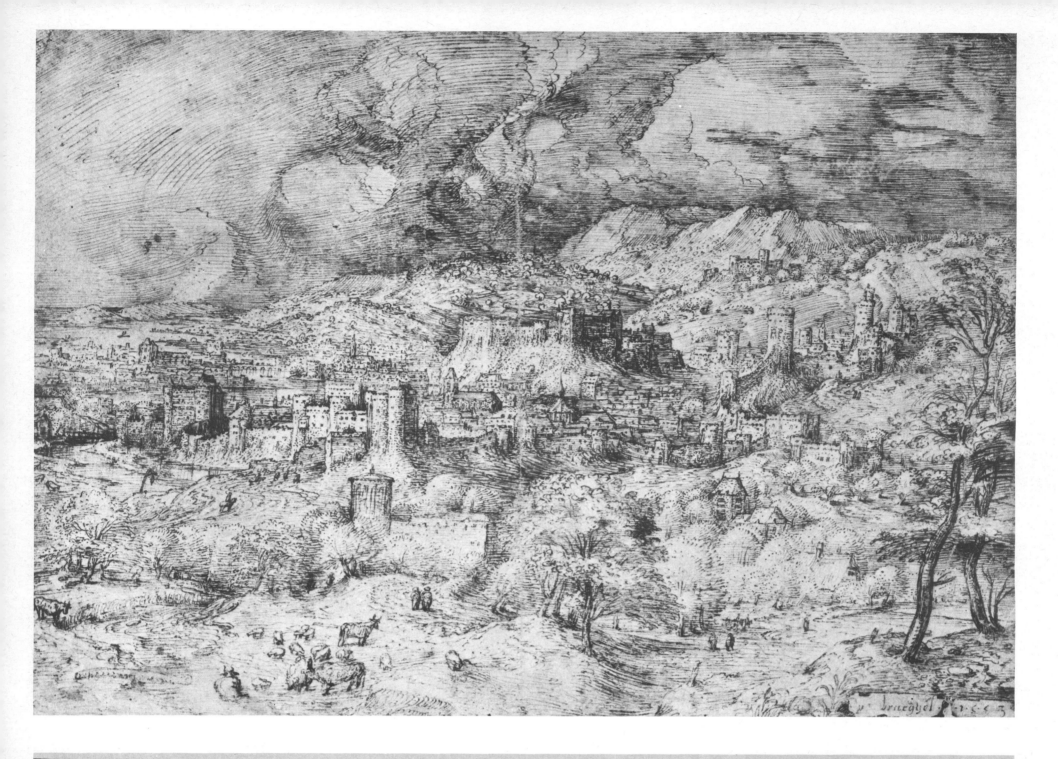

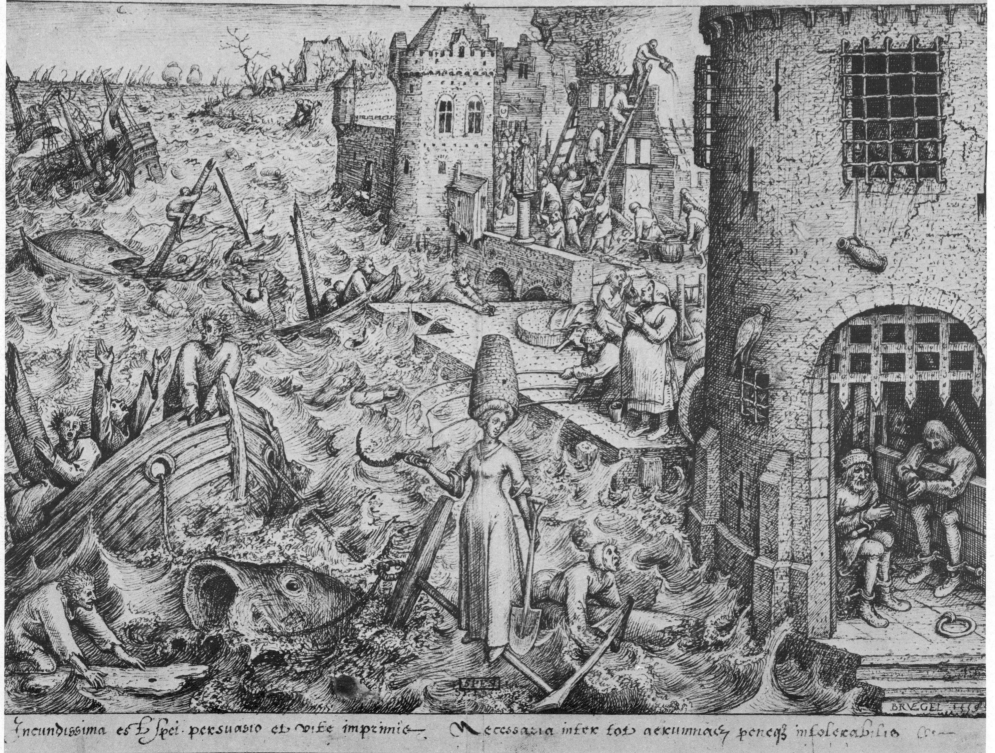

Ireundissima est Spei persuasio et vitæ imprimis — Necessaria inter tot ærumnas penegg intolerabiles Cr—

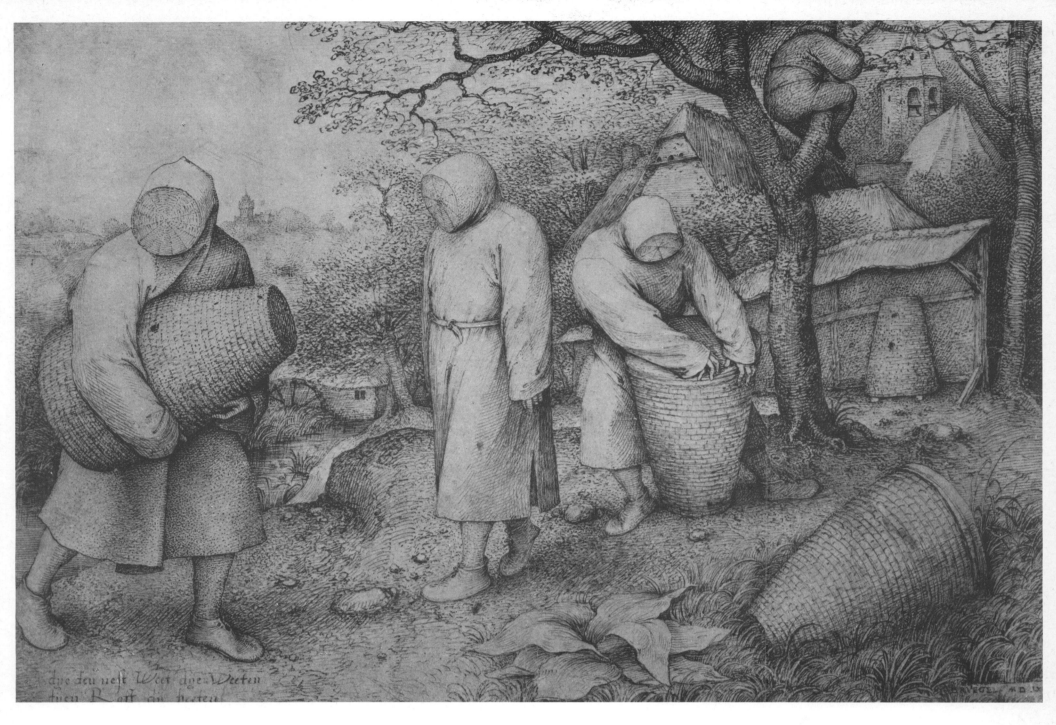

die den nest weet die weeten
huen roest en heeten

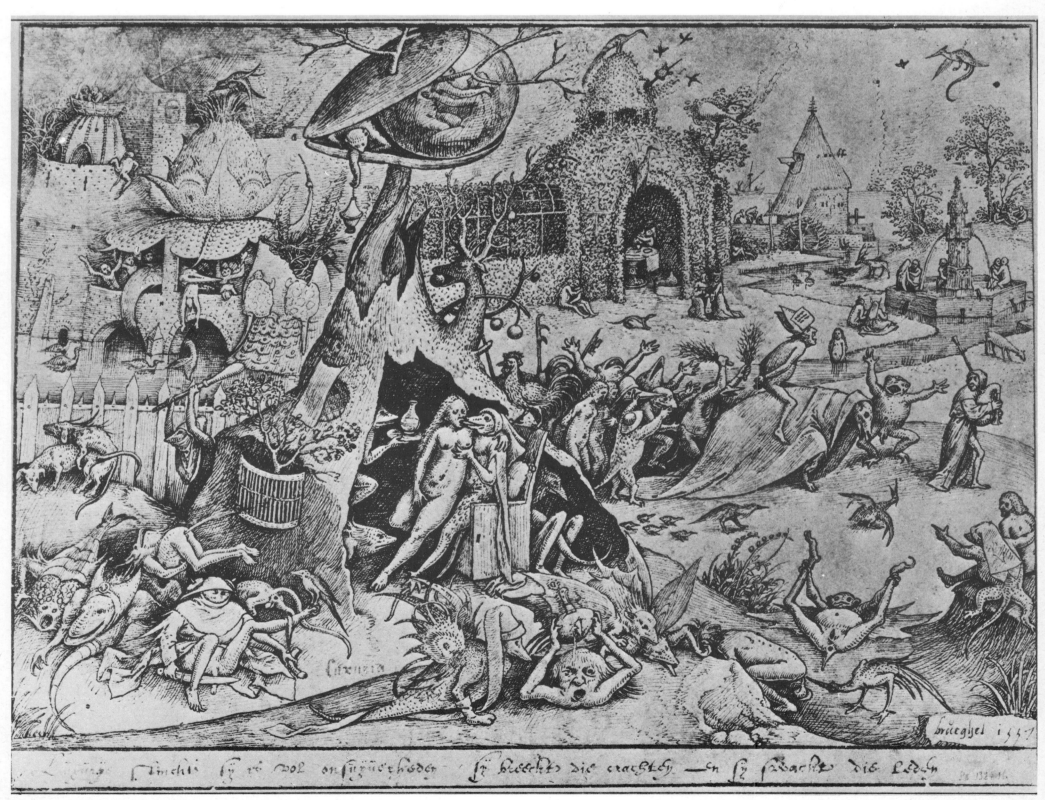

Inuidia

...tinckt sy is vol onspoedigheden Sy bekelt die crachten En sy sonckde die leden

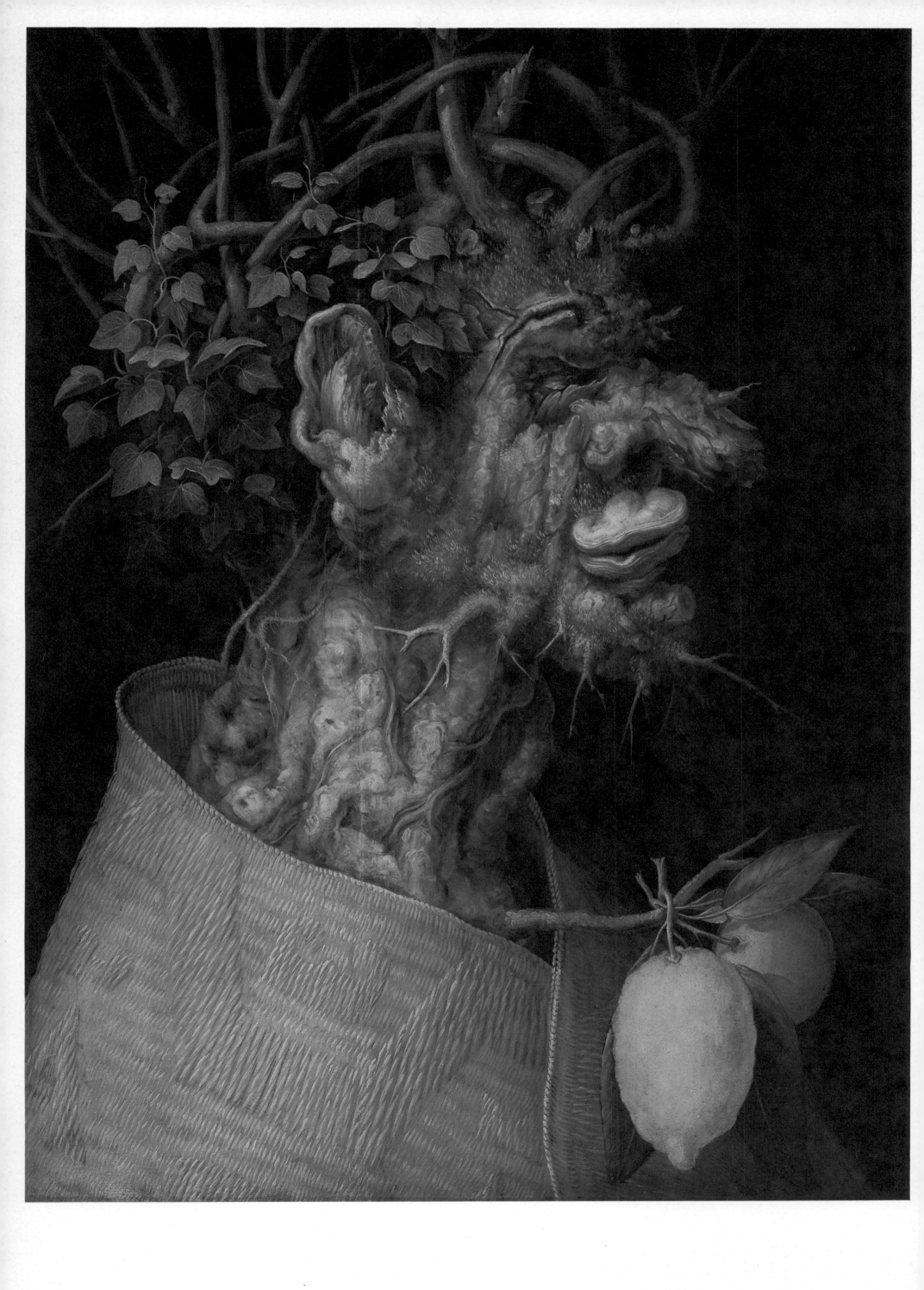

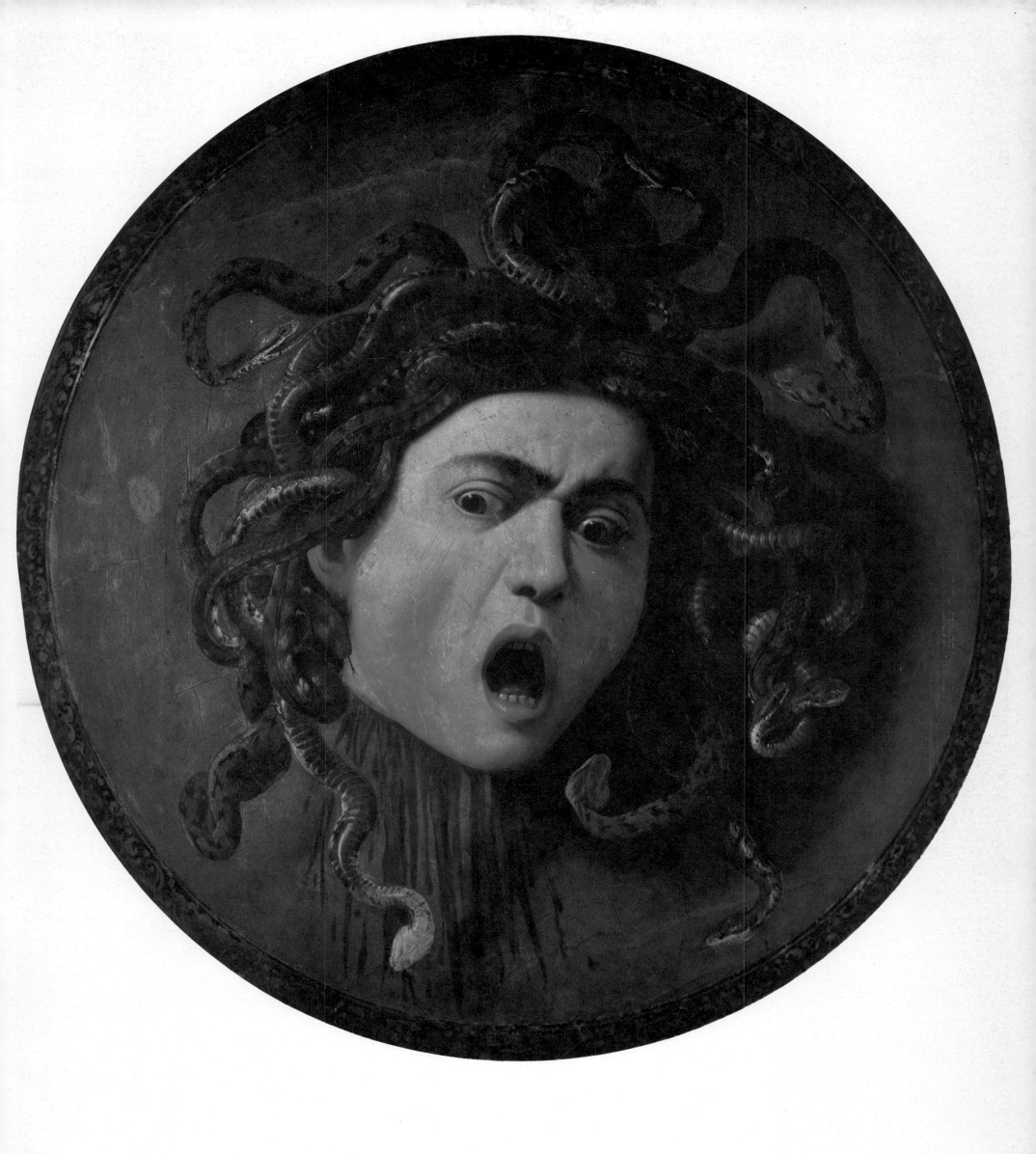

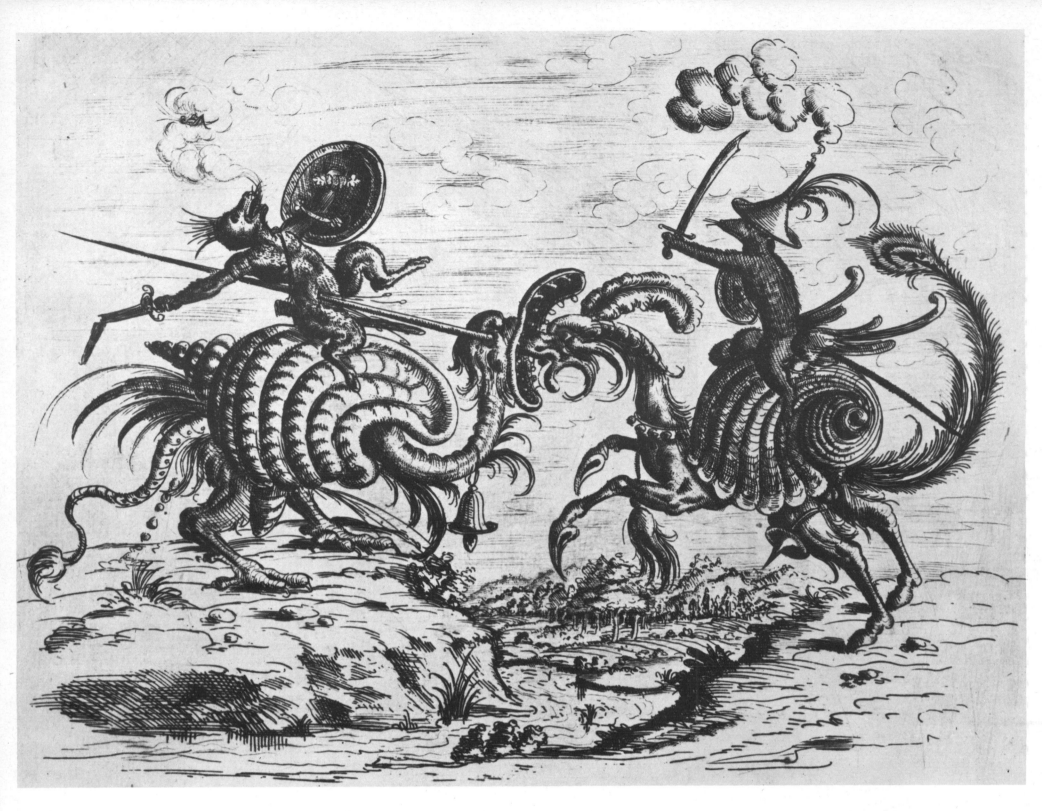

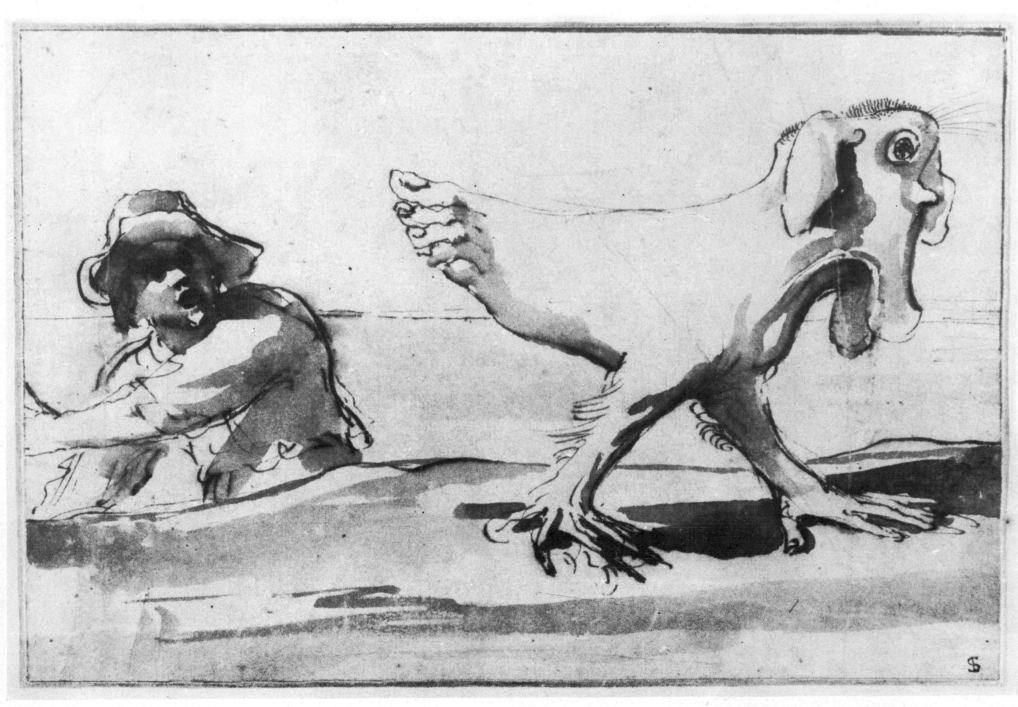

24

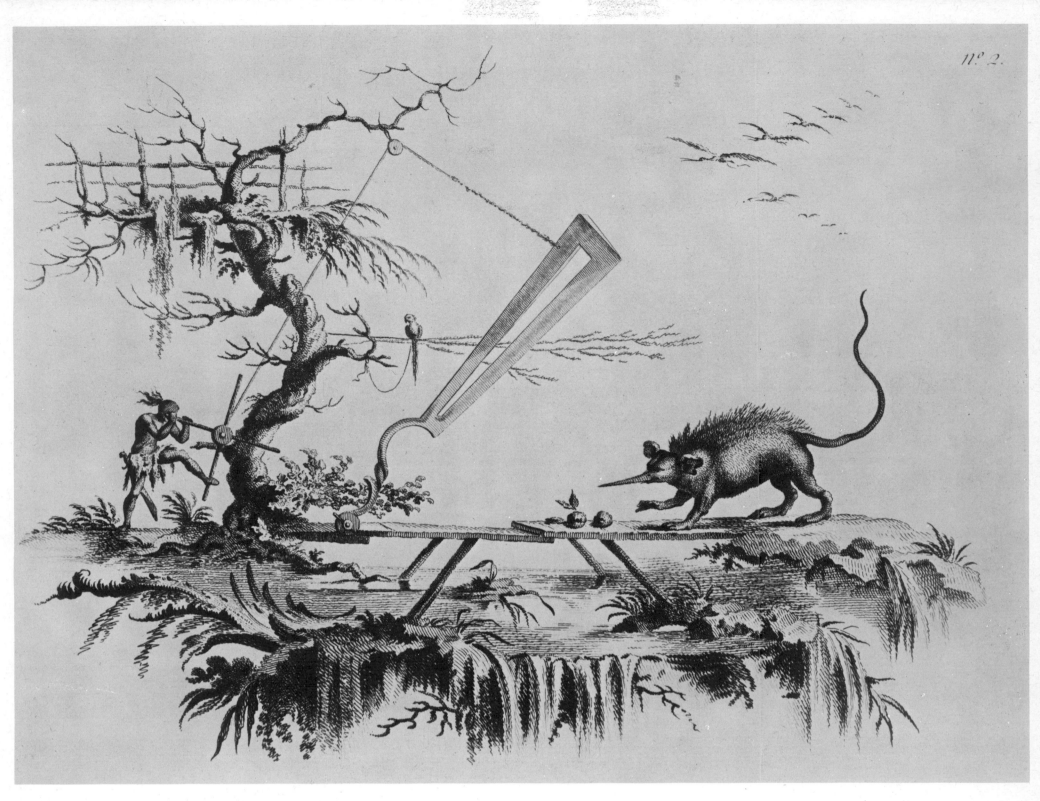

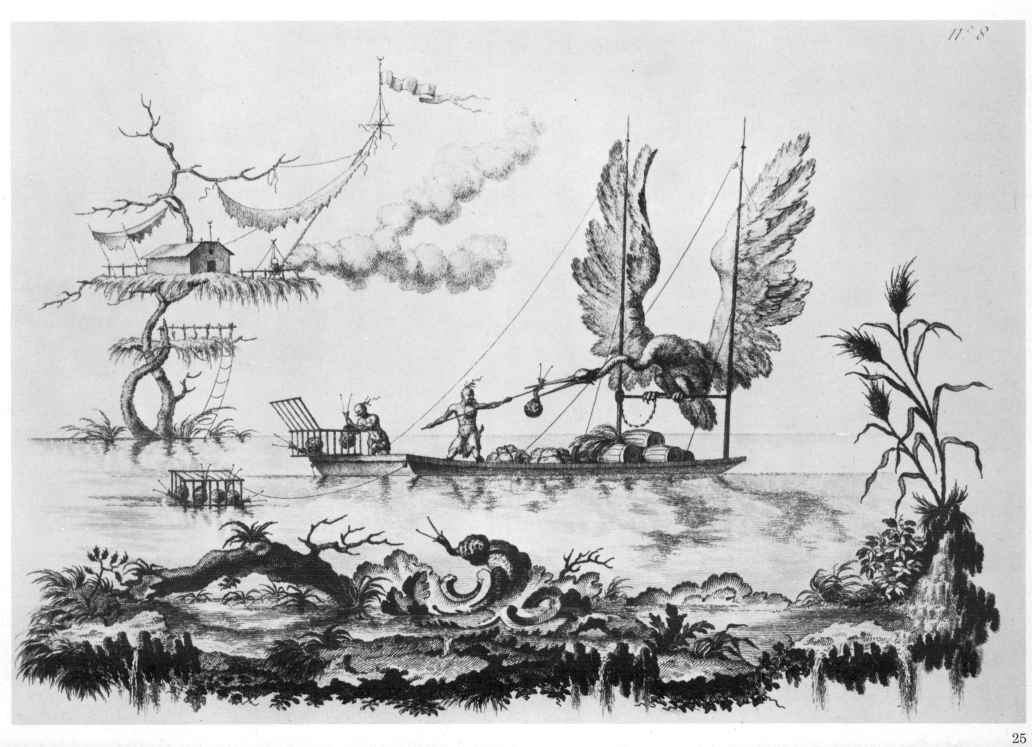

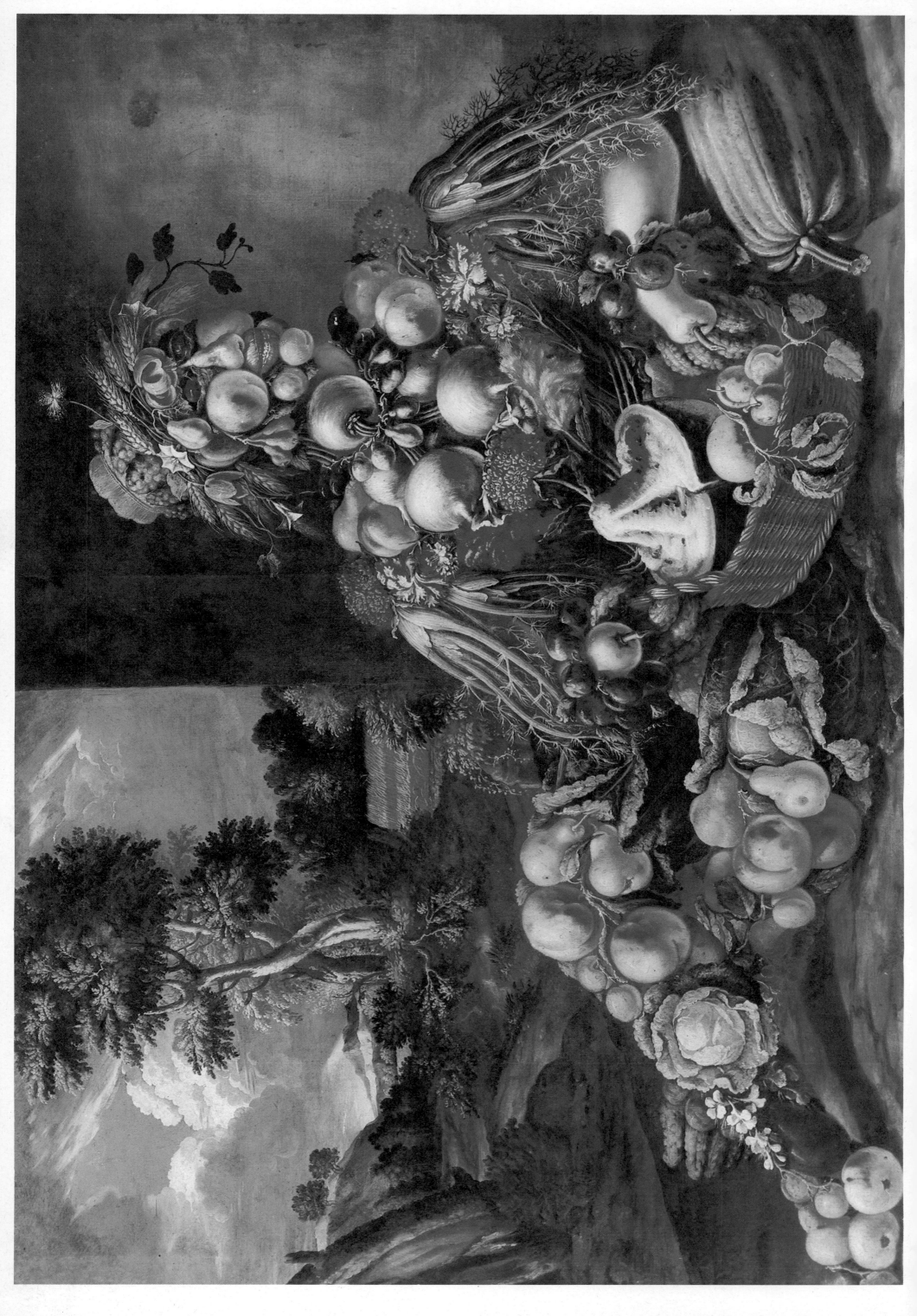

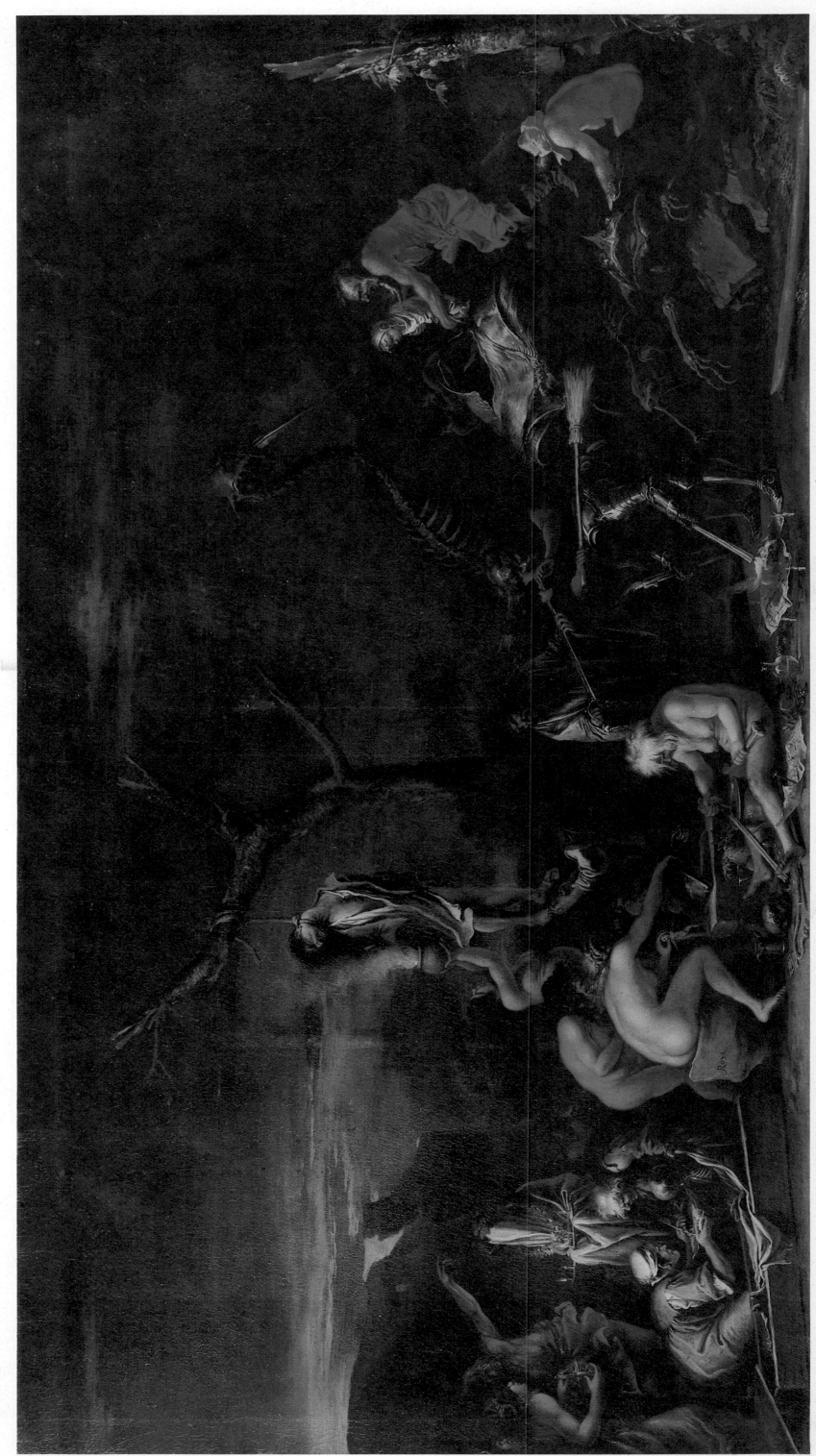

27

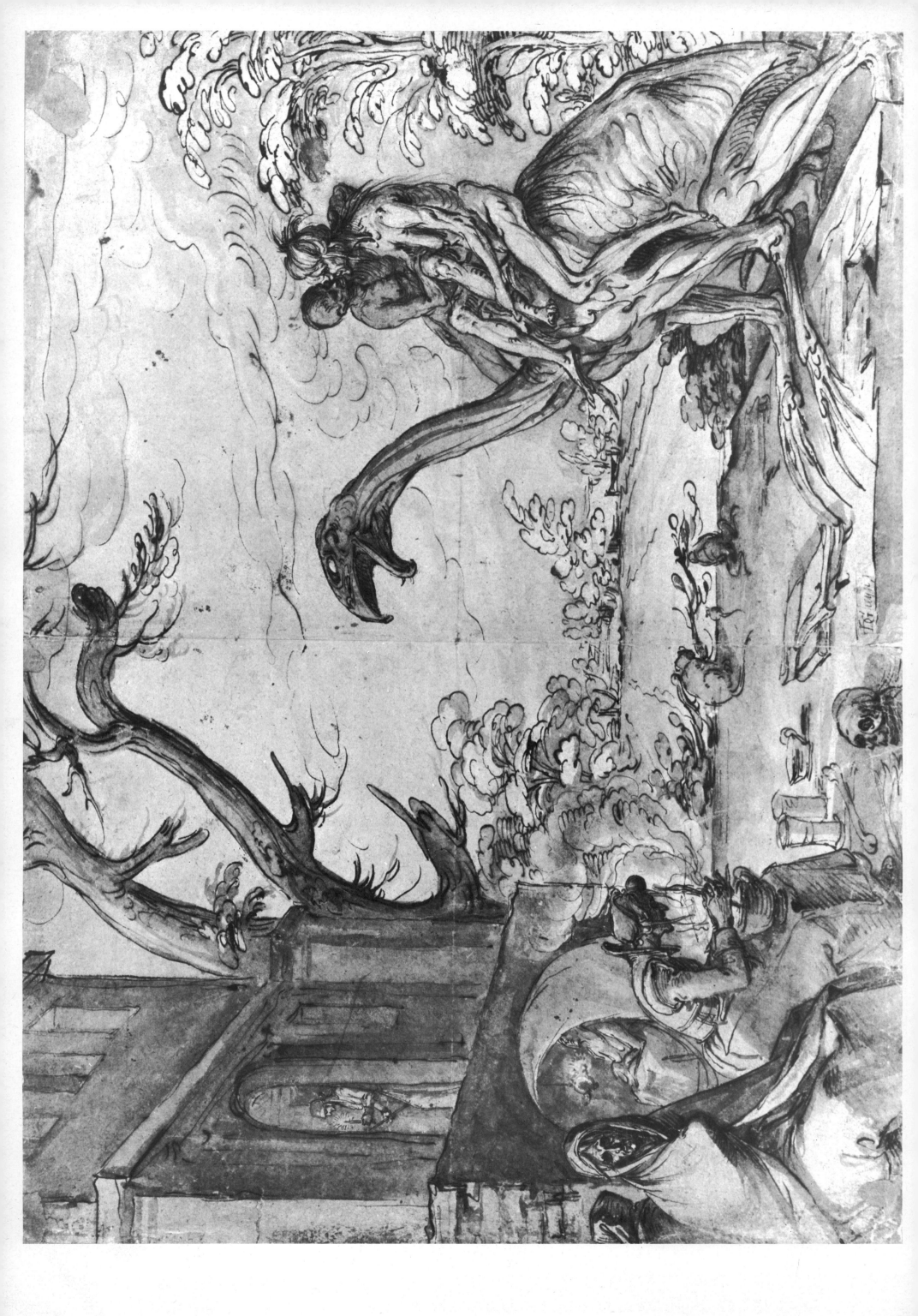

28

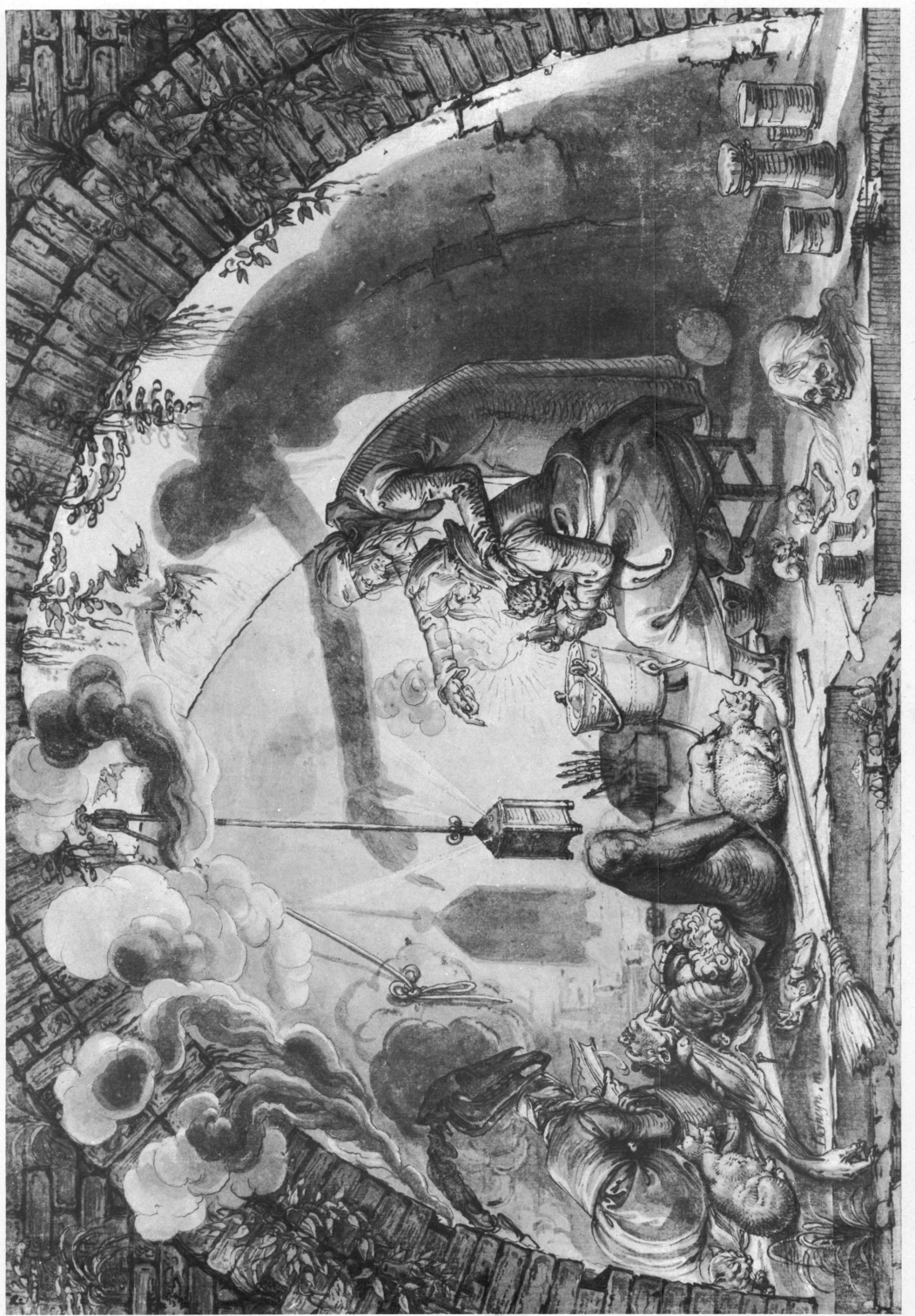

29

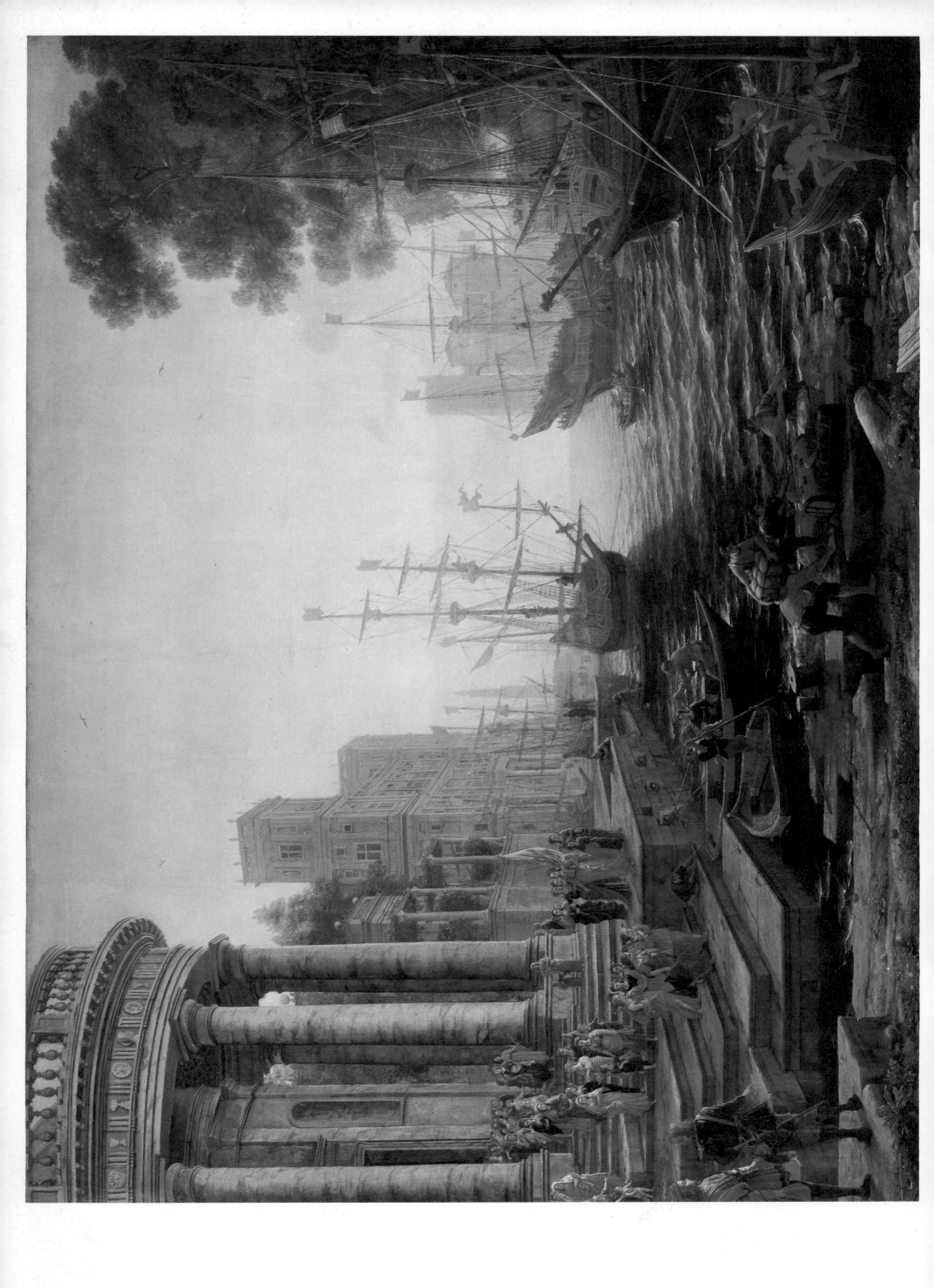

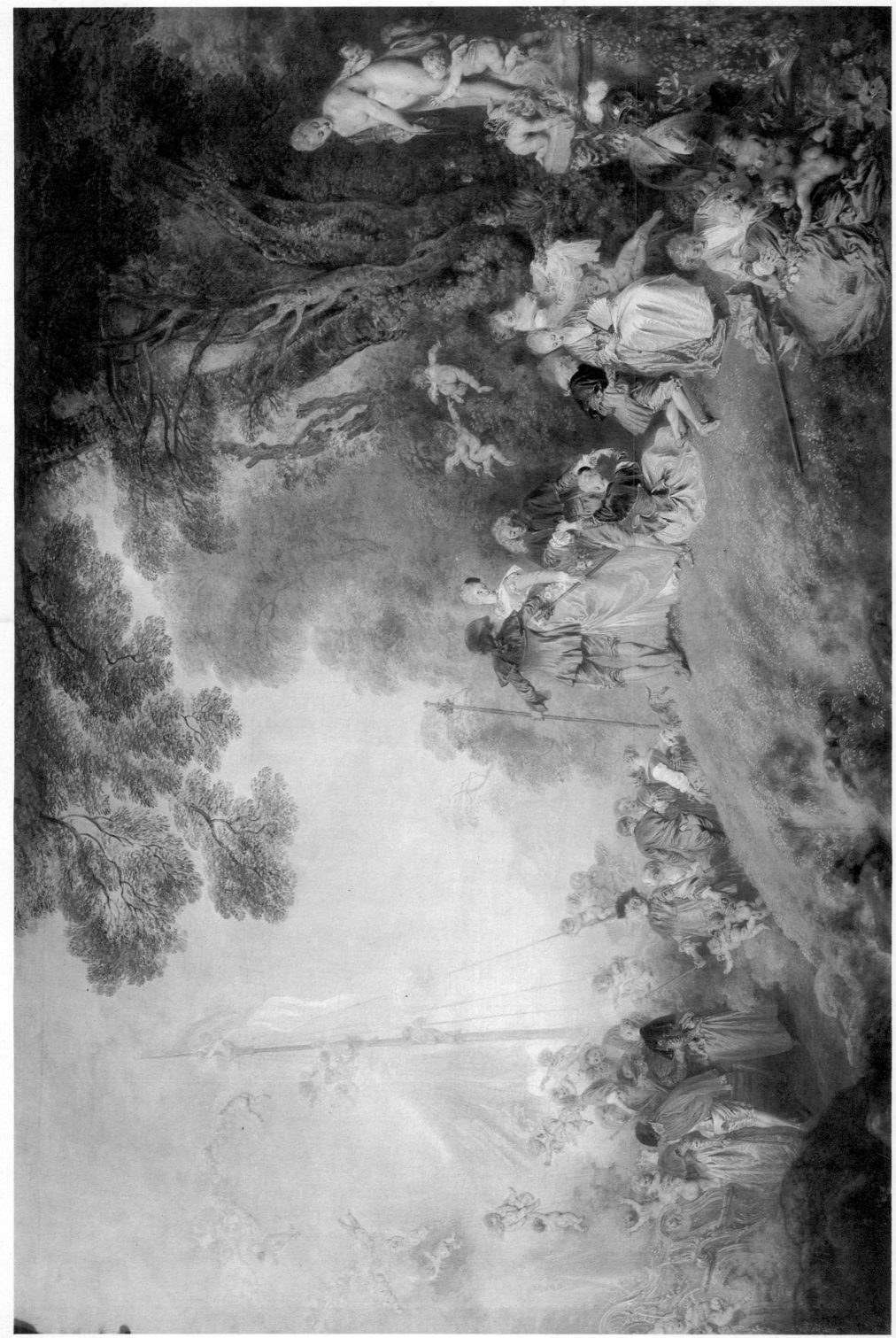

31

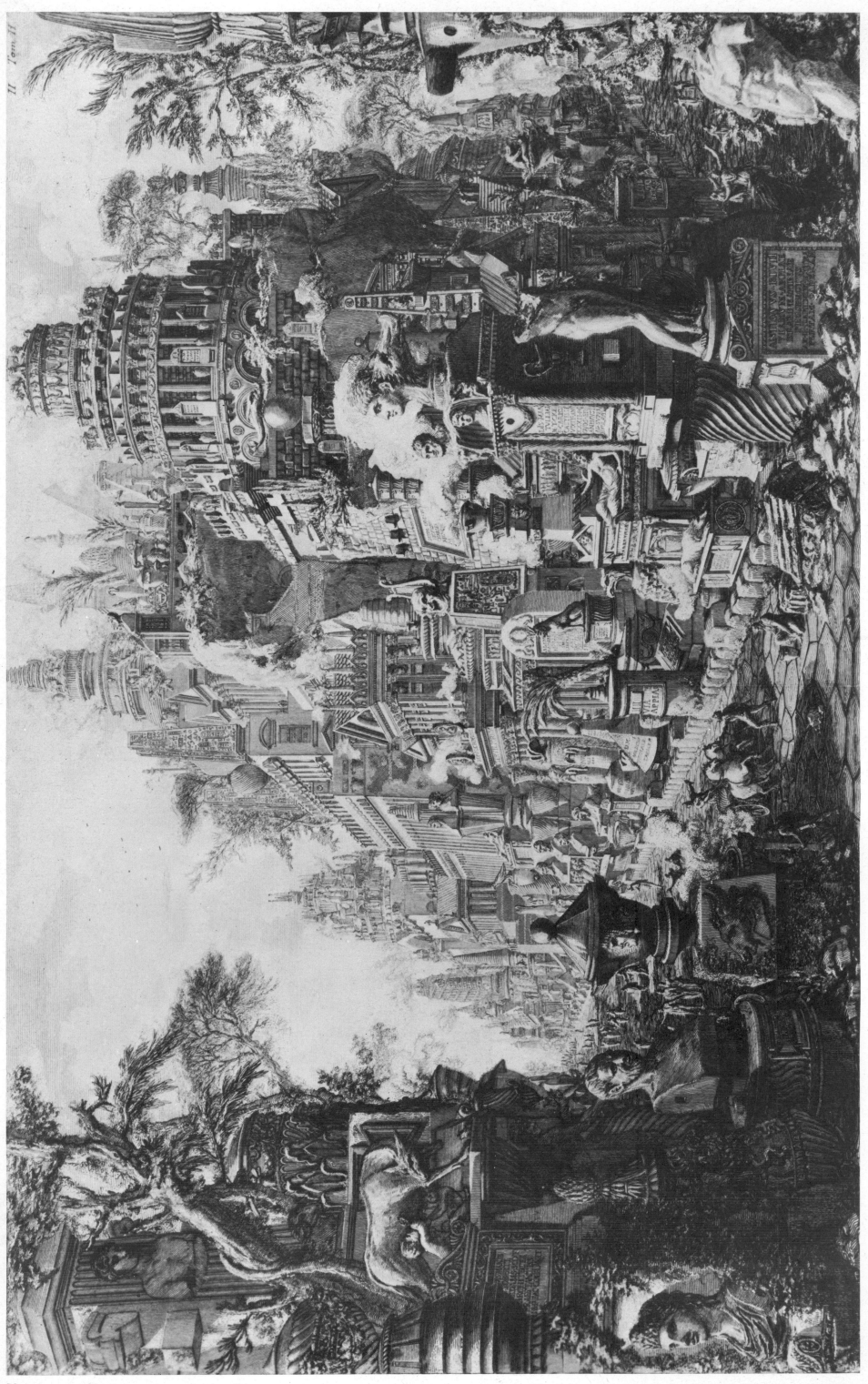

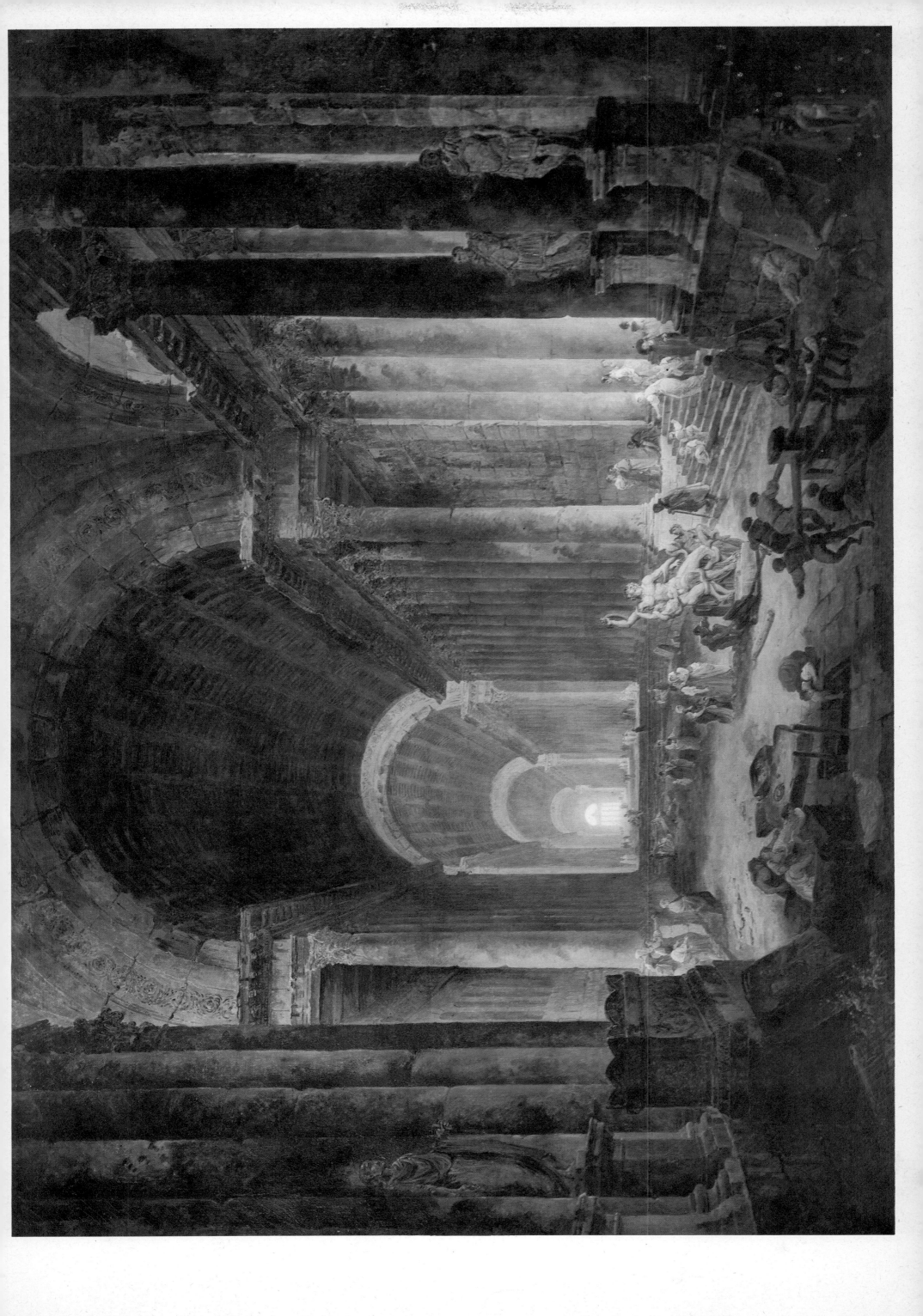

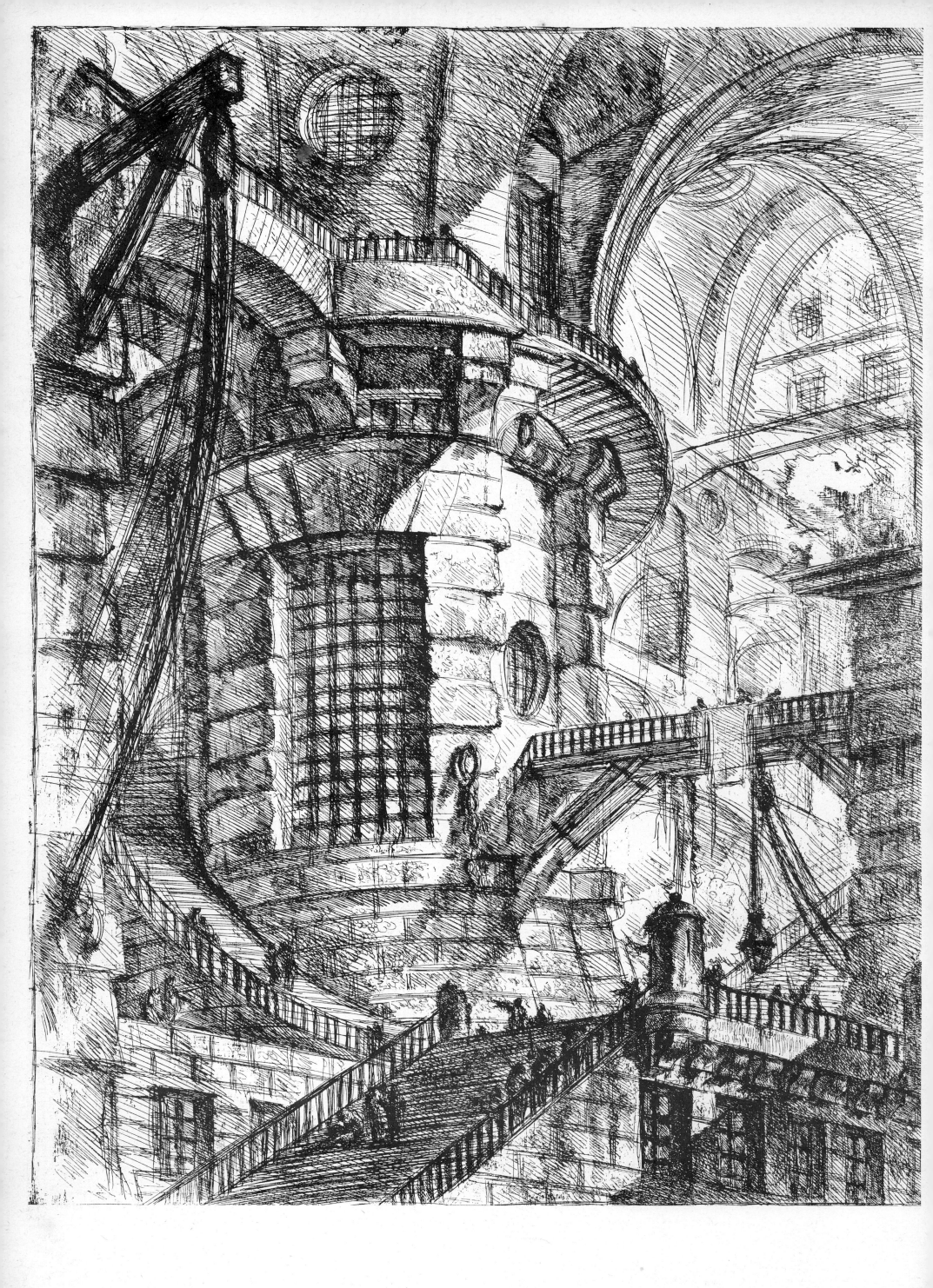

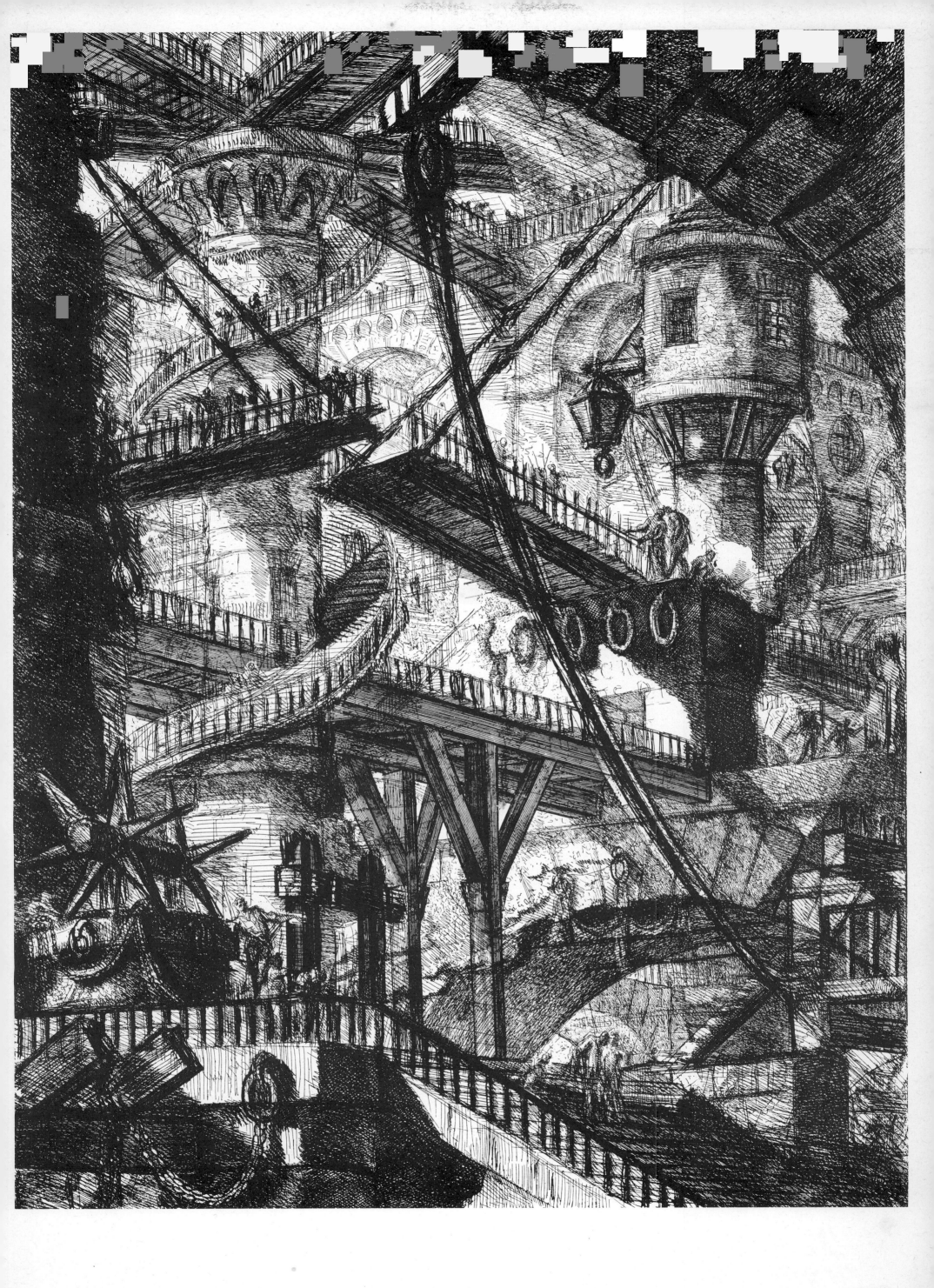

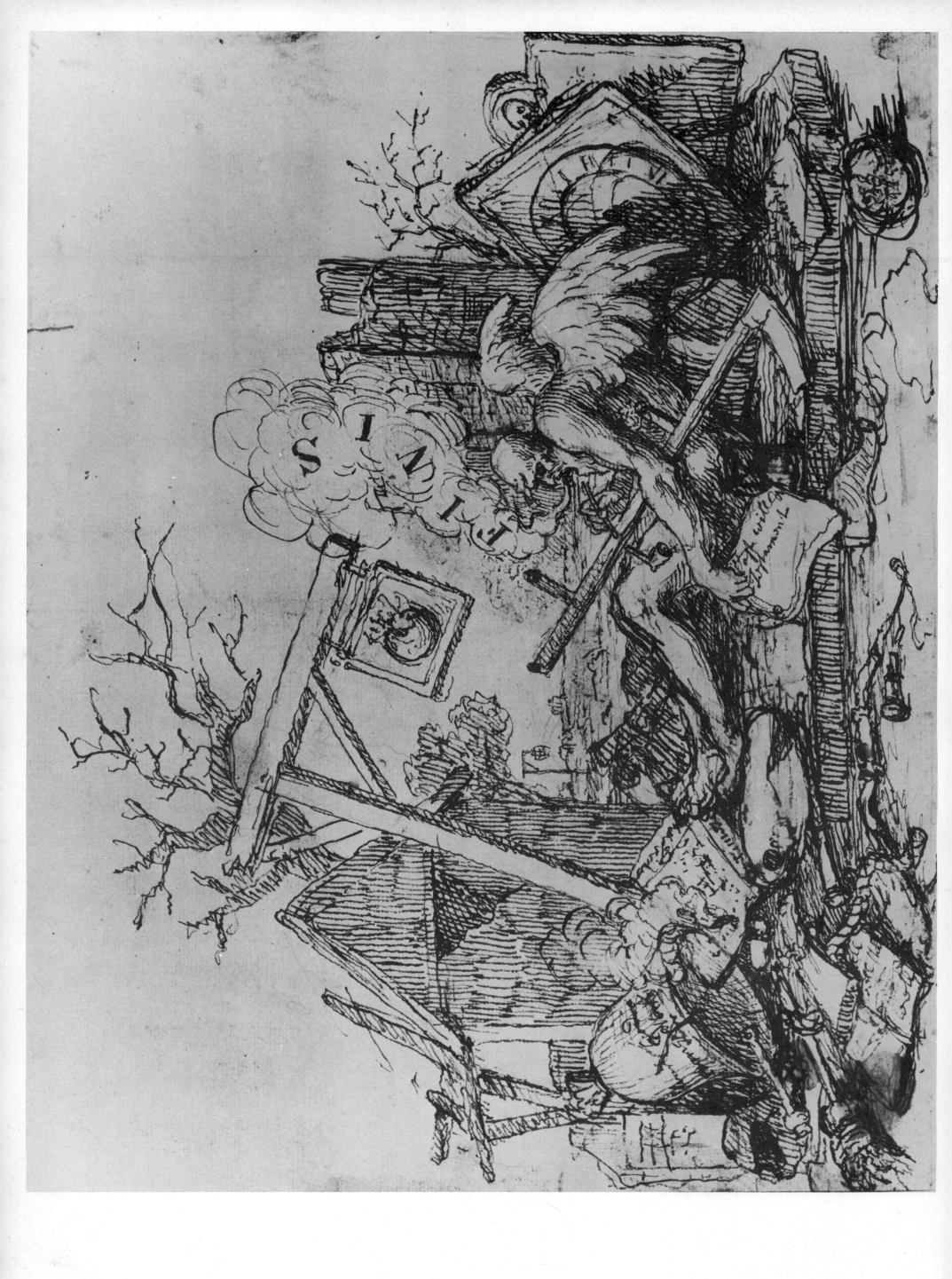

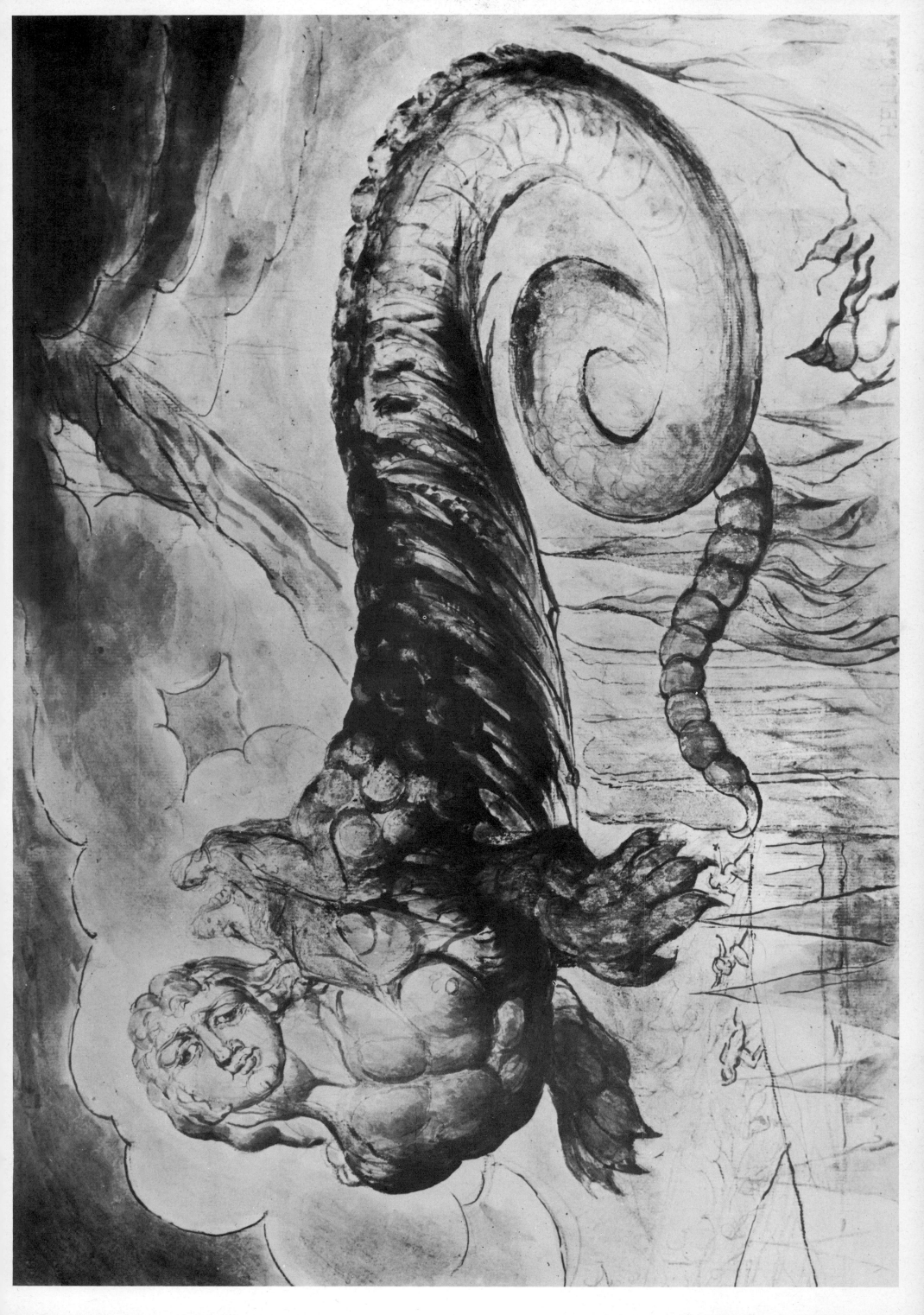

39

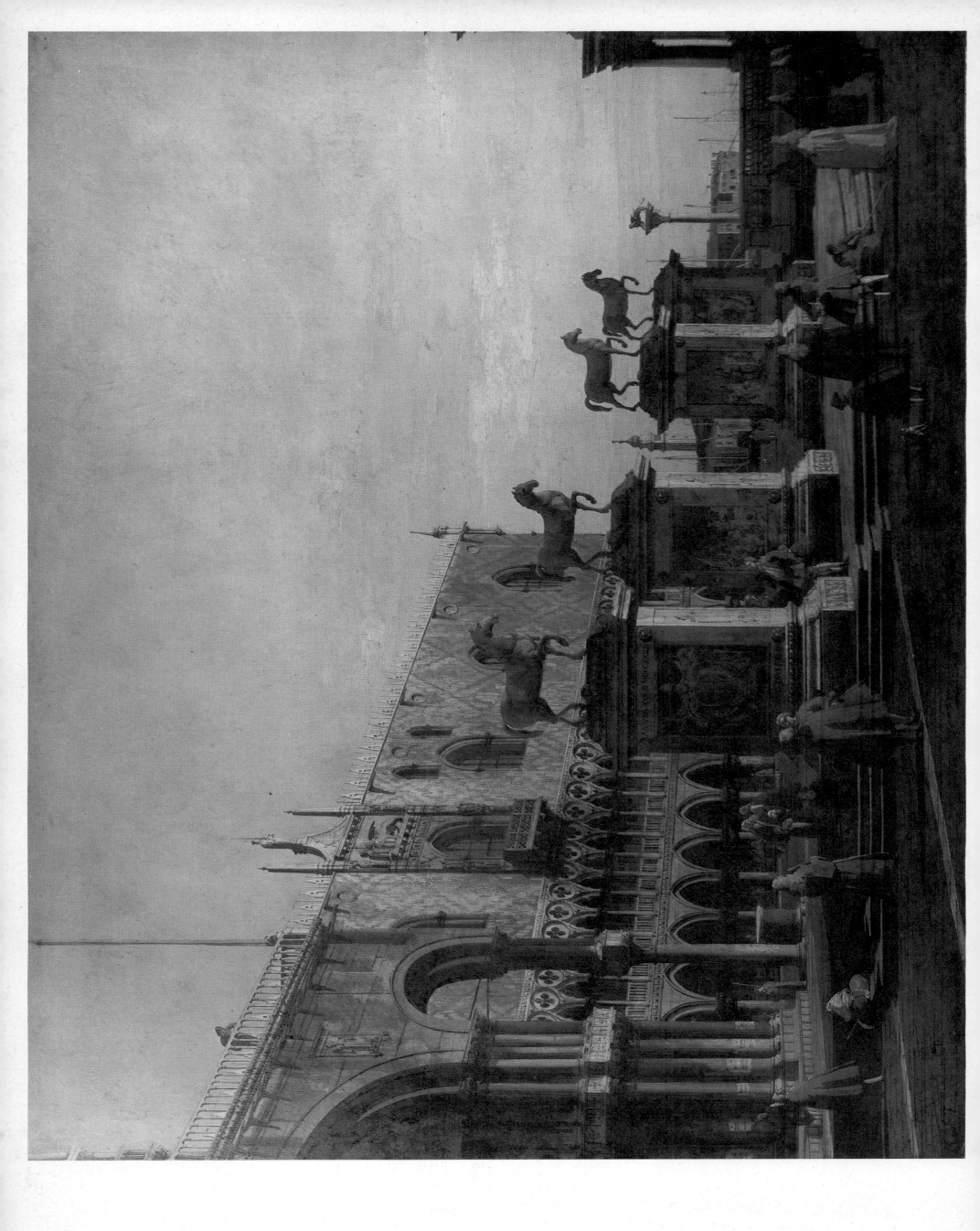

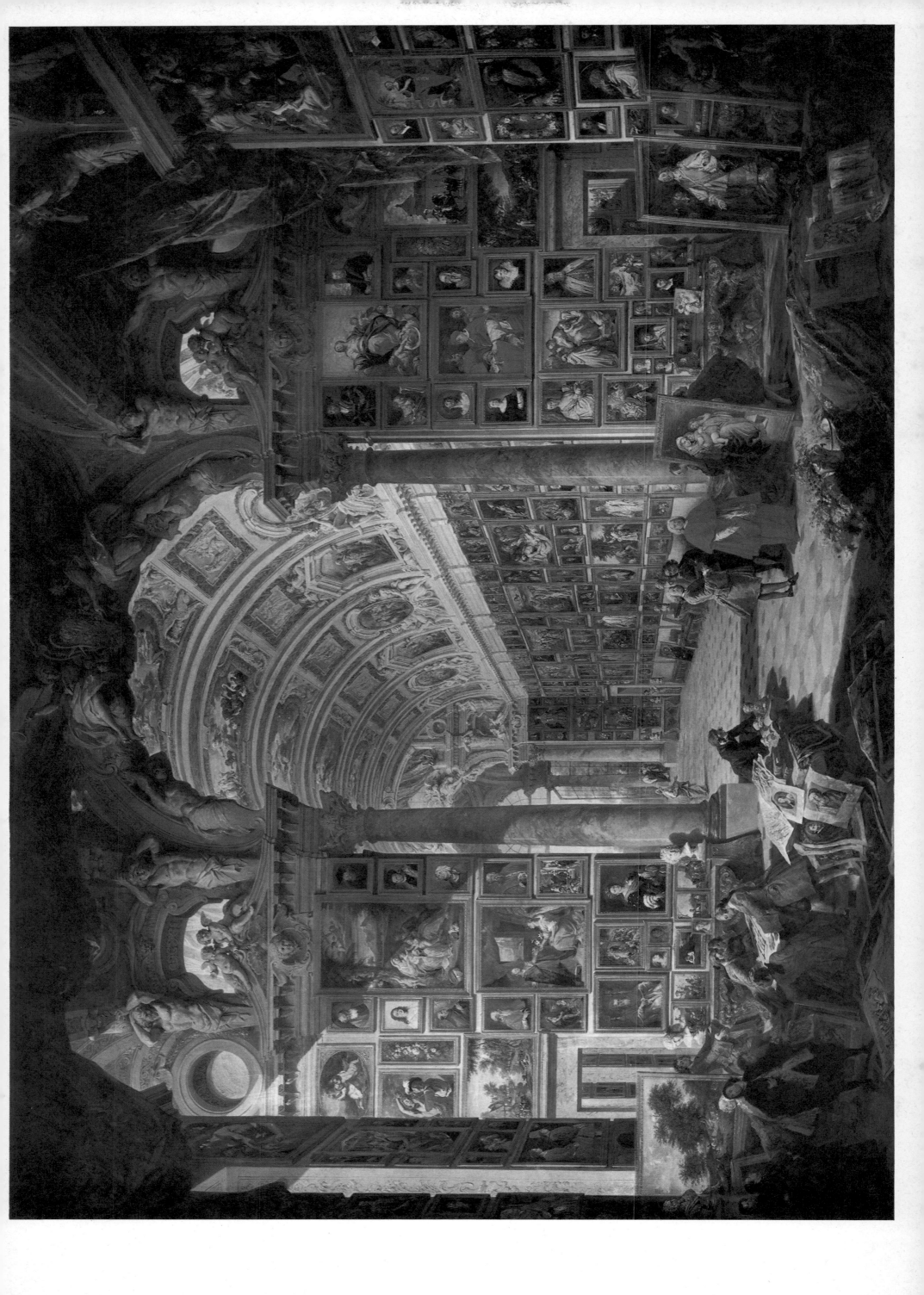

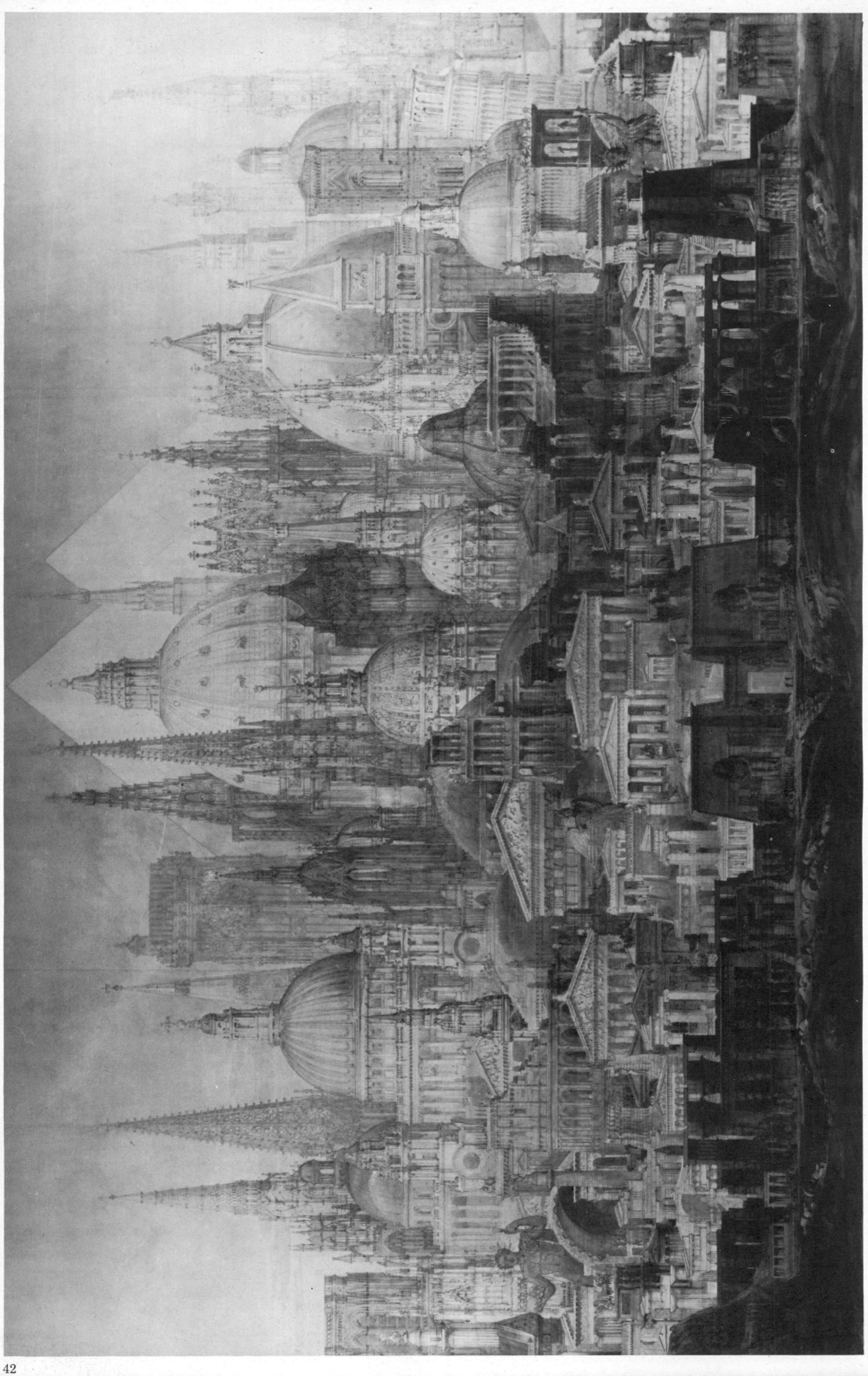

42

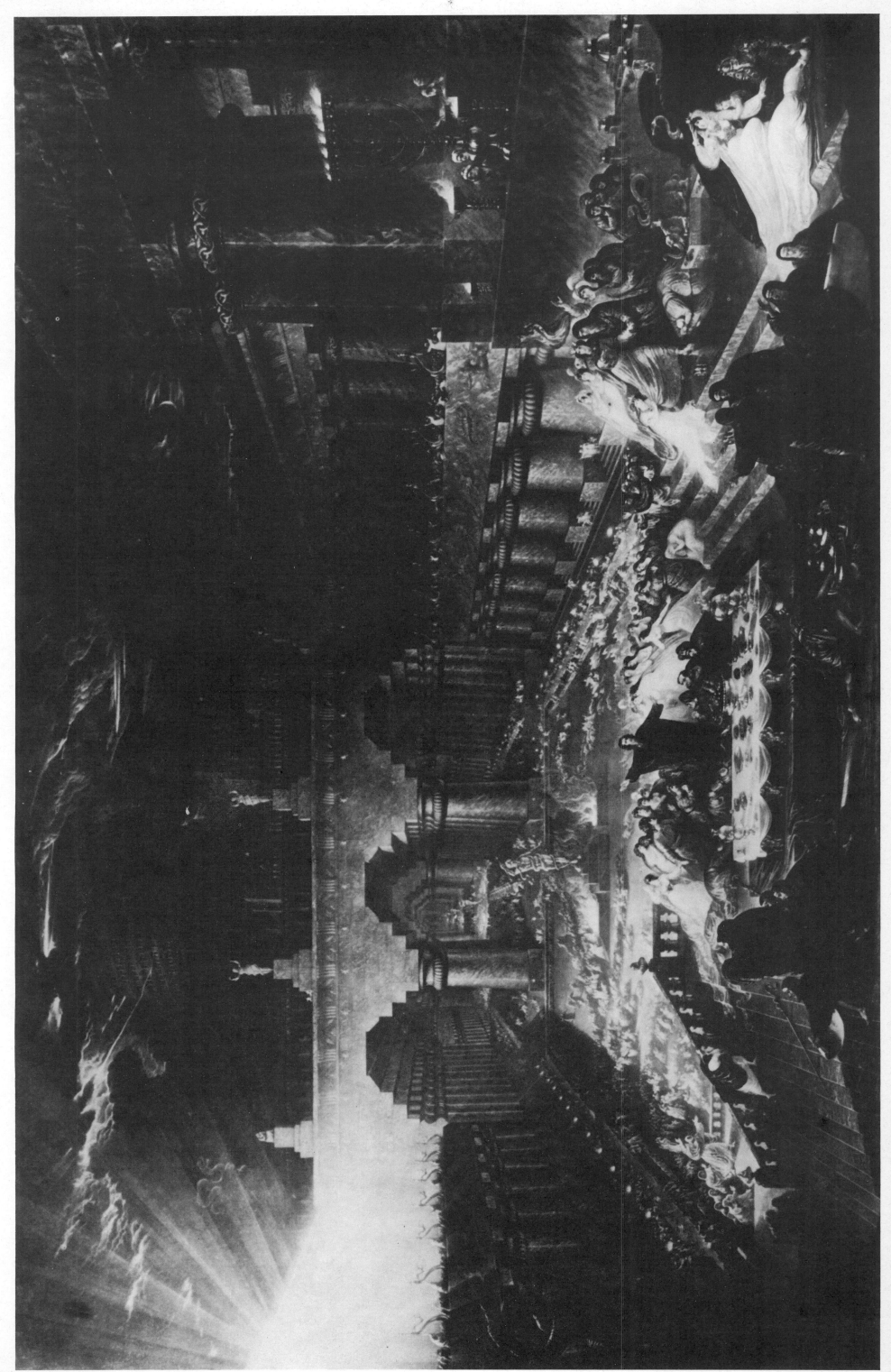

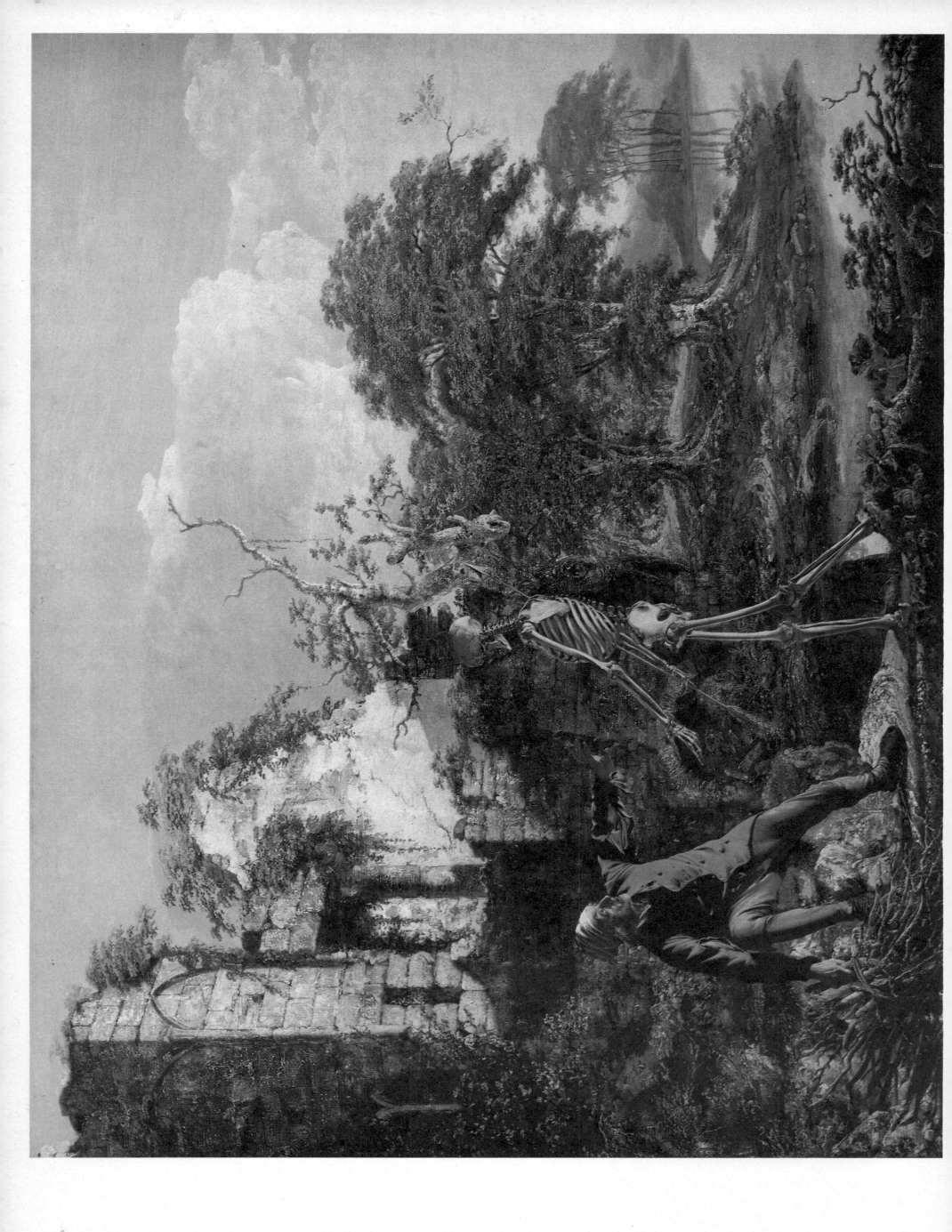

44

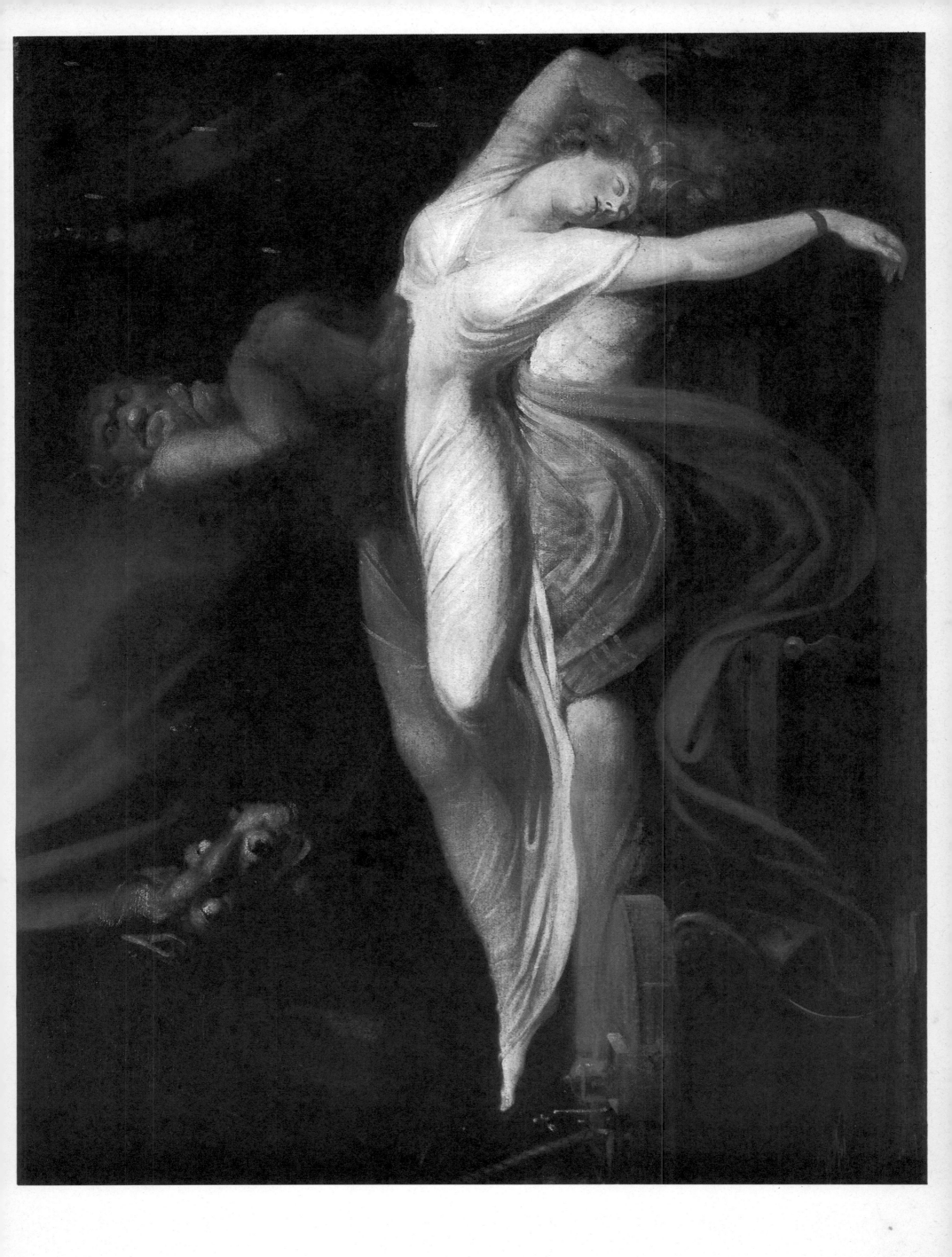

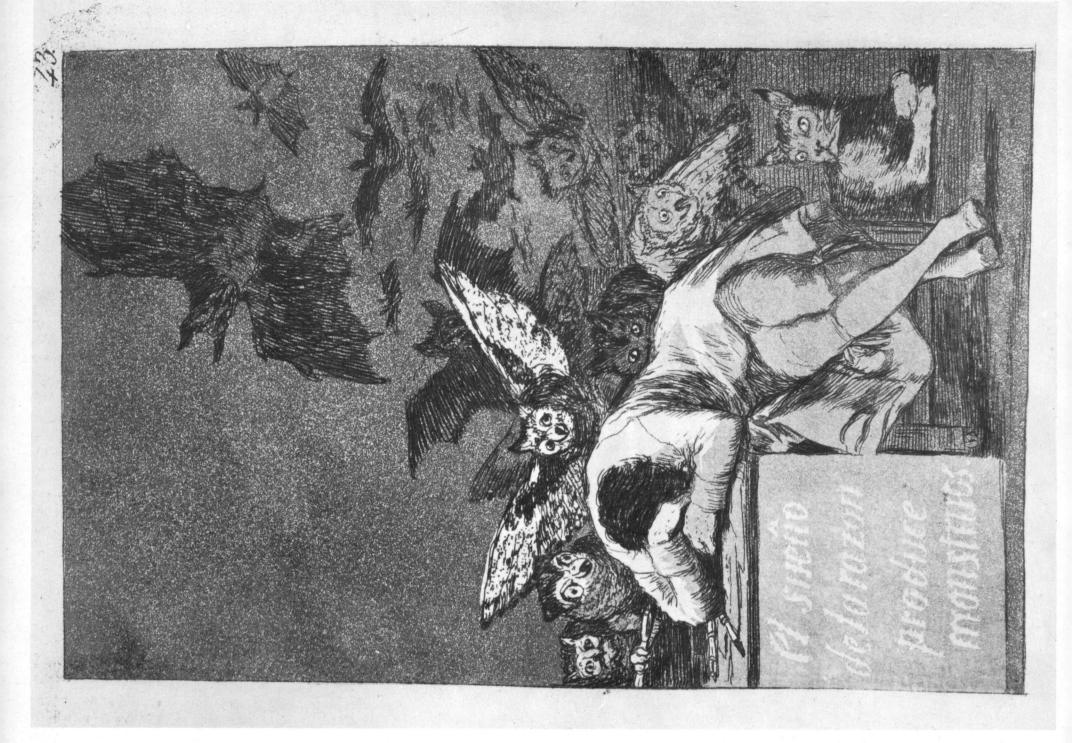

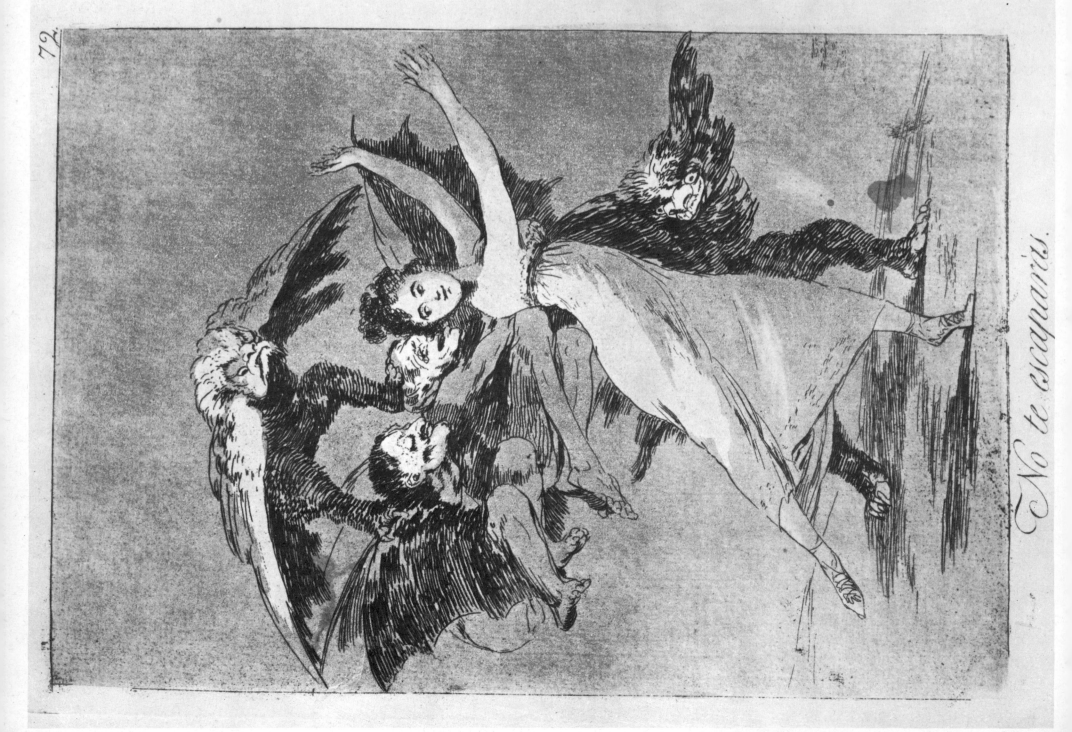

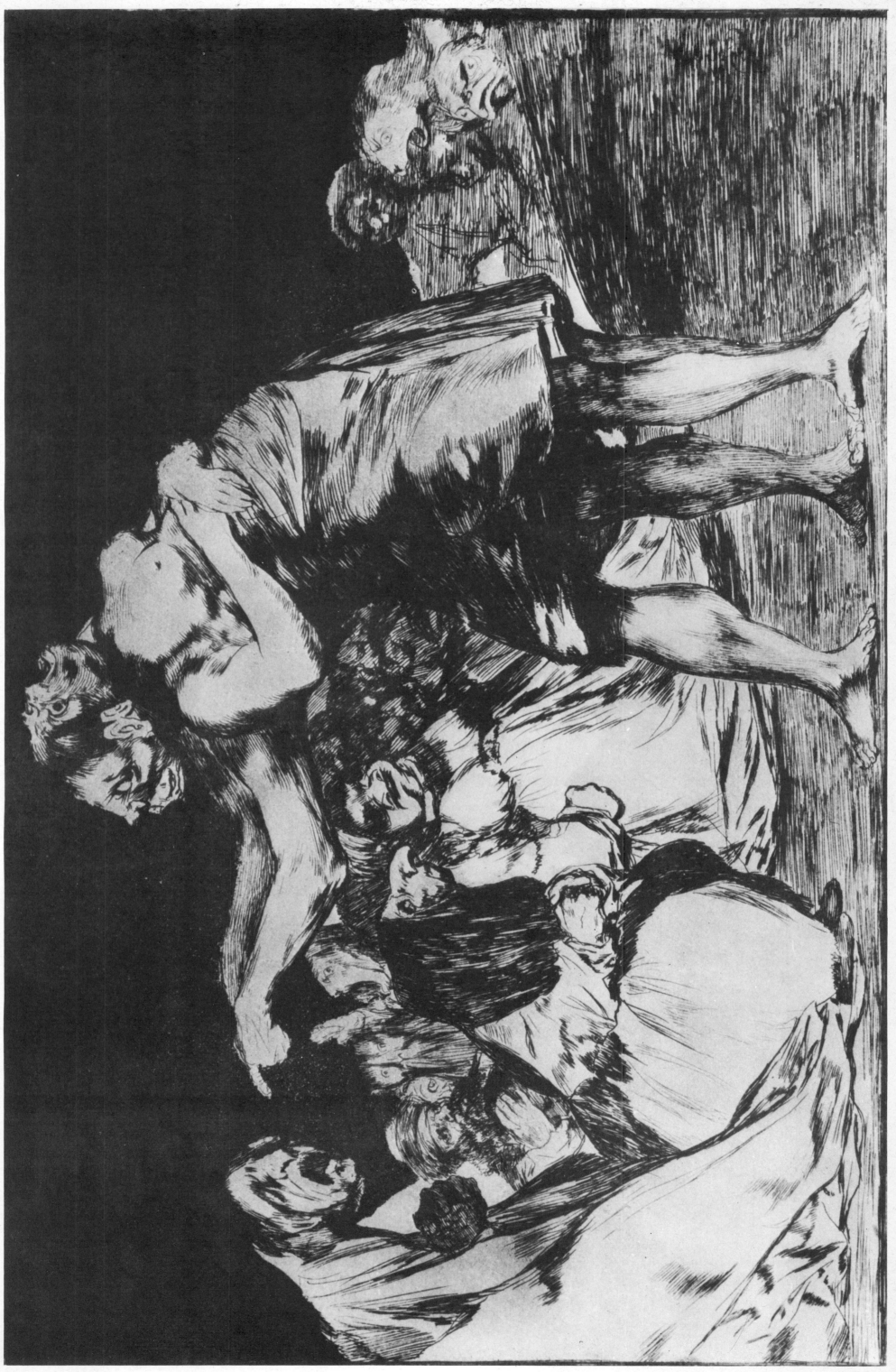

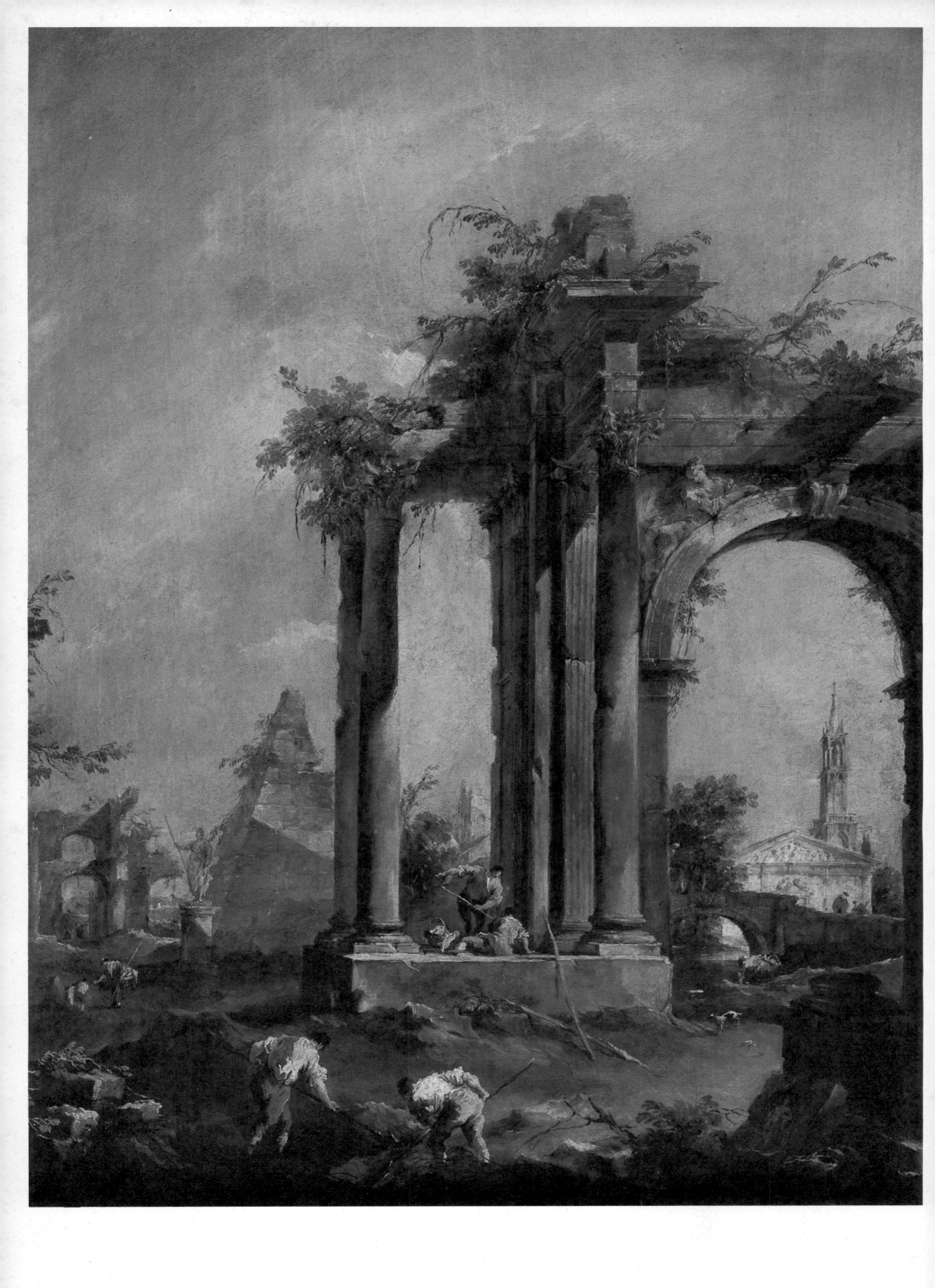

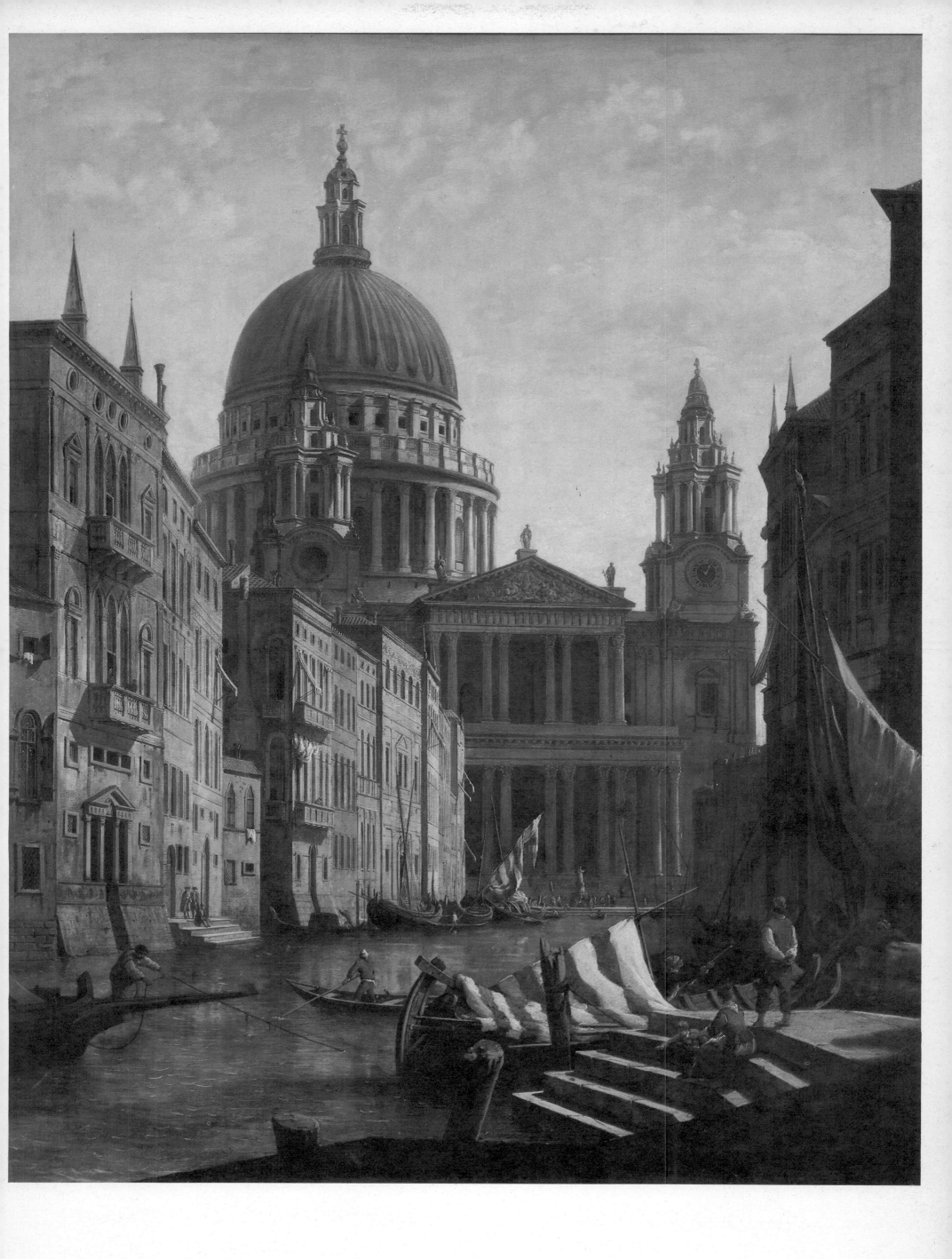

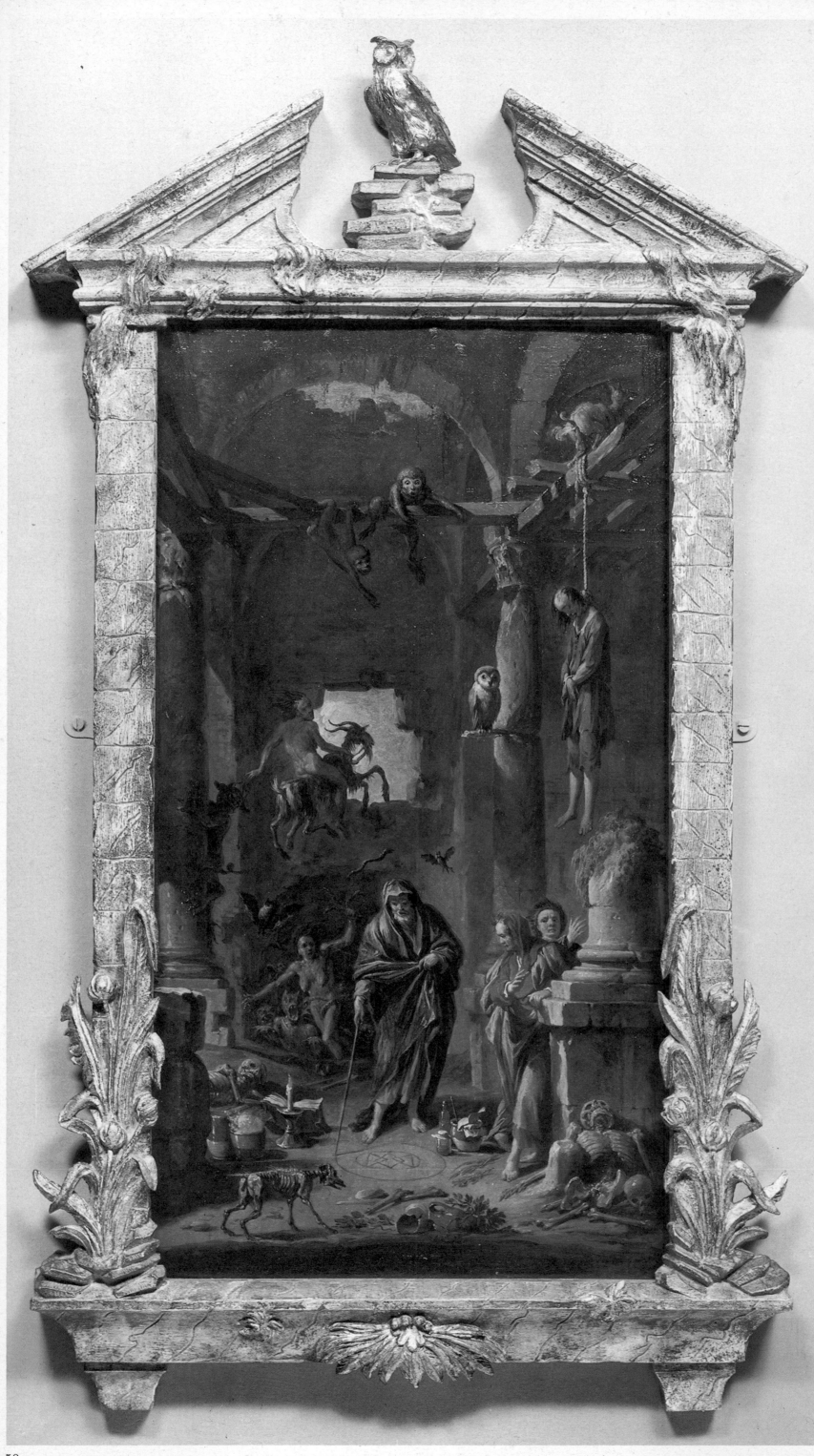

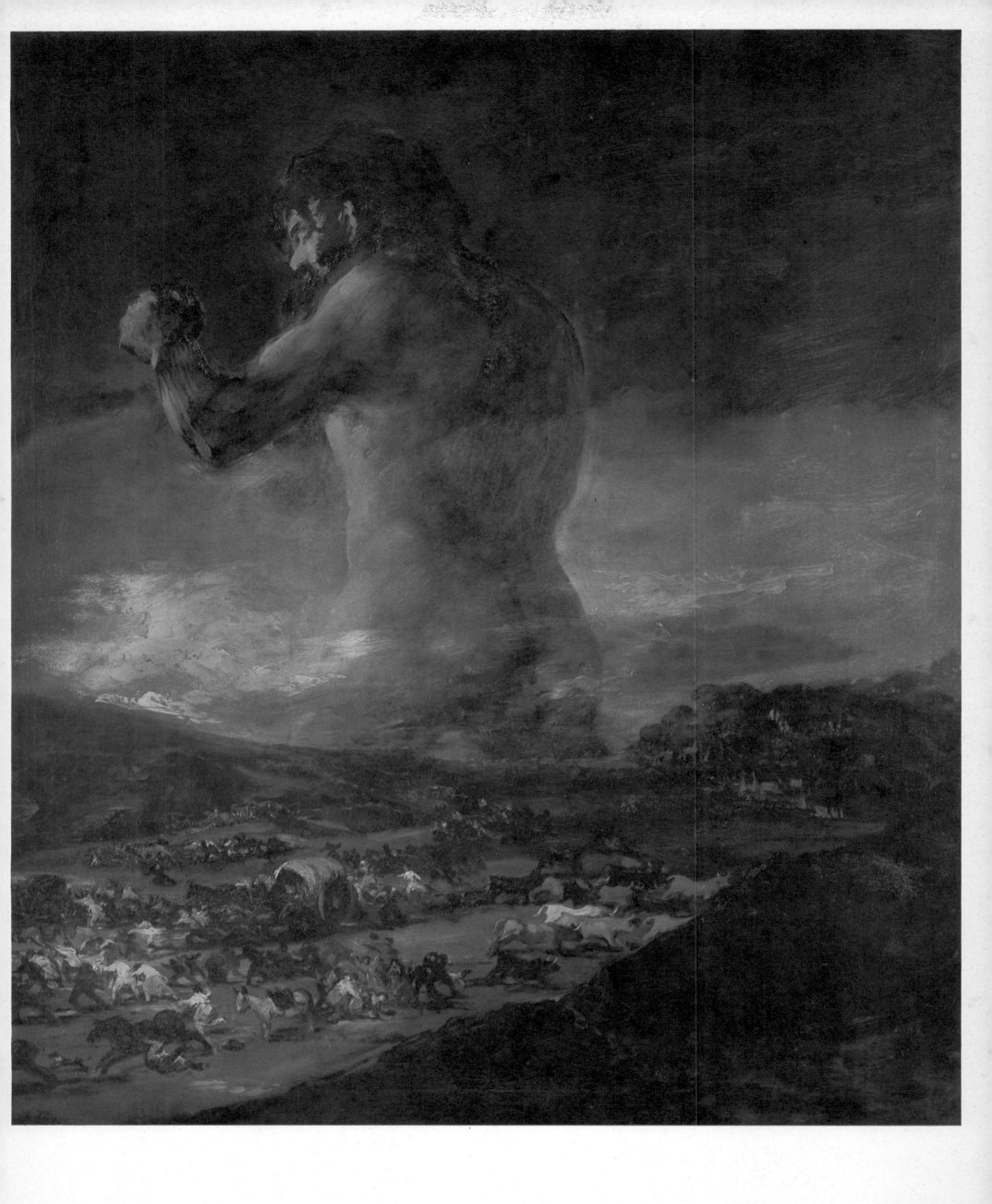

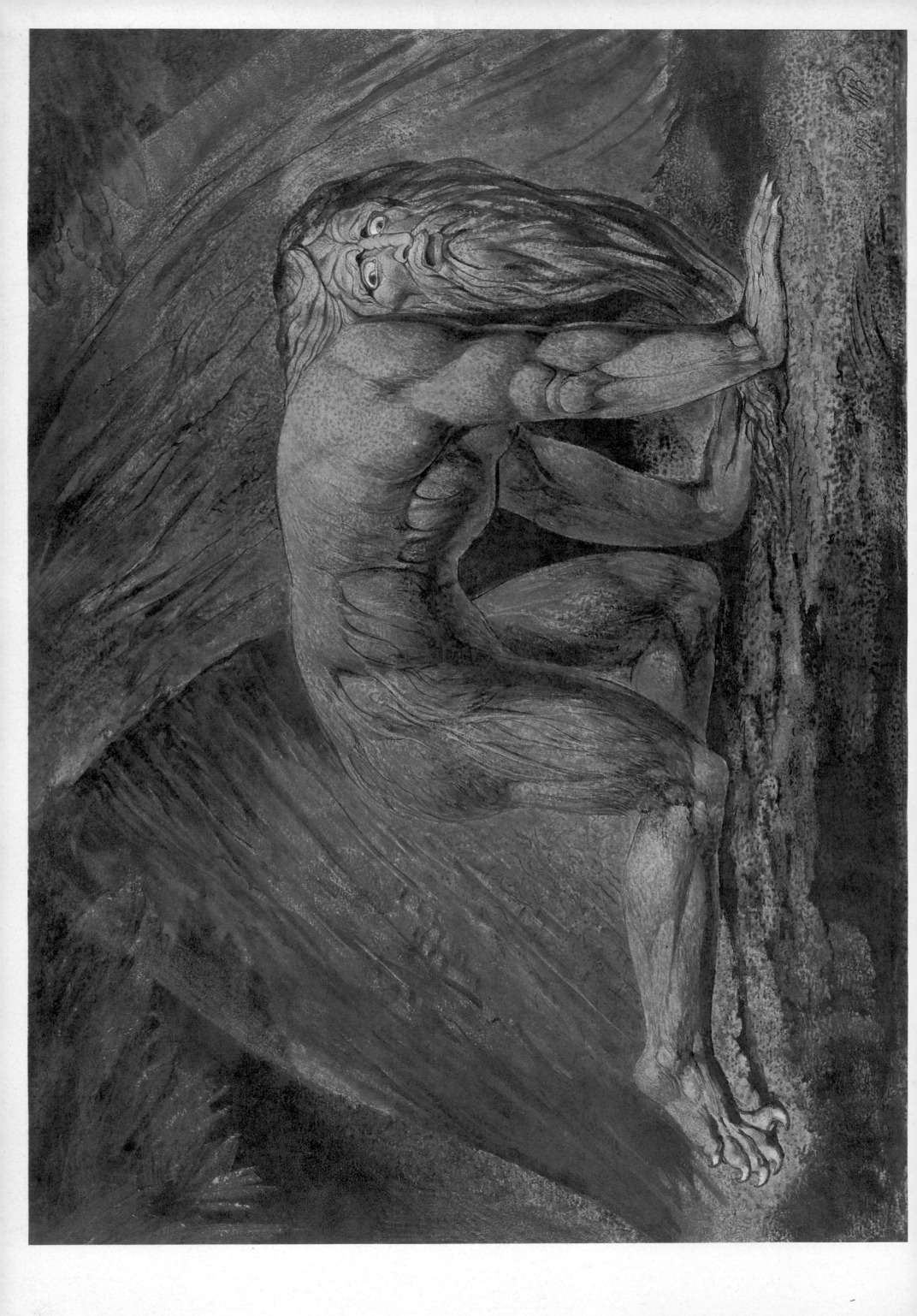

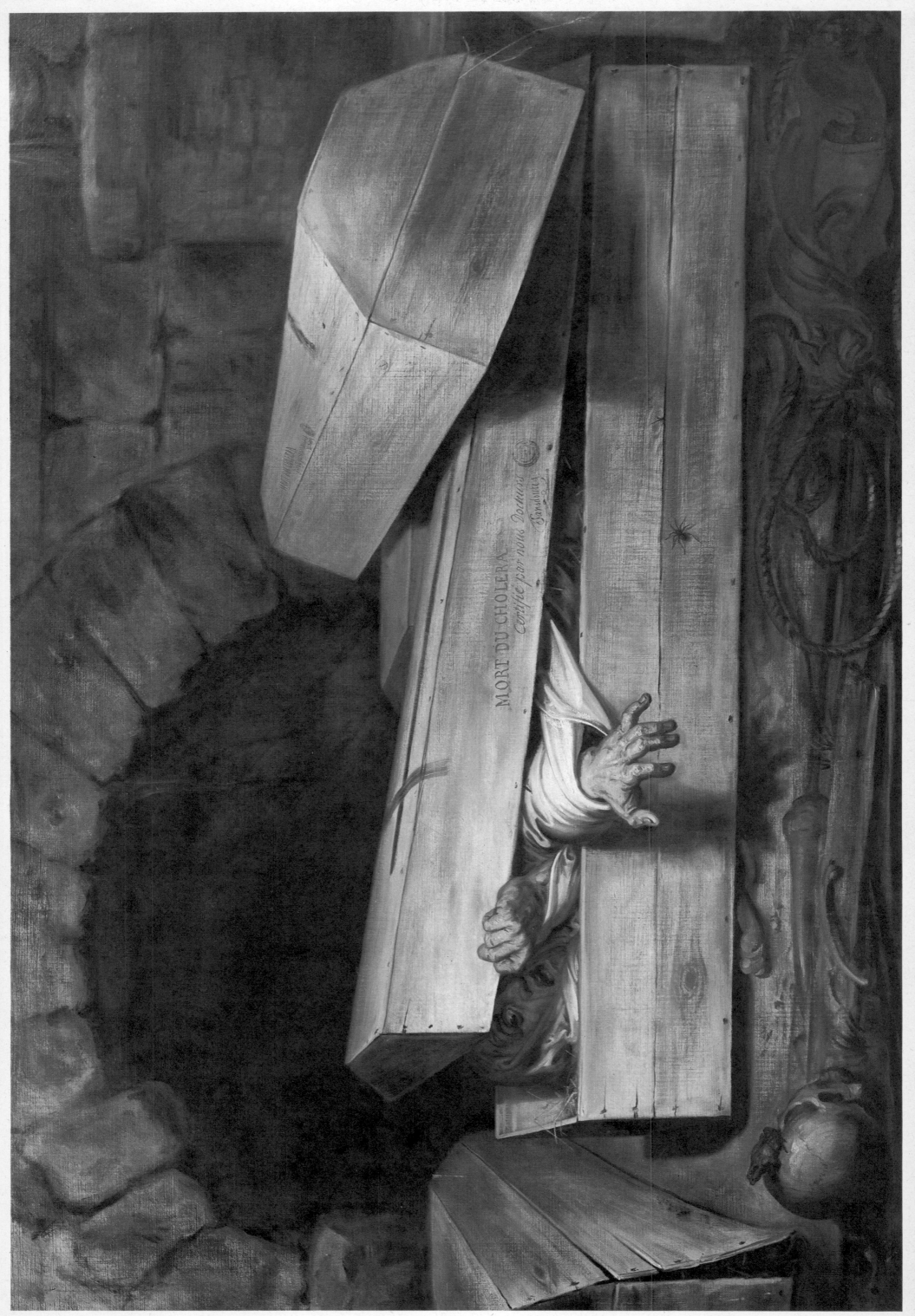

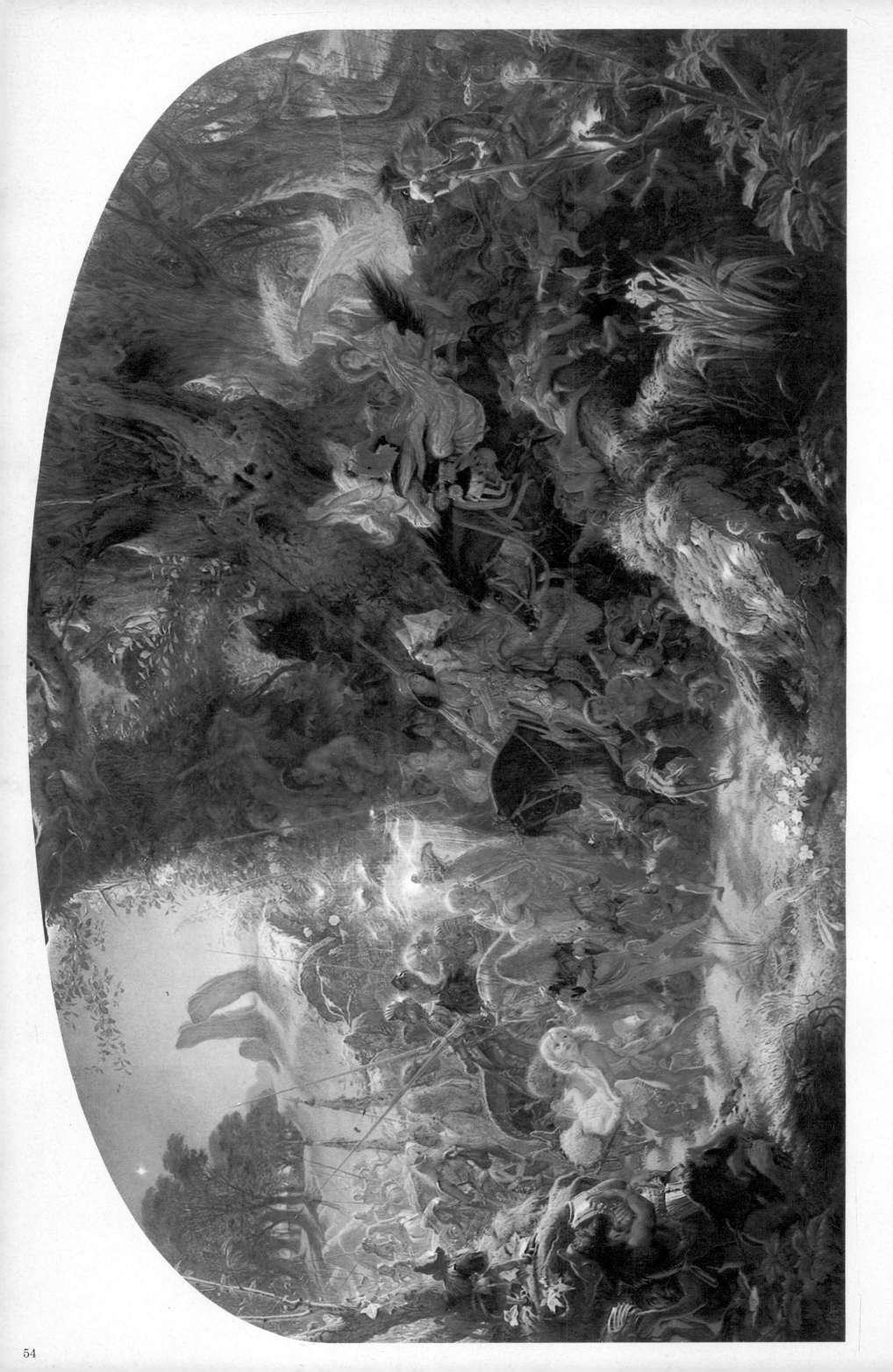

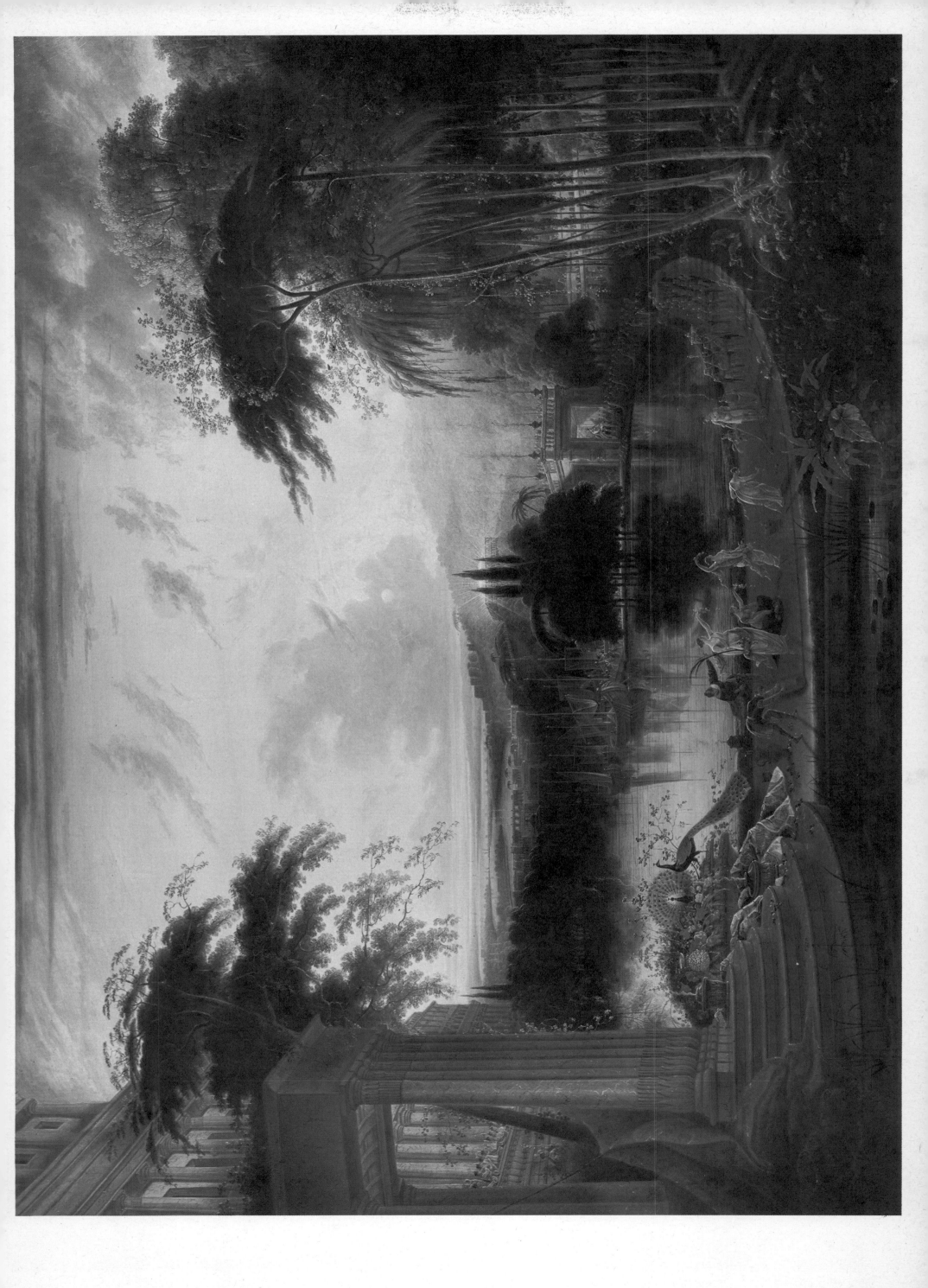

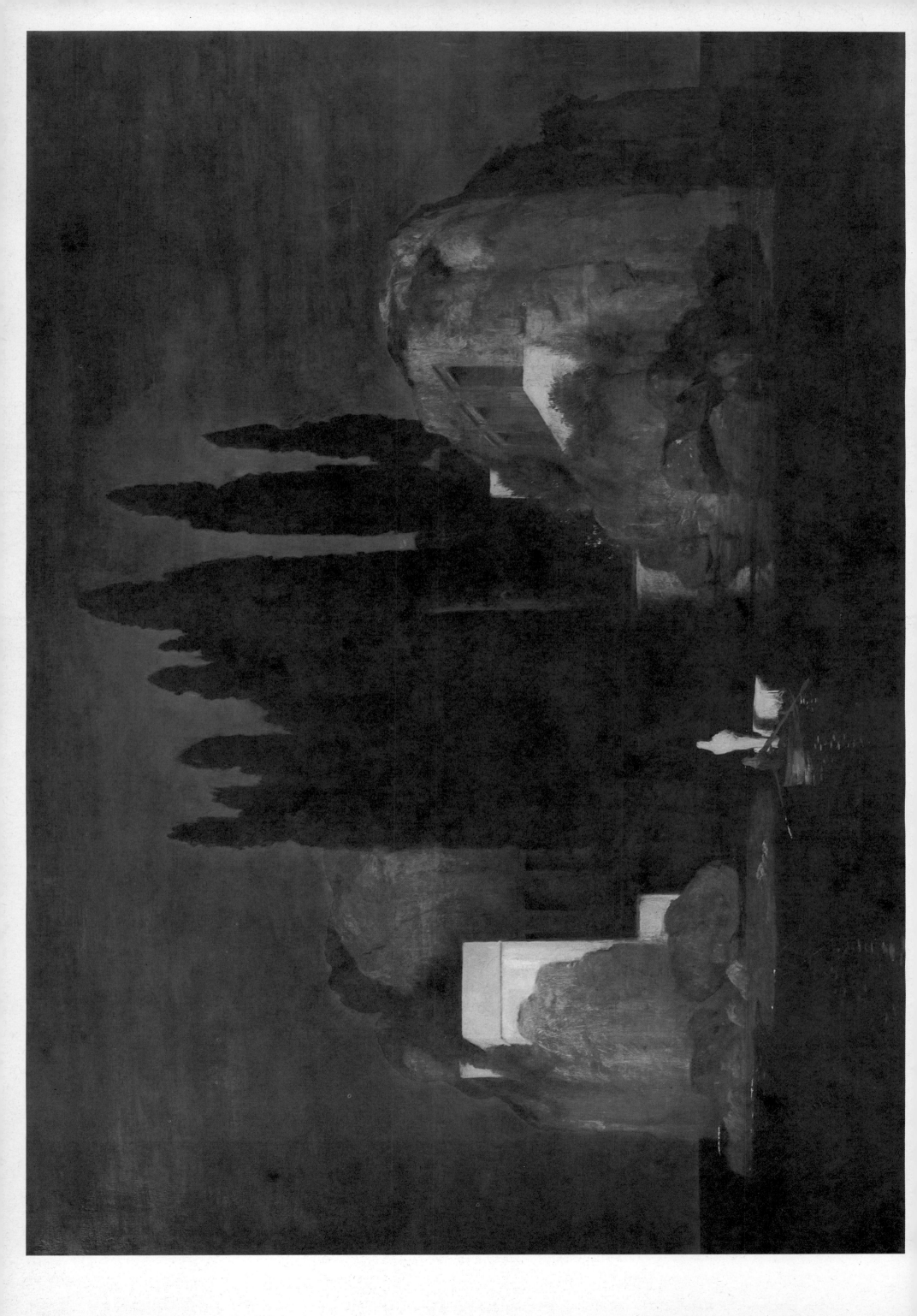

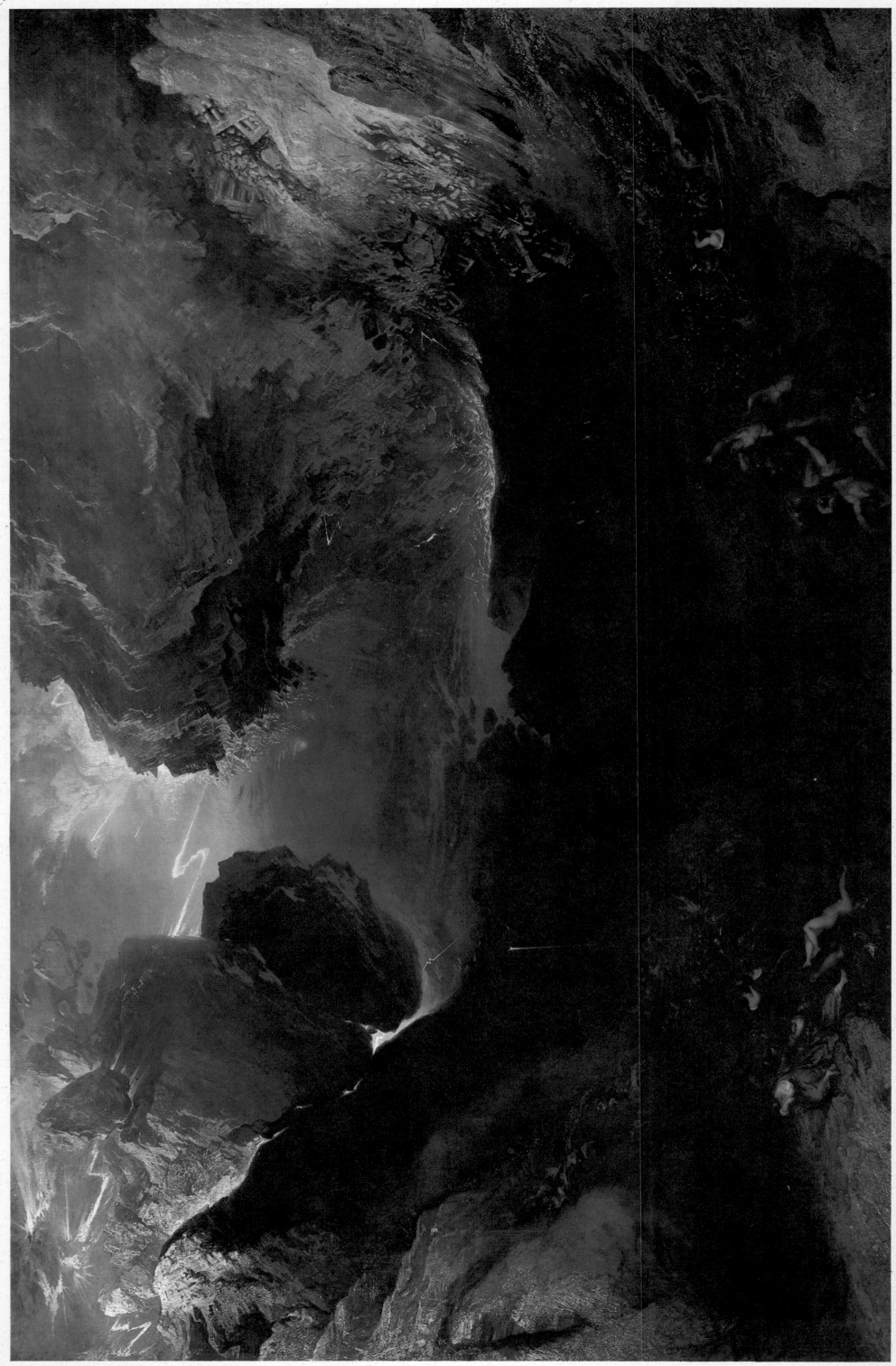

57

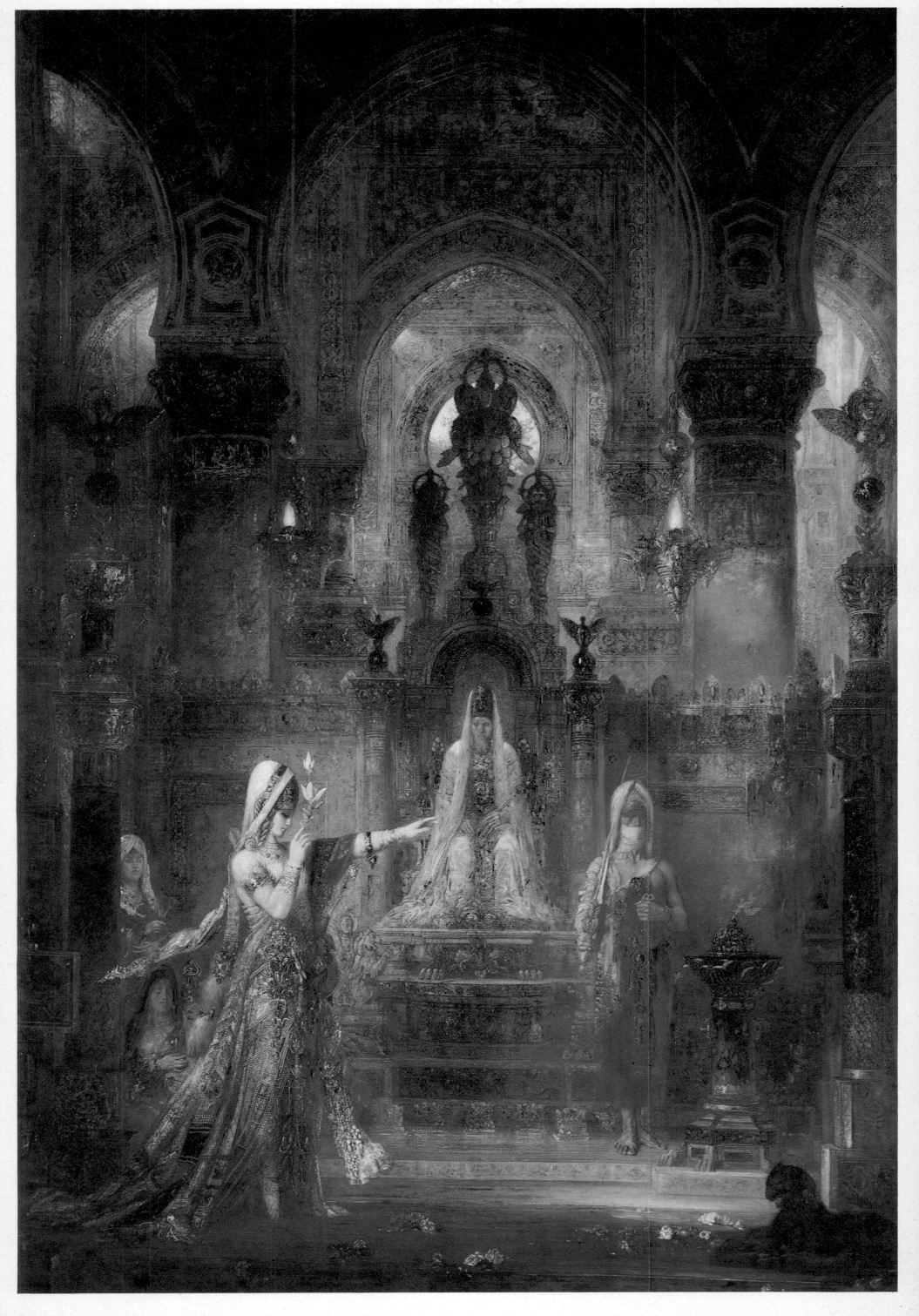

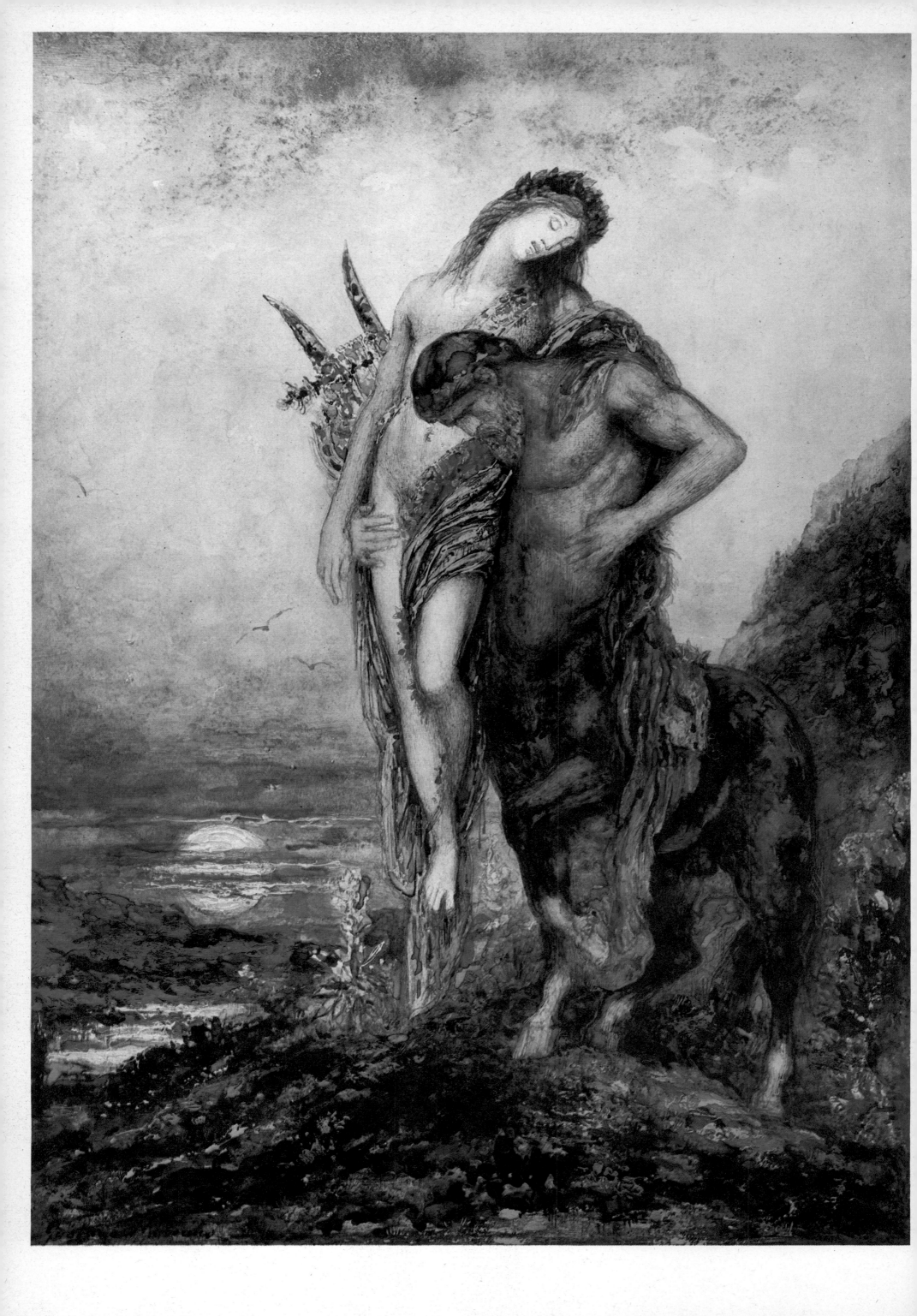

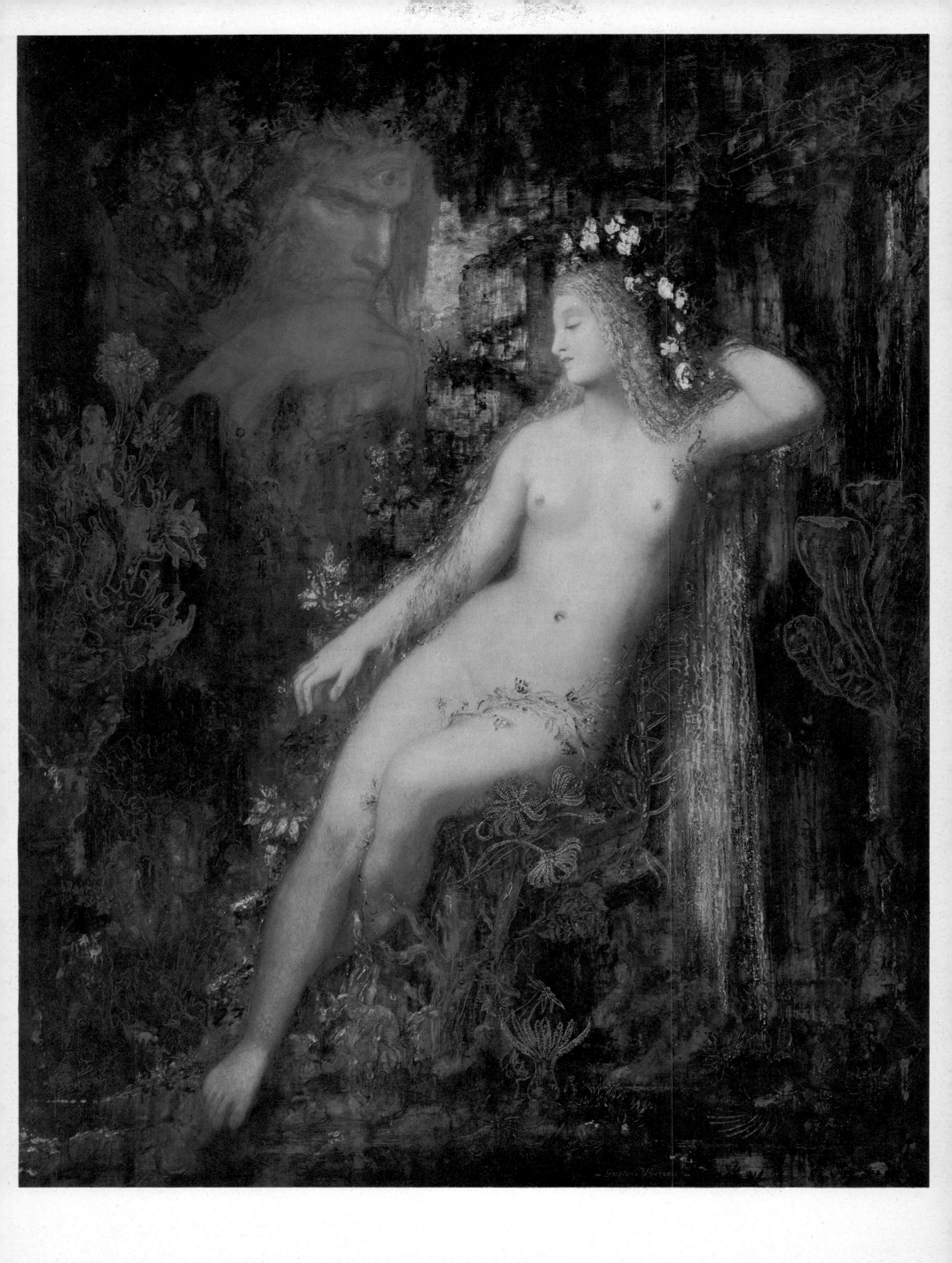

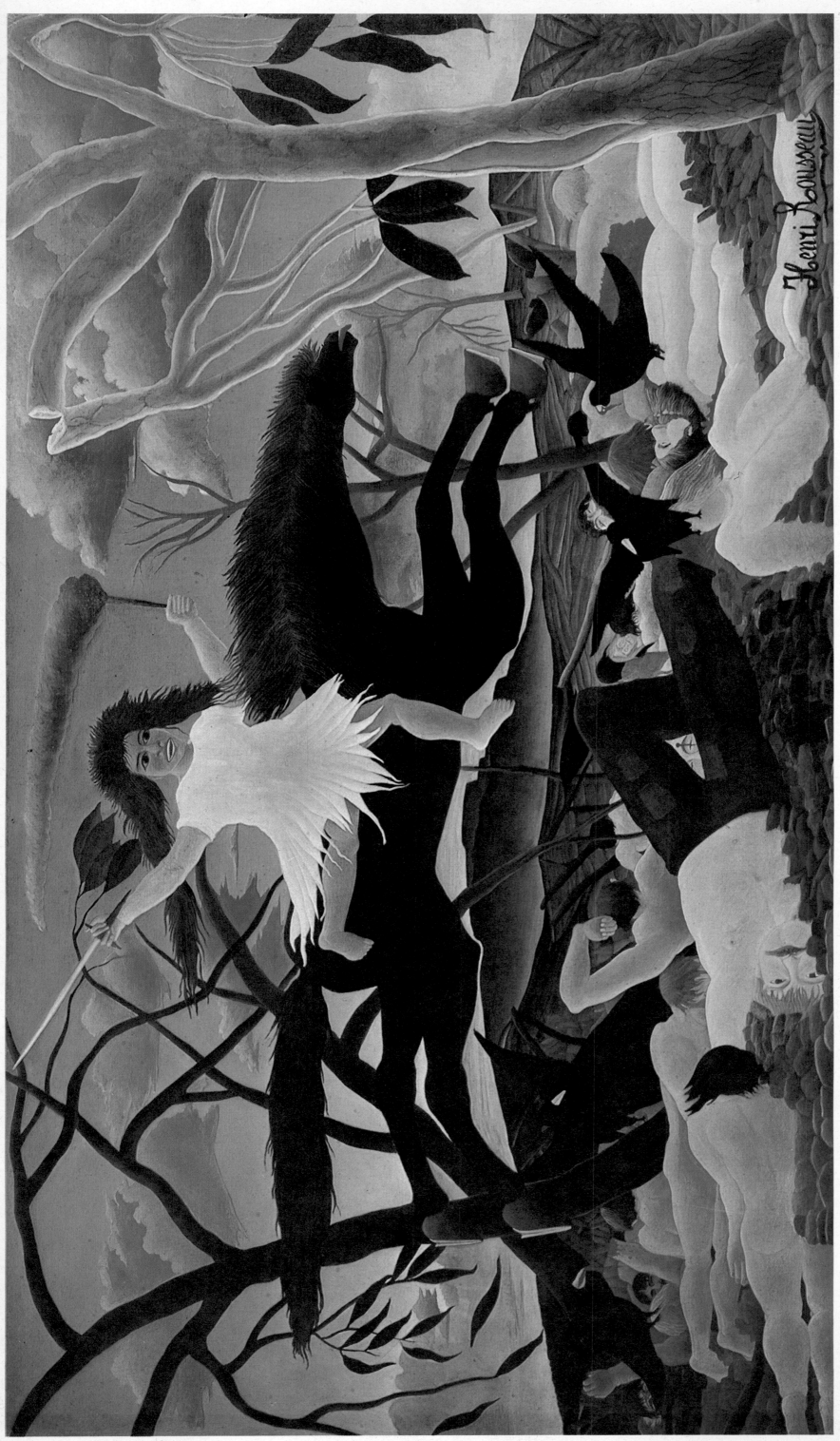

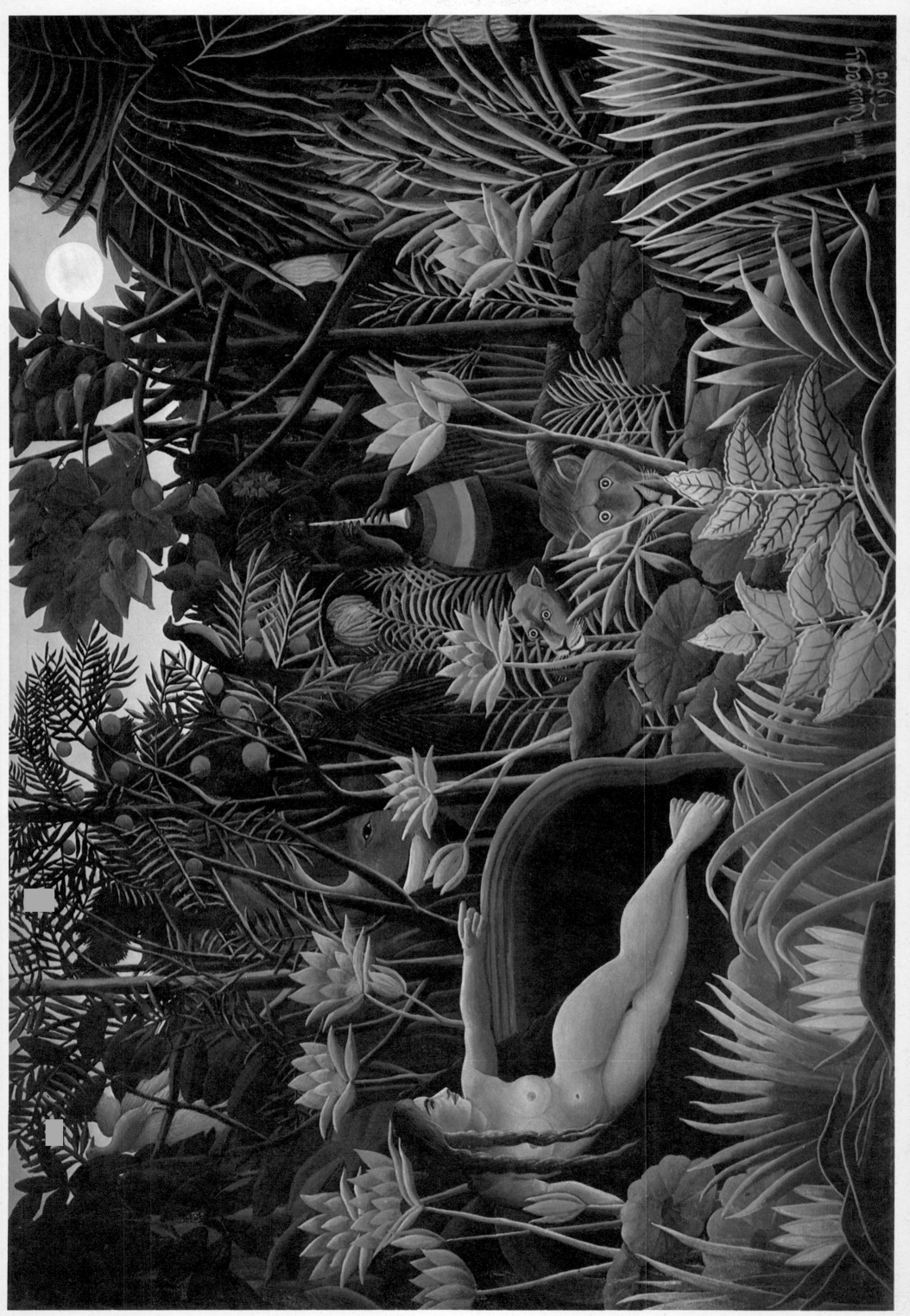

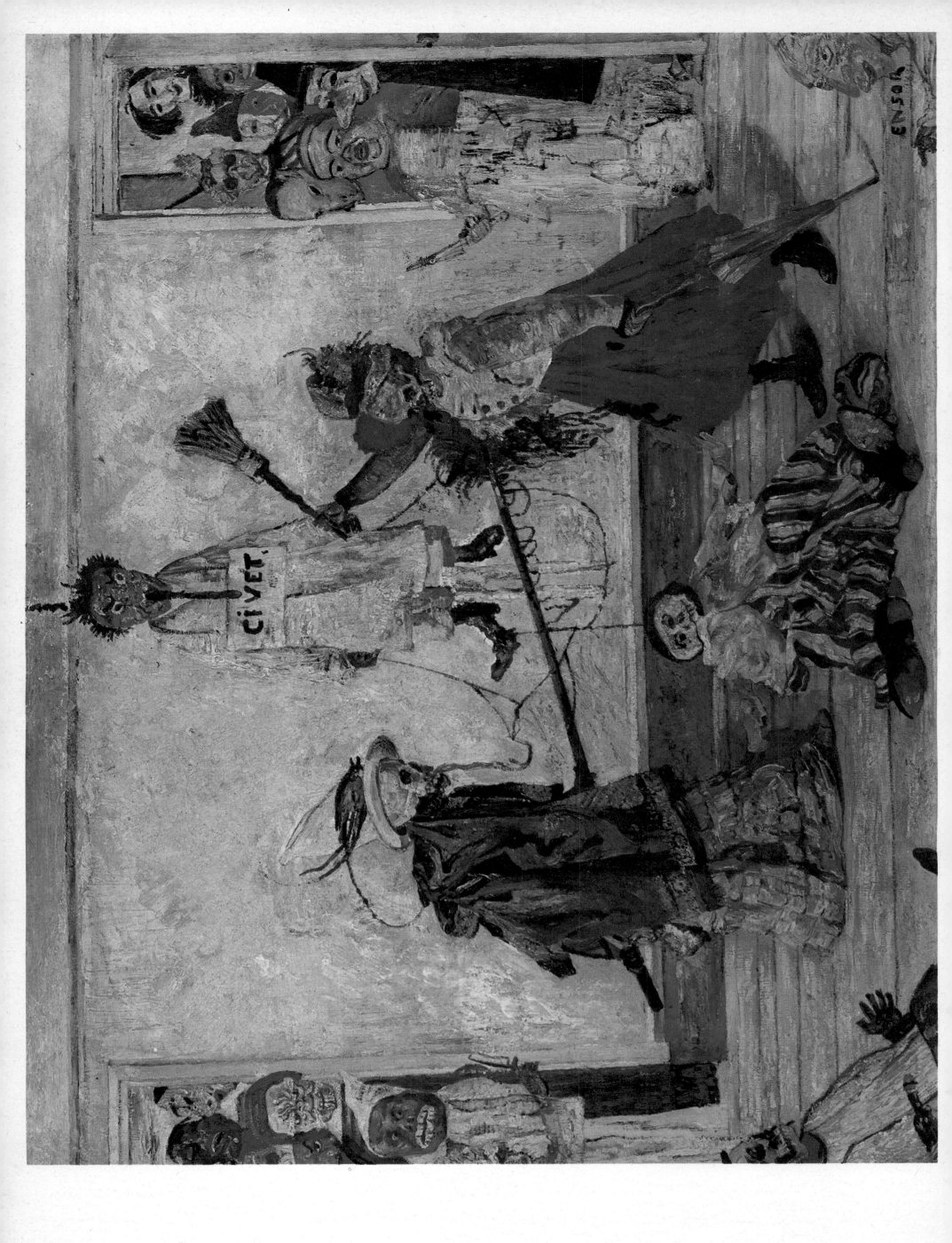

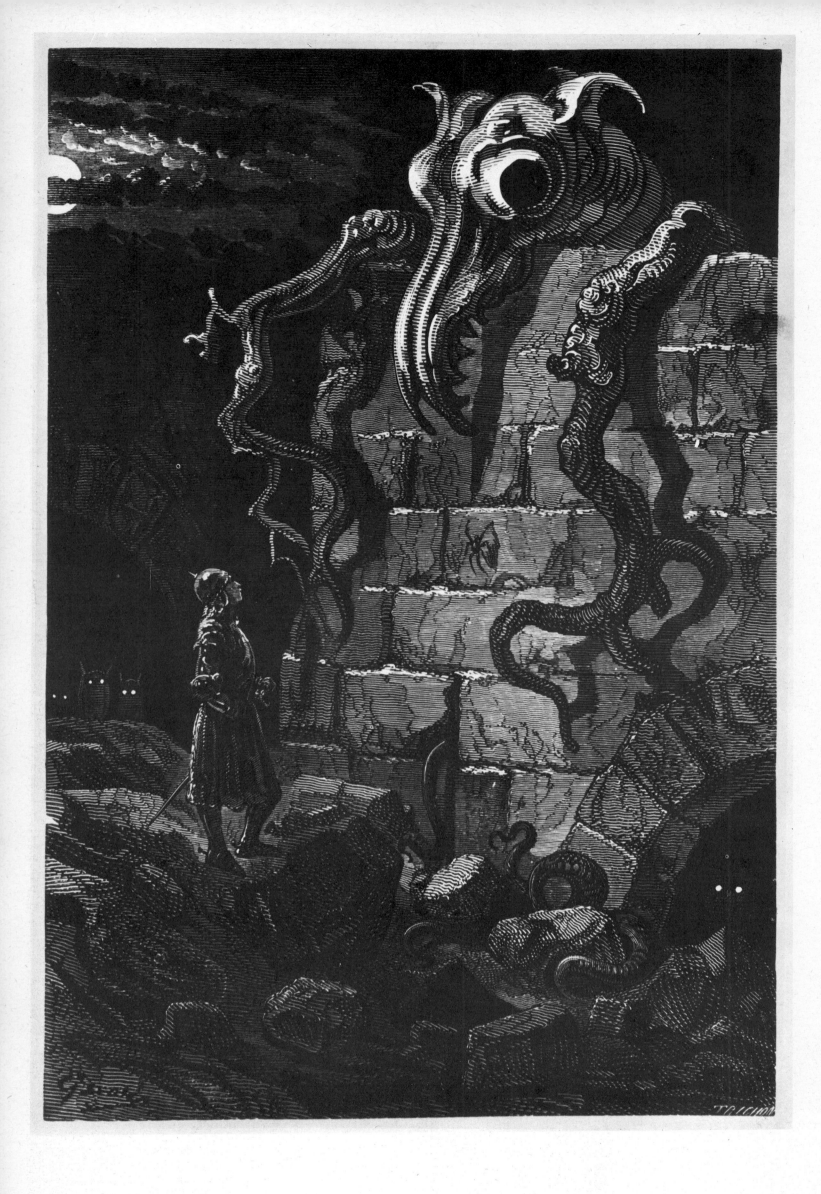

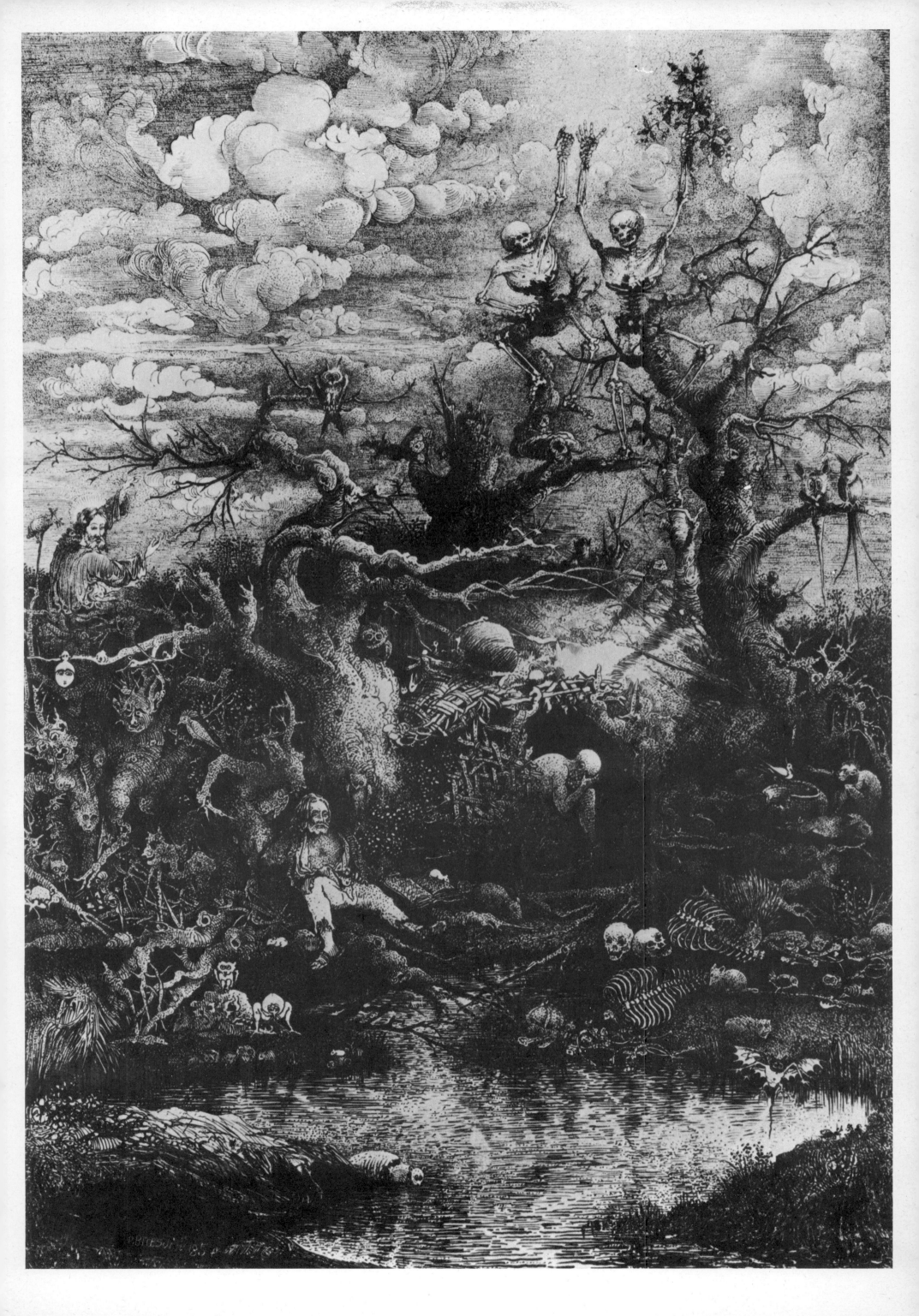

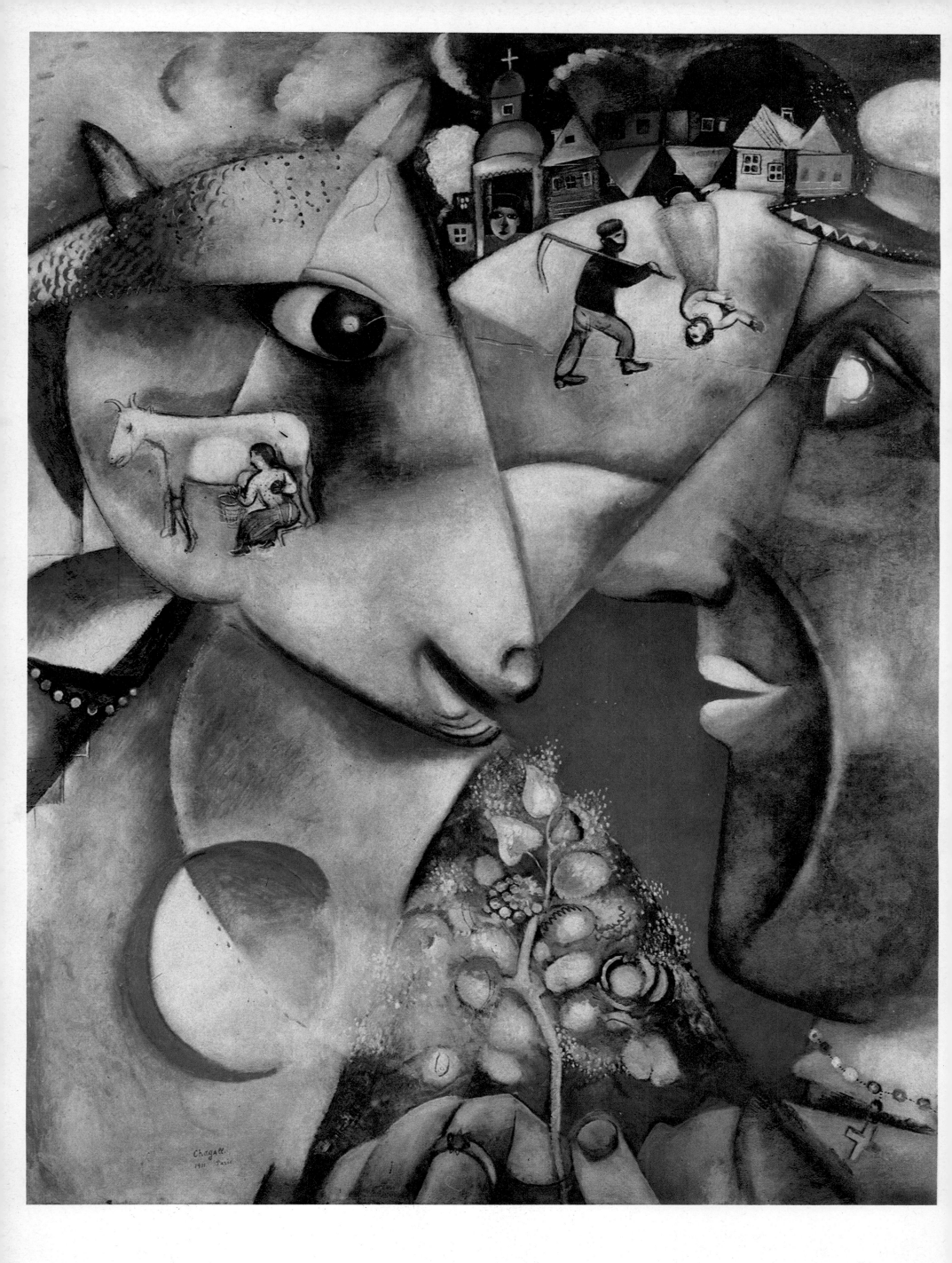

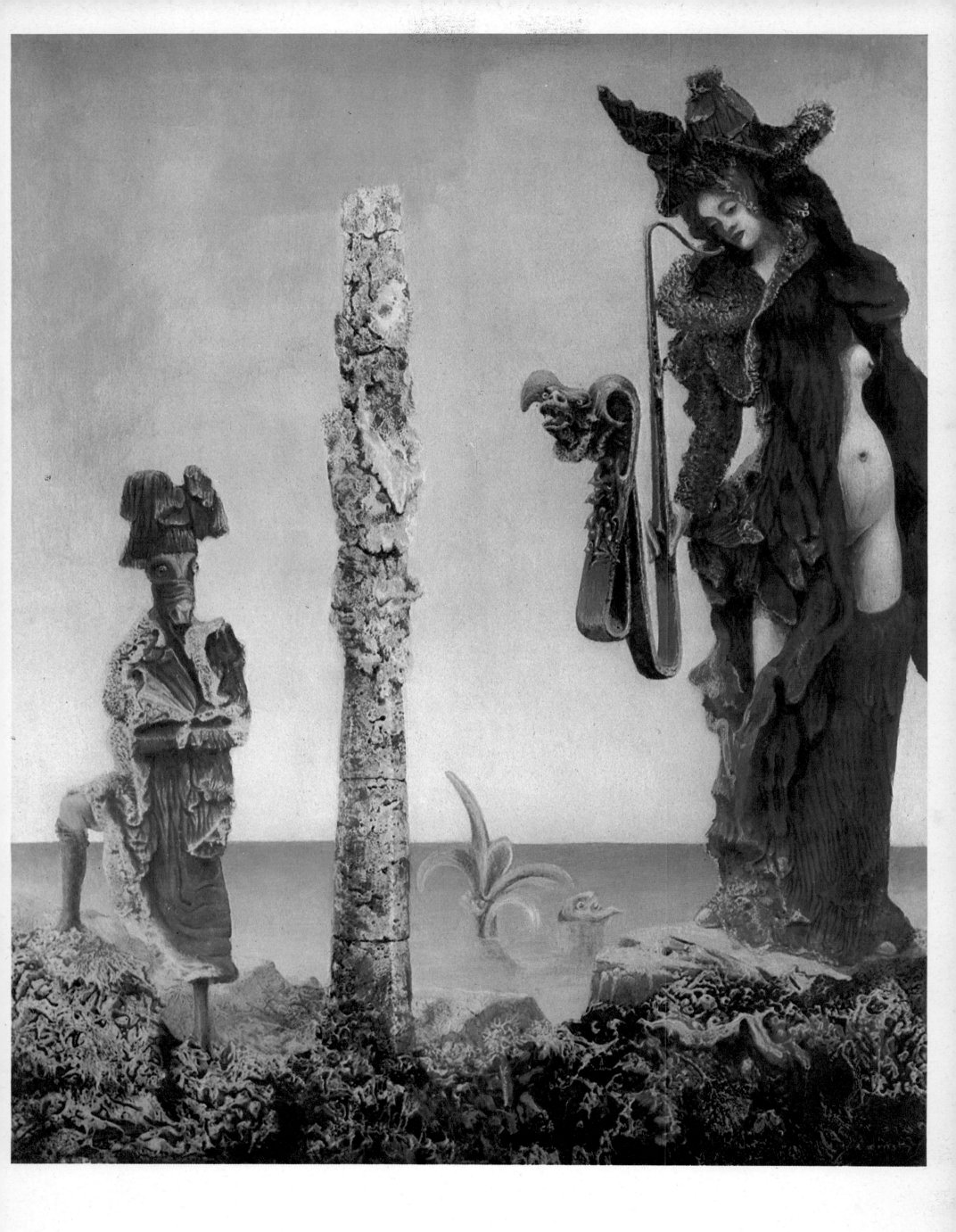

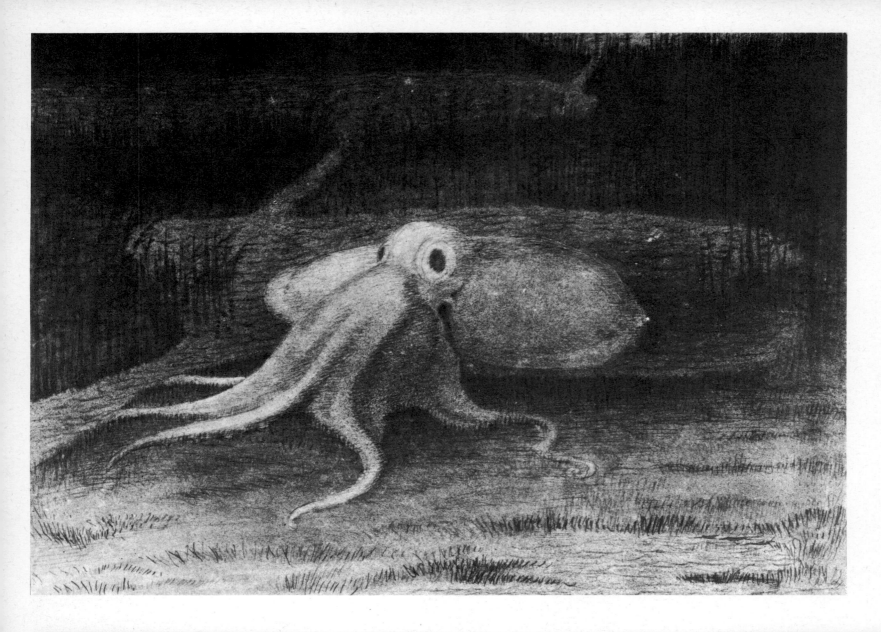

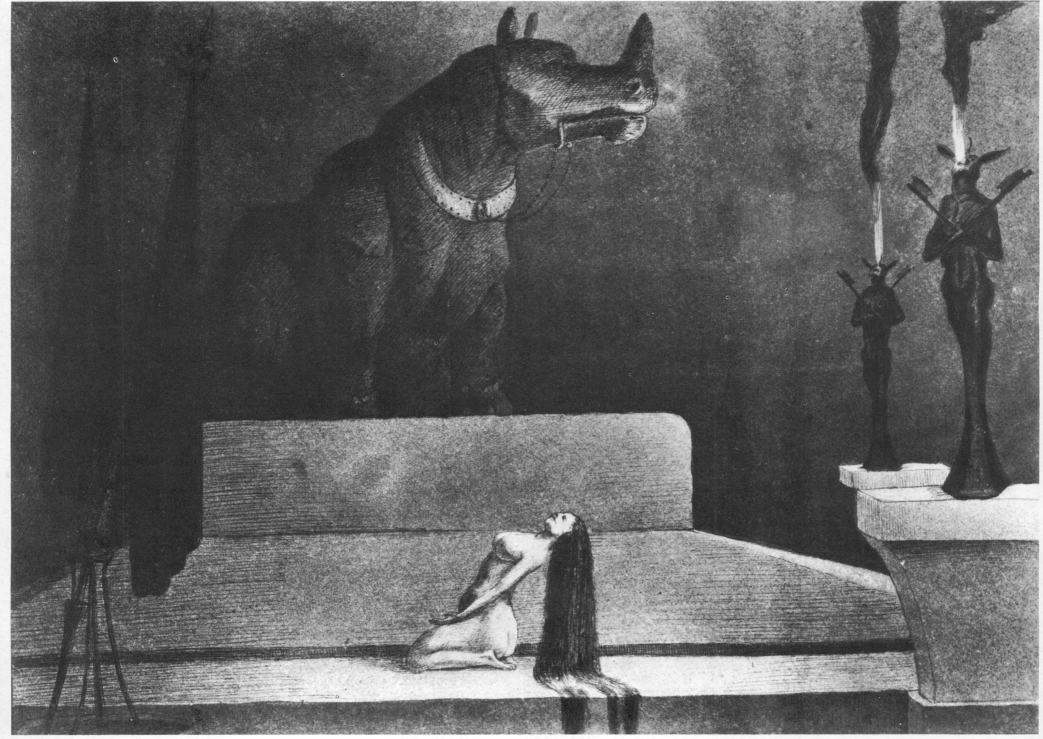

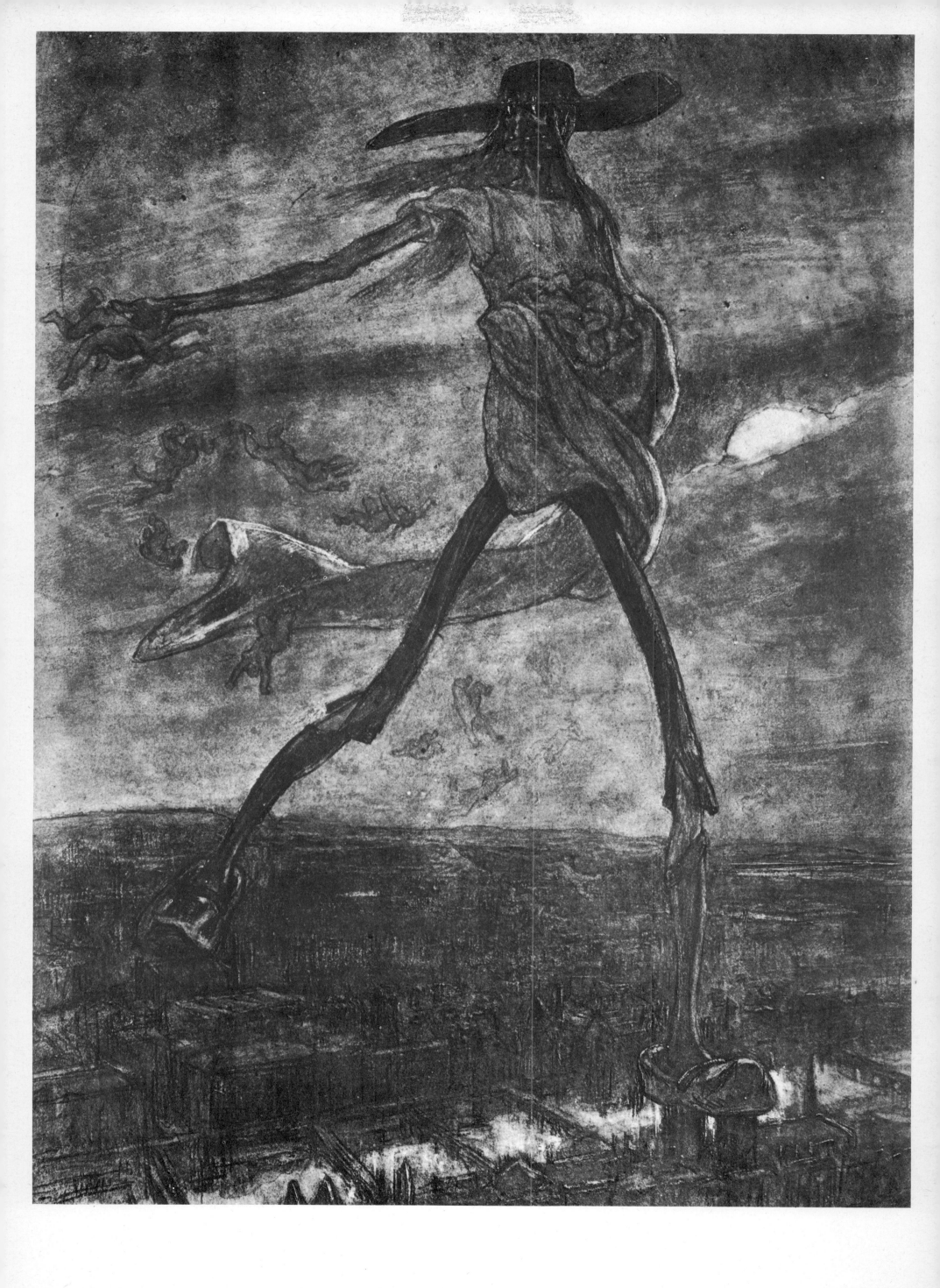

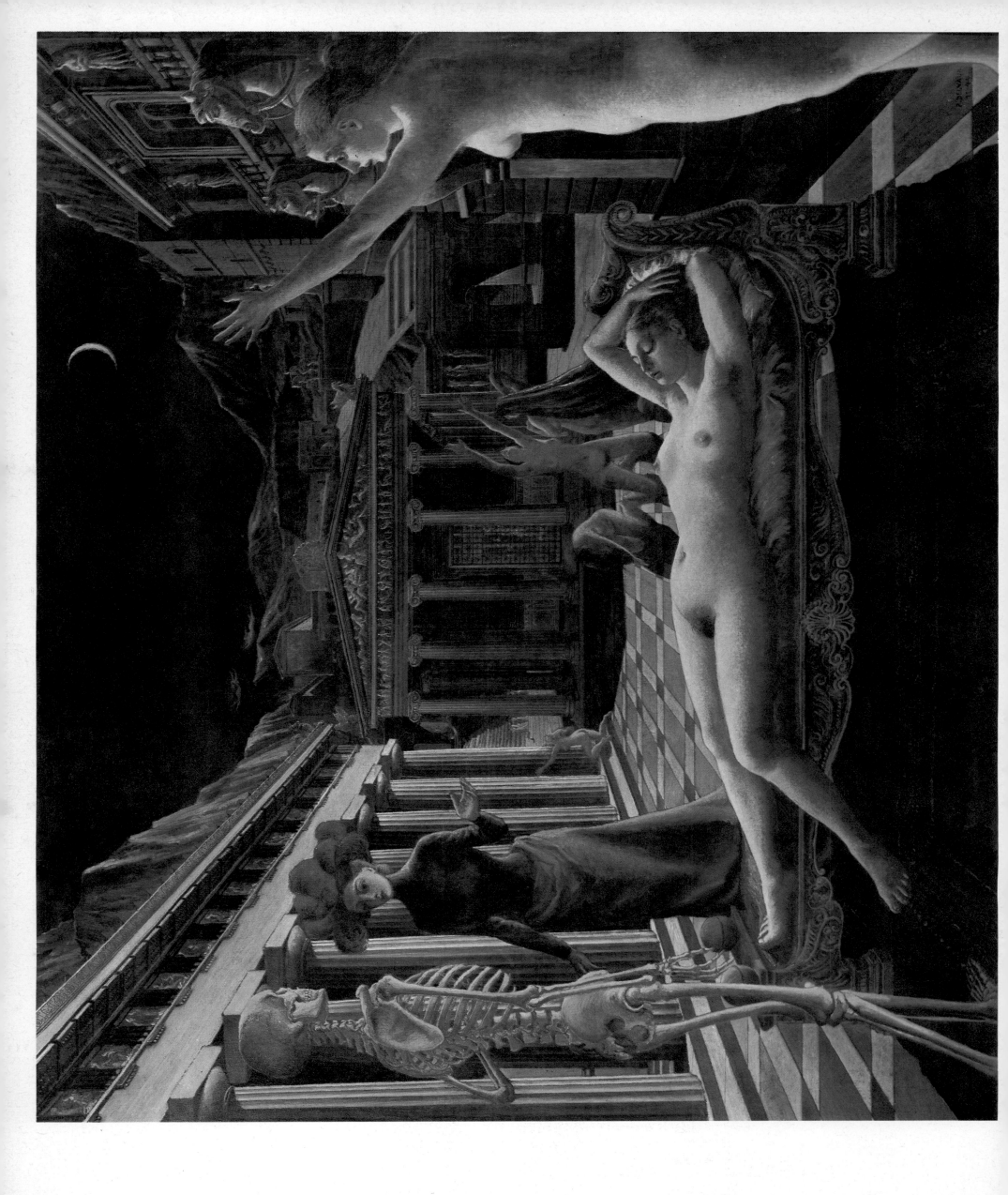

72

73

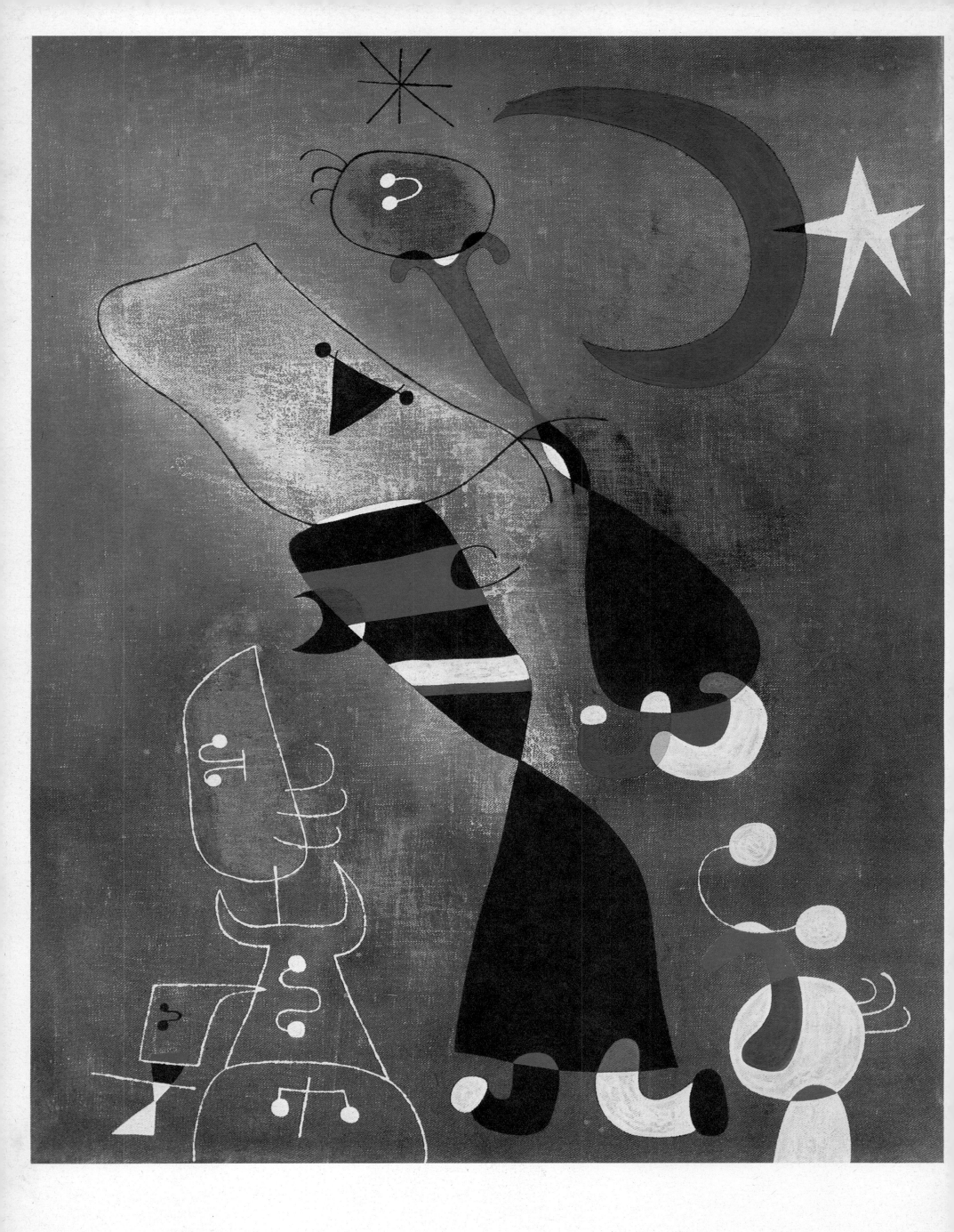

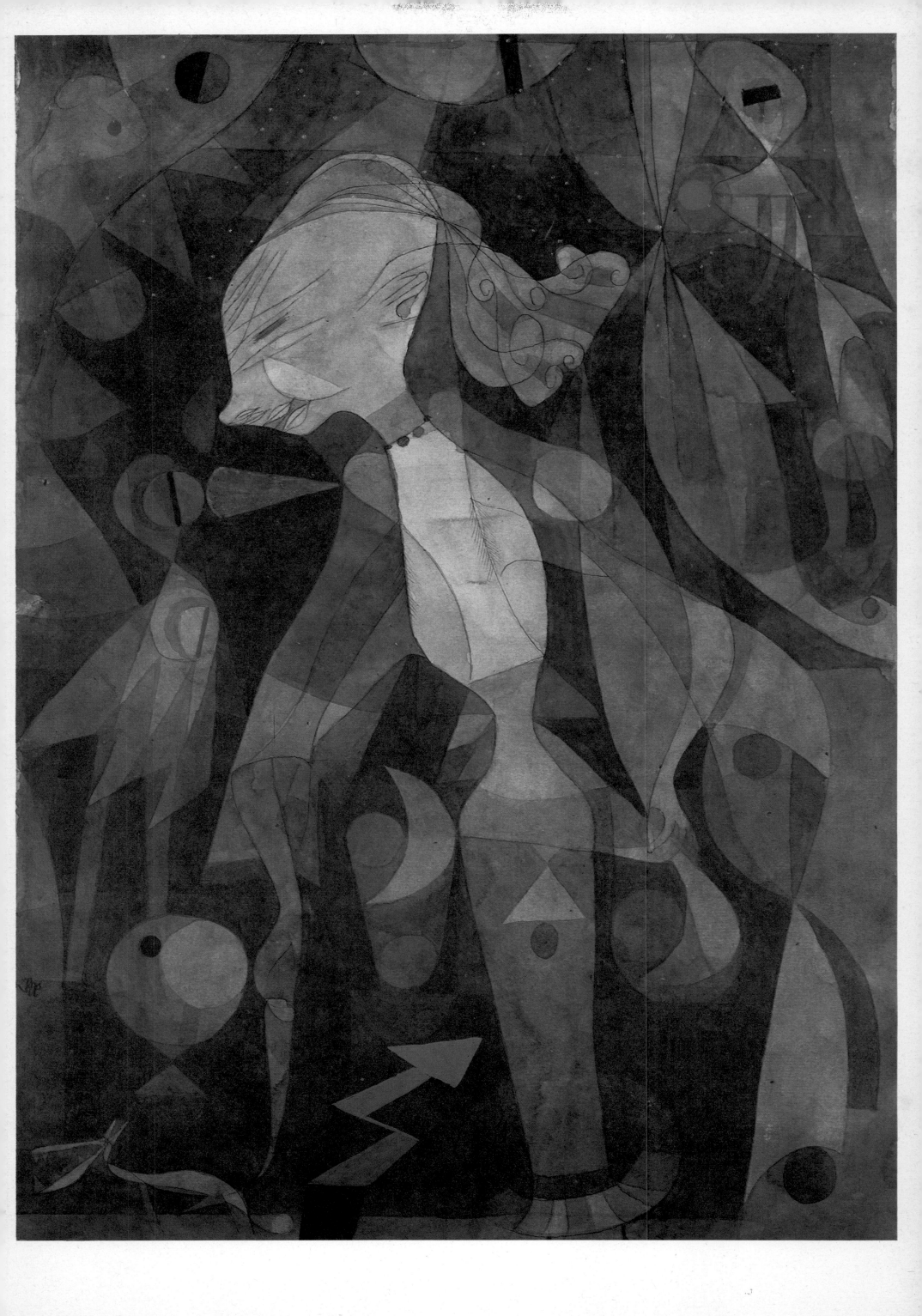

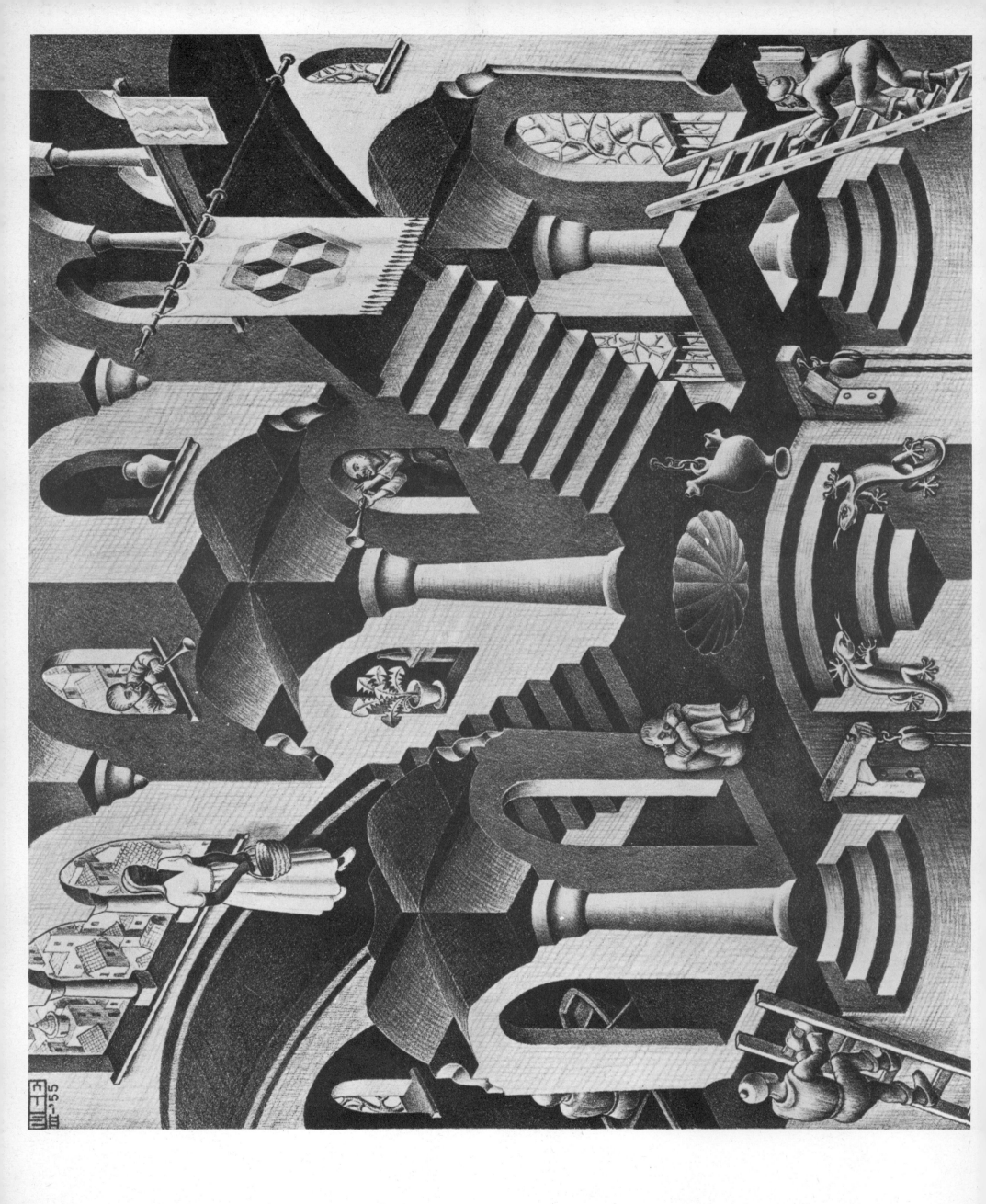

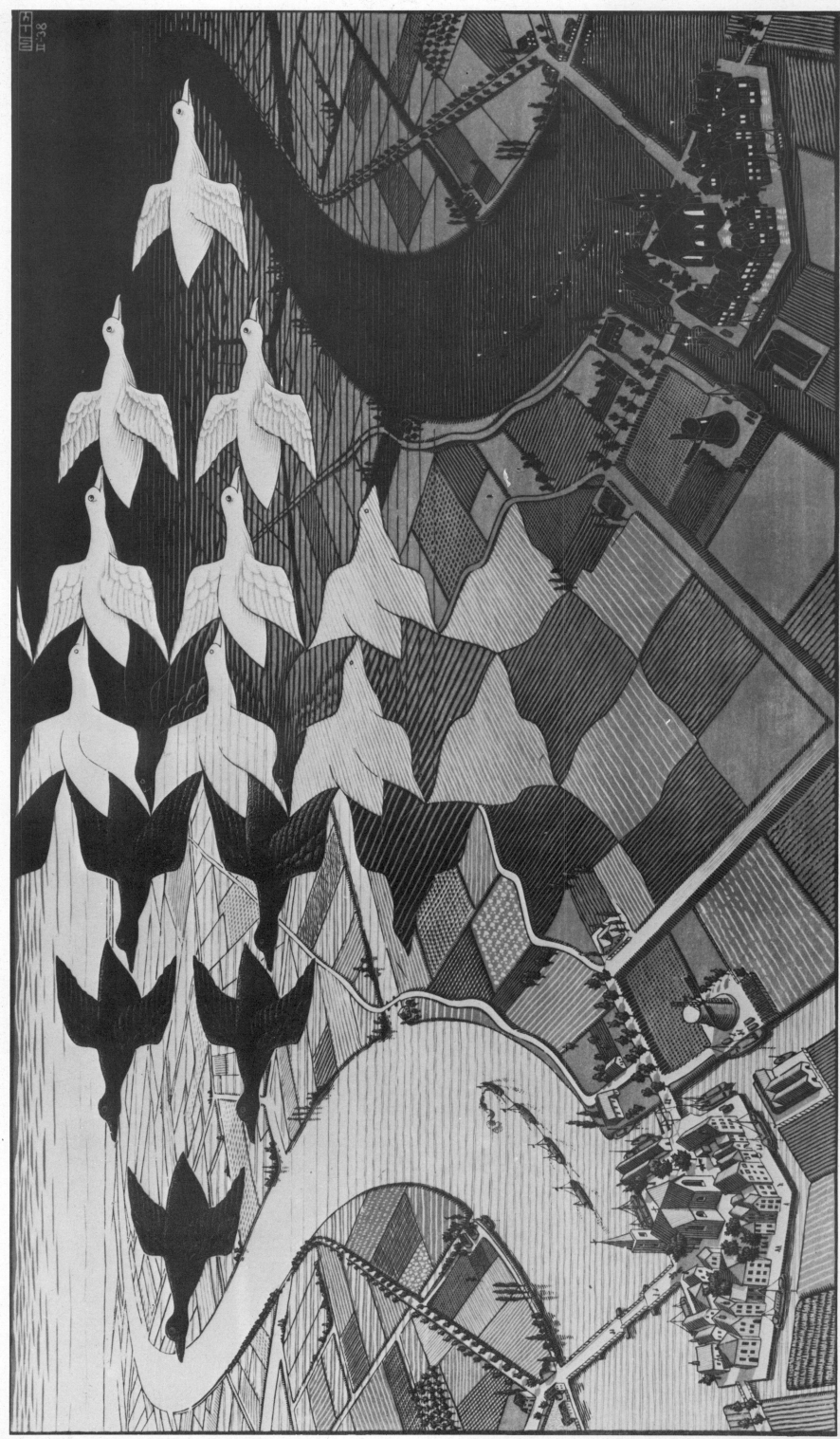

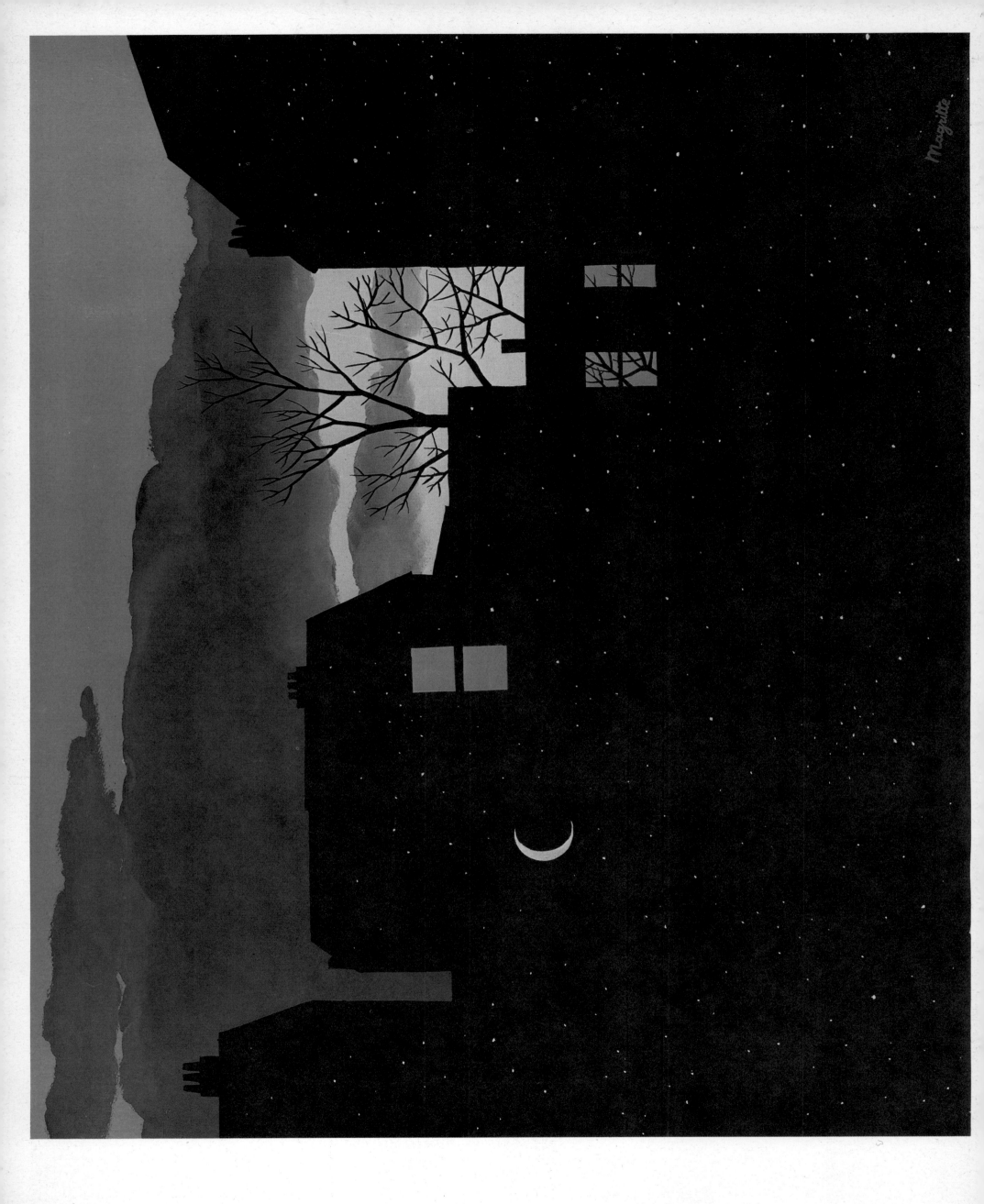

80

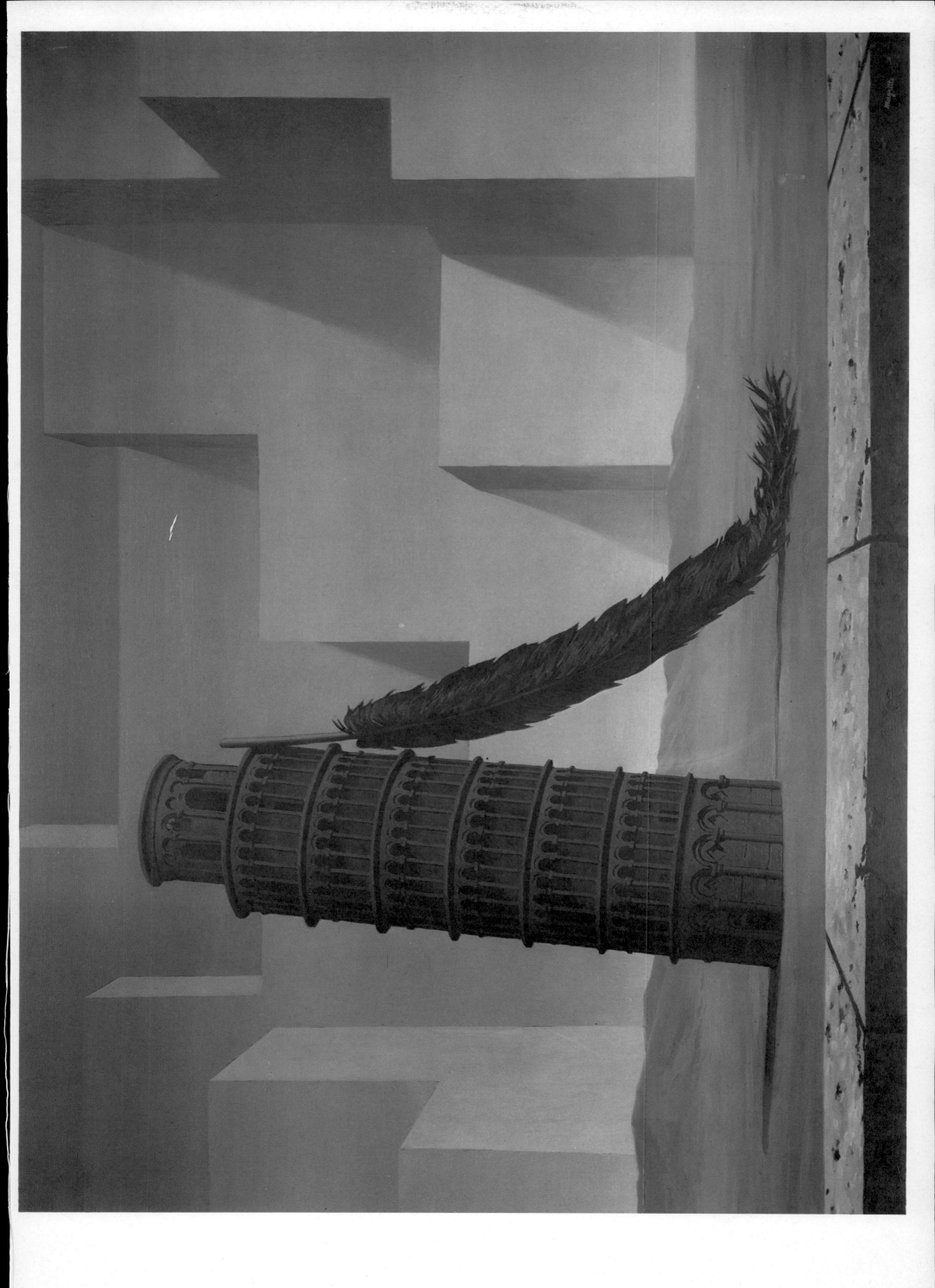

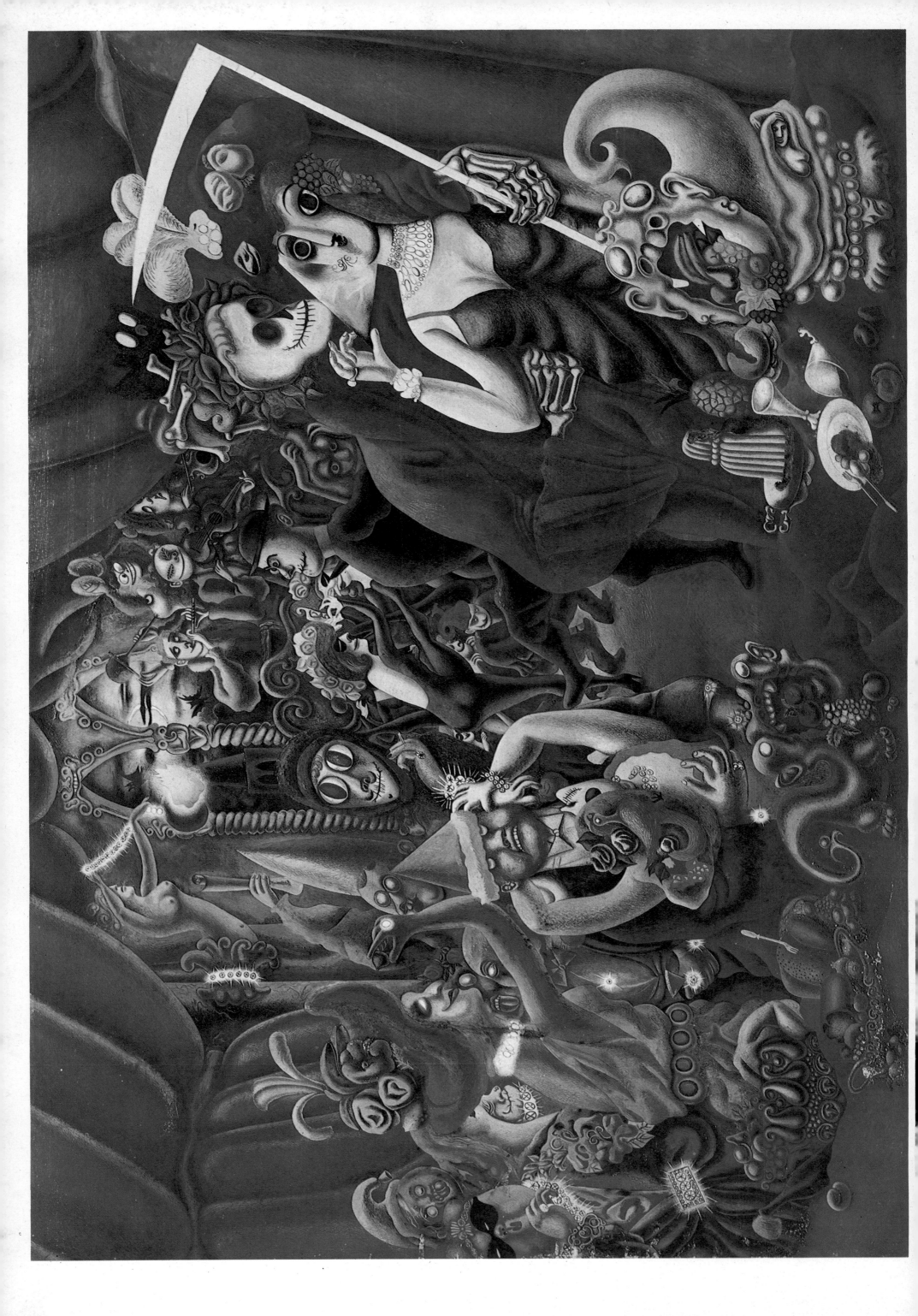

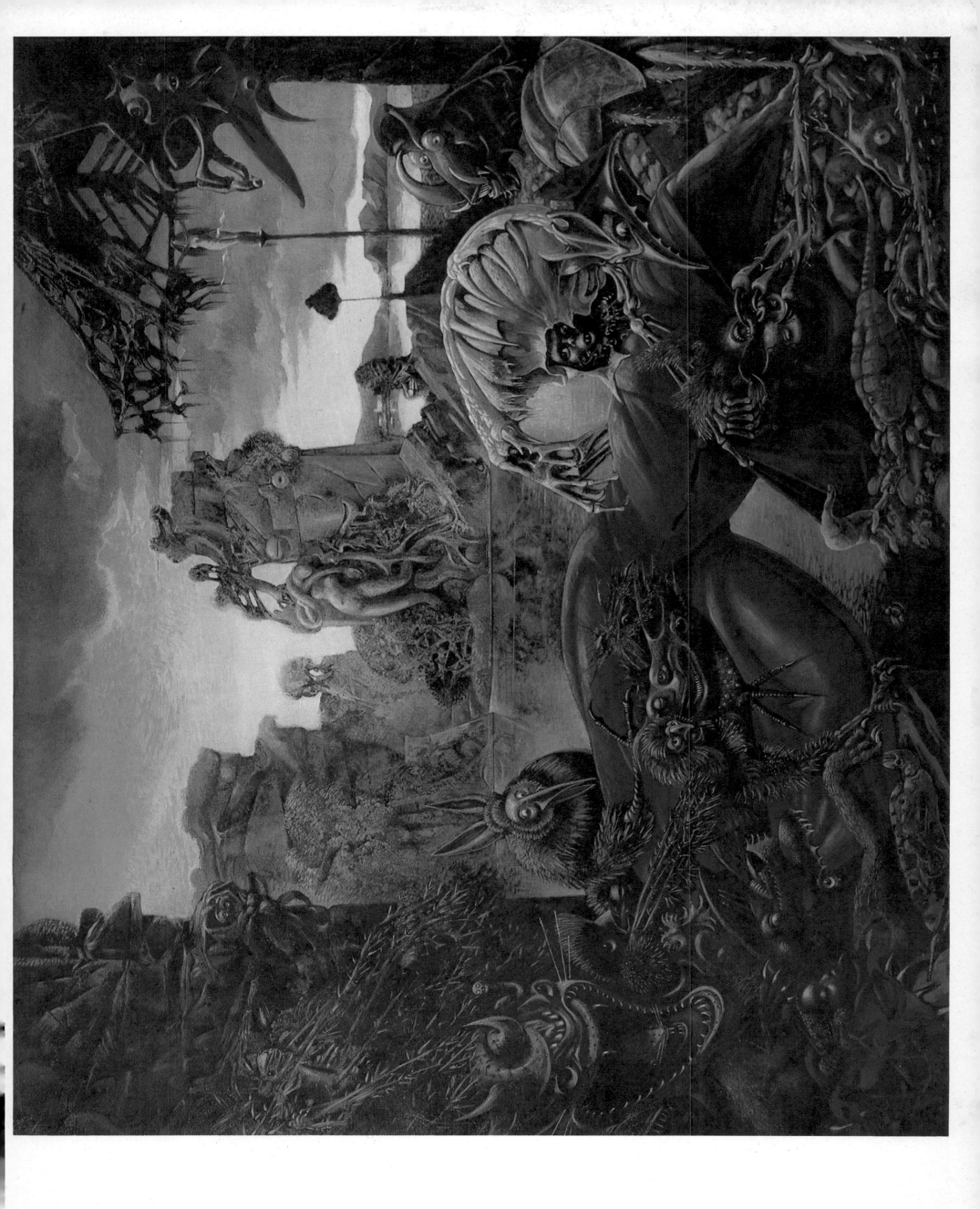

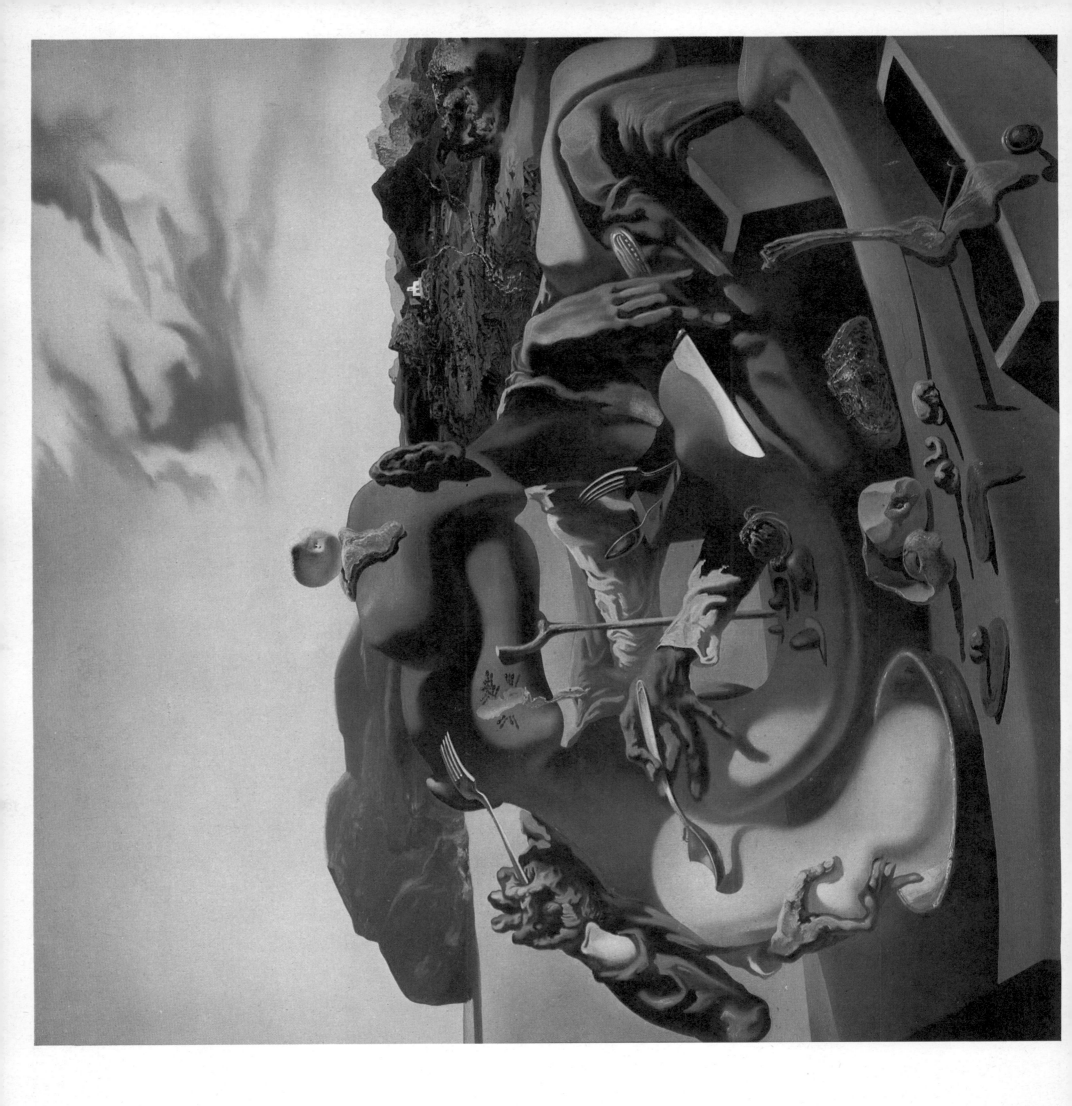

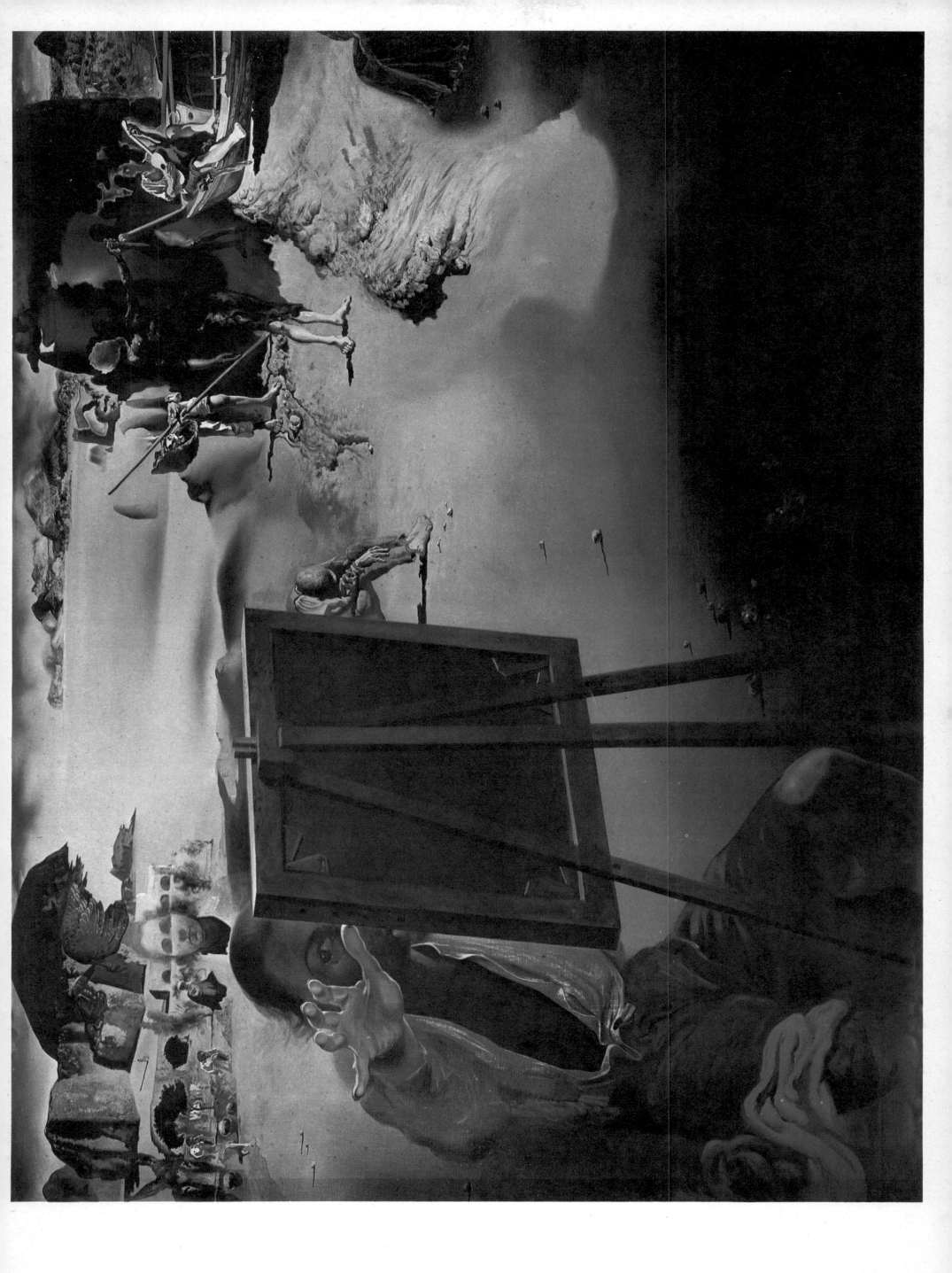

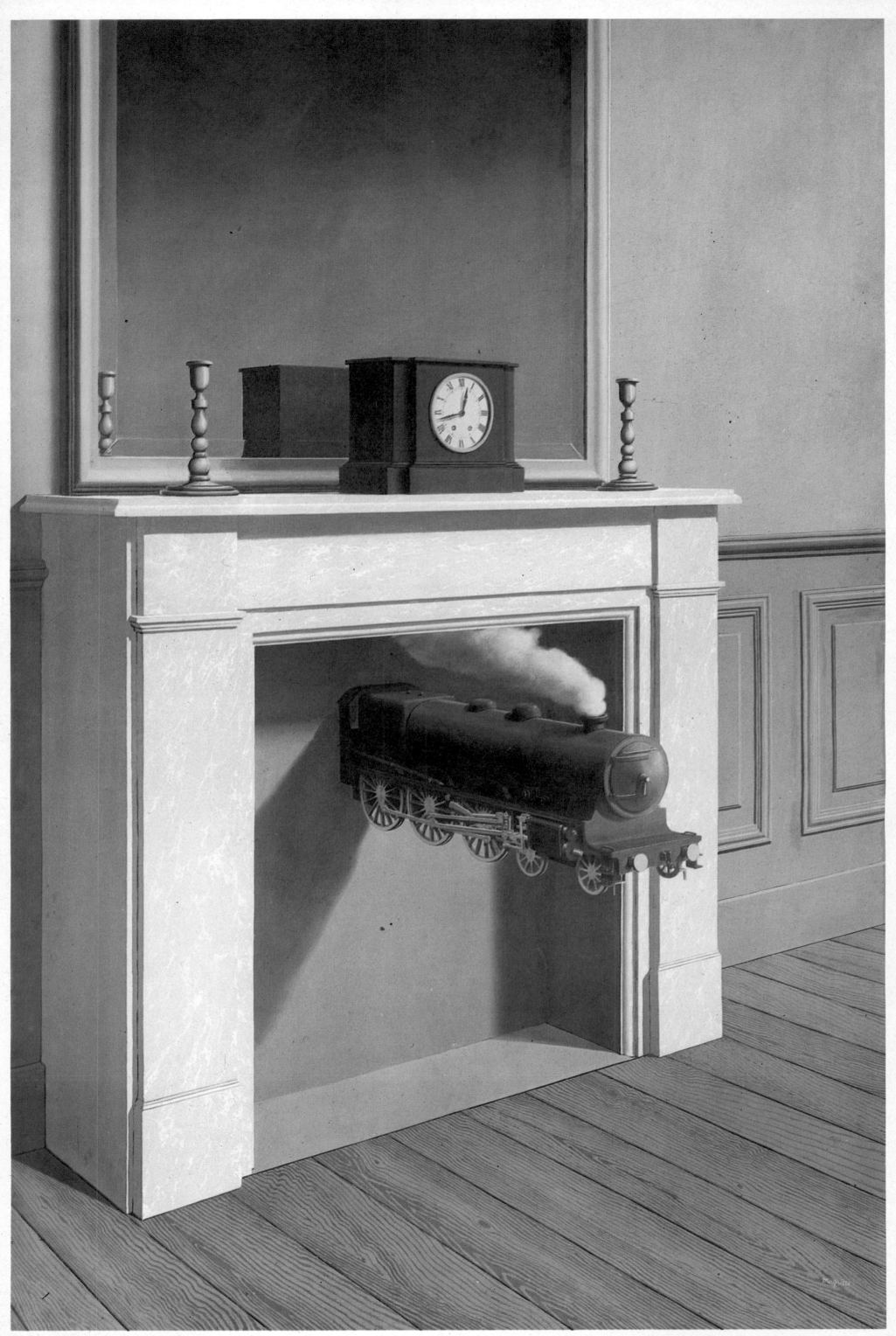

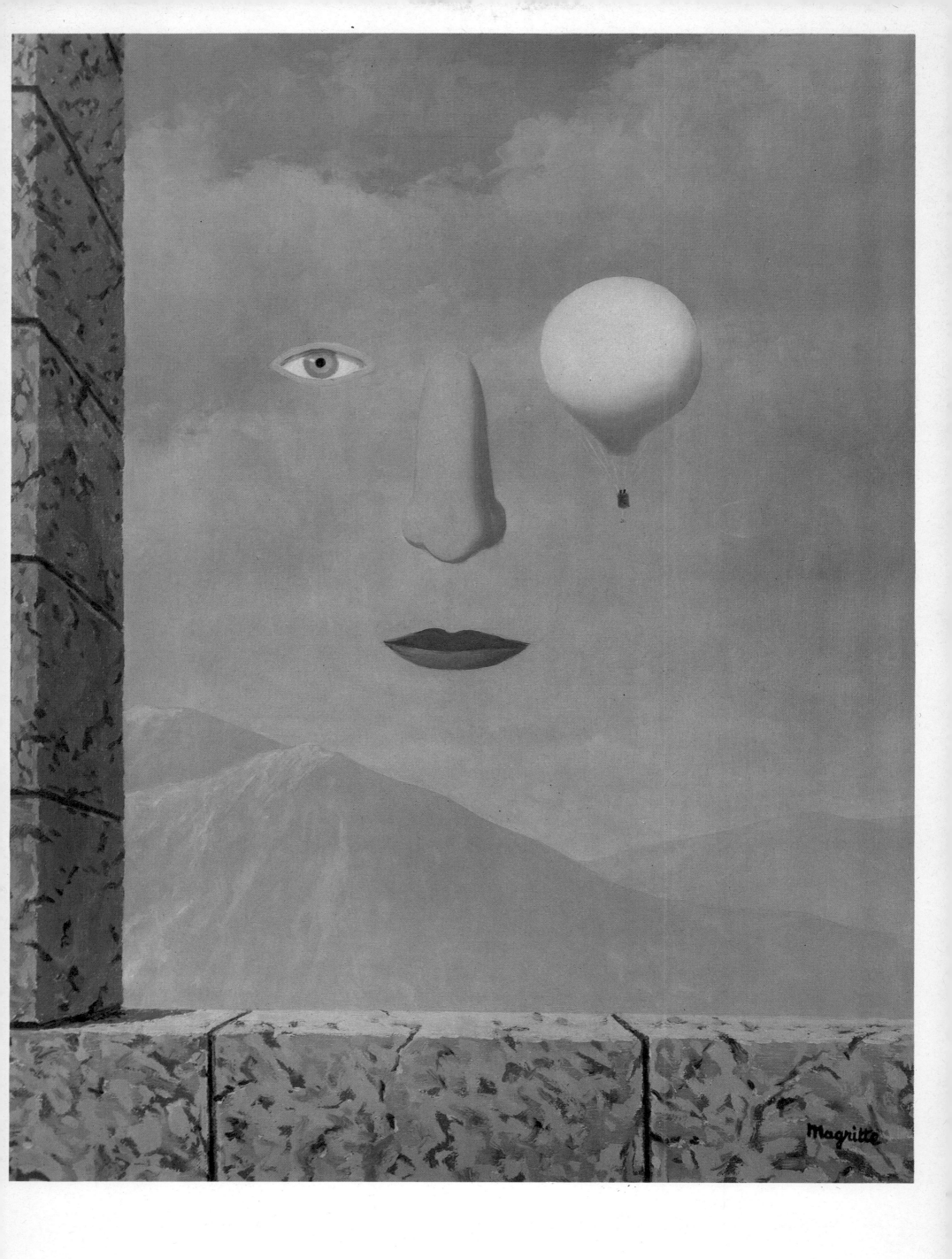

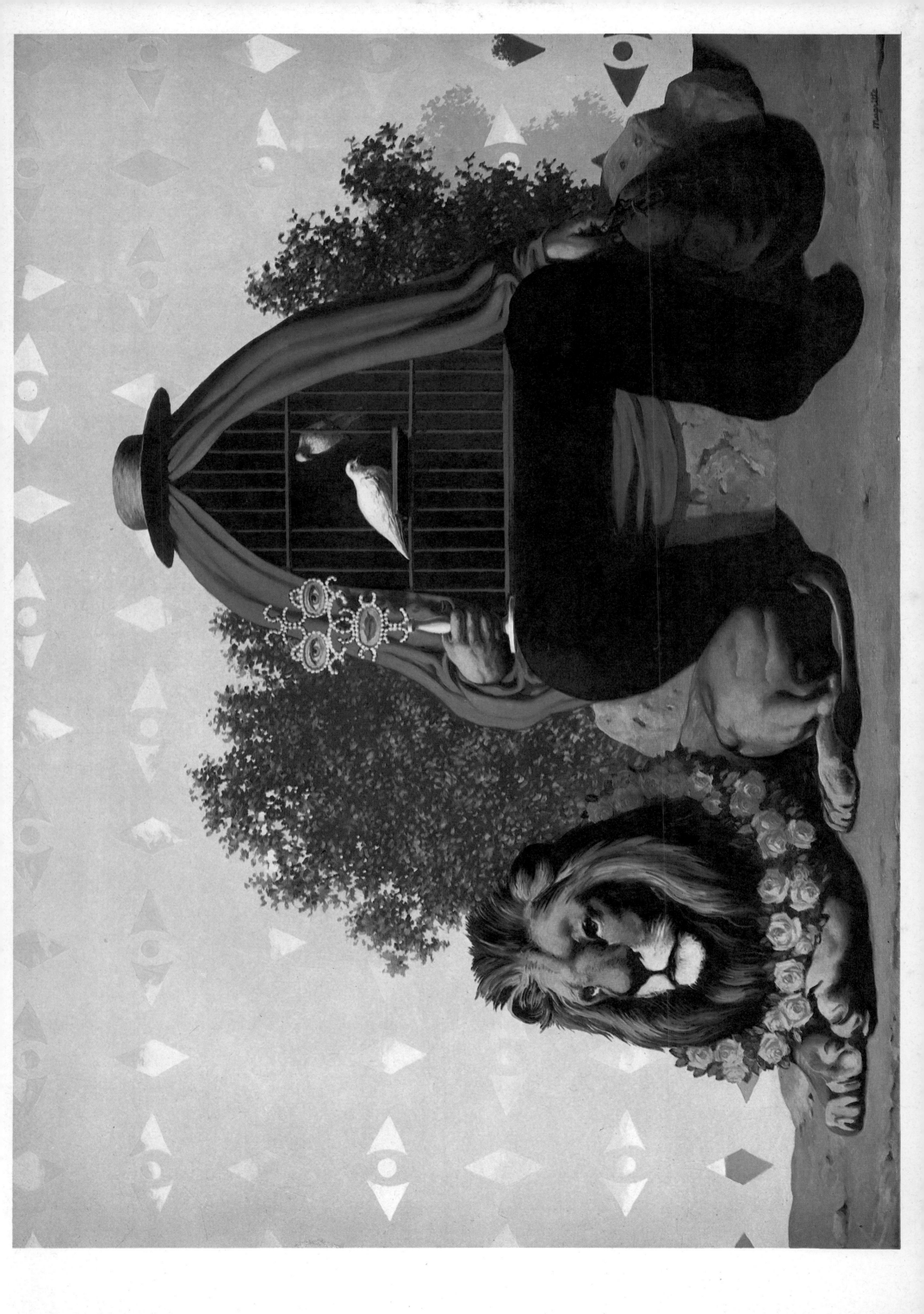

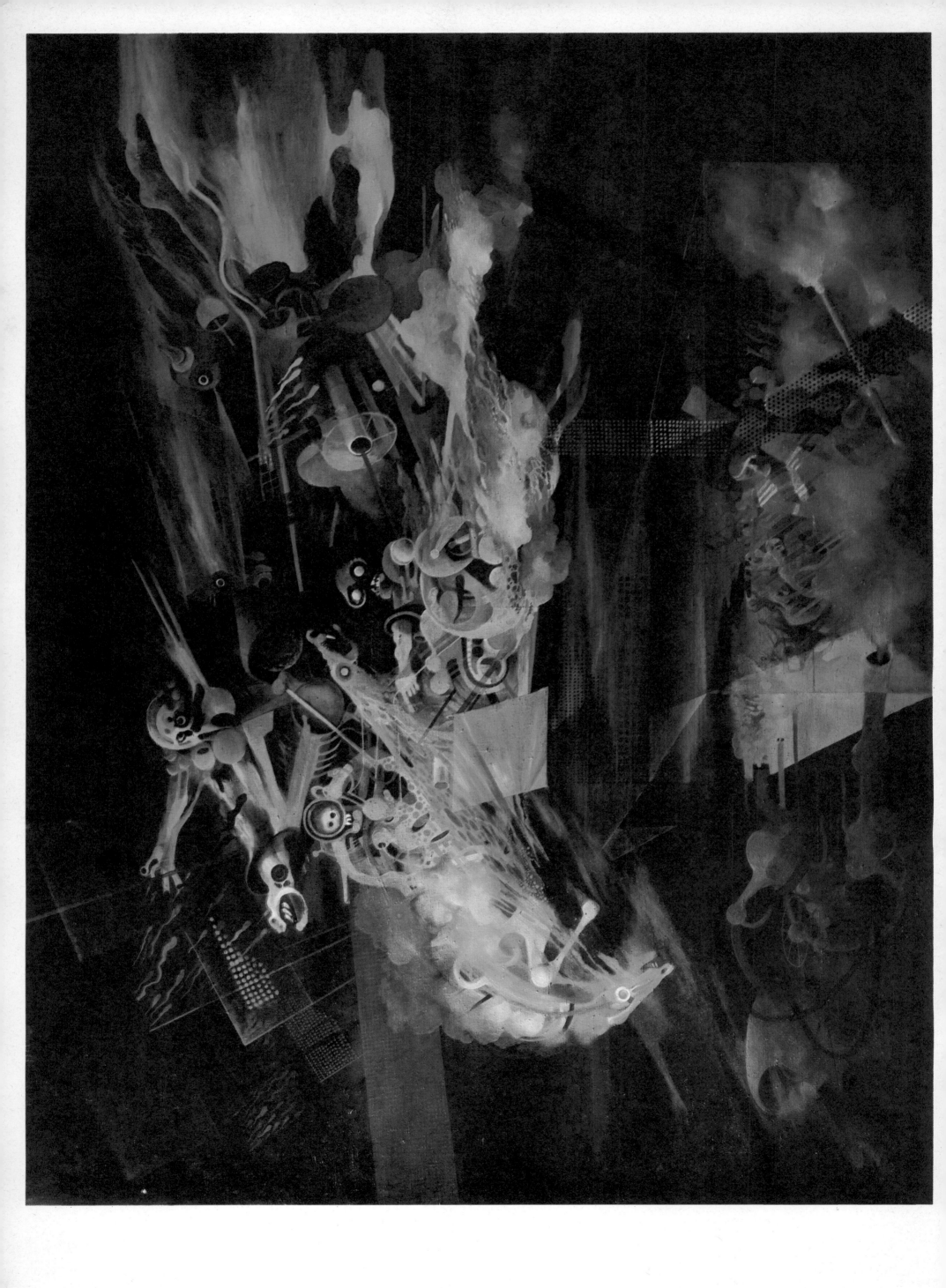

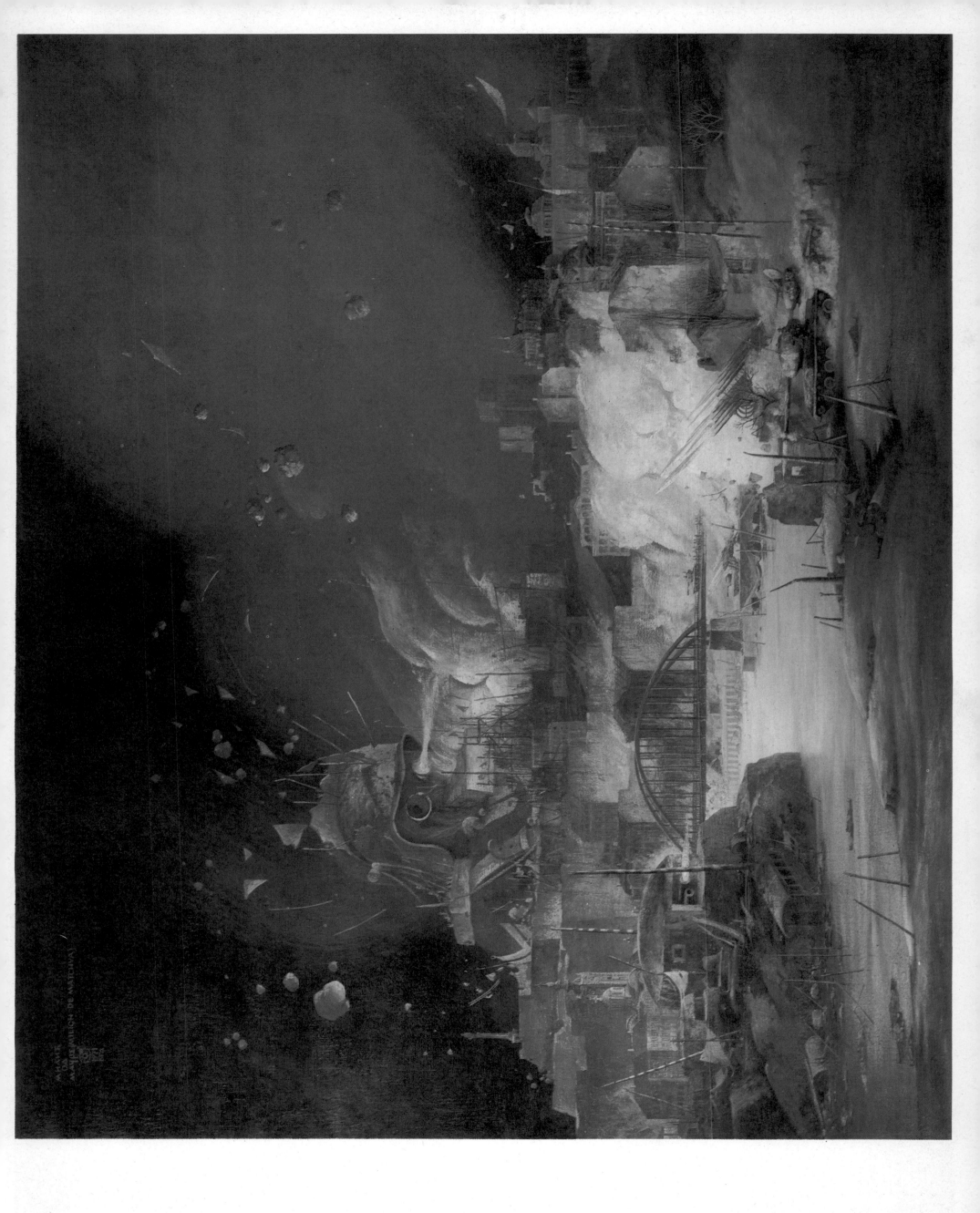

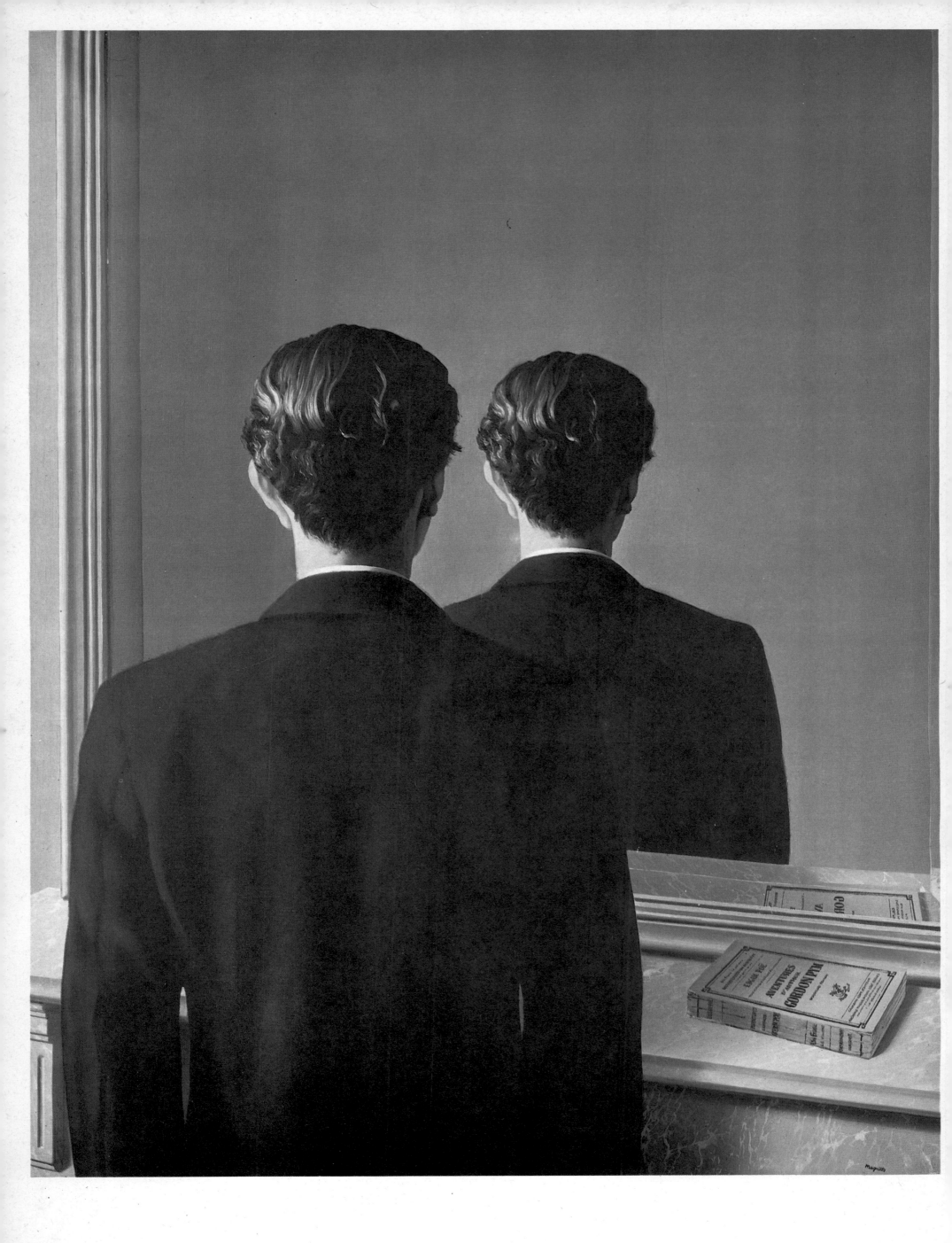